Travel and Street Photography:
From
Snapshots to Great Shots

Travel and Street Photography:
From
Snapshots to Great Shots

John Batdorff

Peachpit
Press

Travel and Street Photography: From Snapshots to Great Shots
John Batdorff

Peachpit Press
www.peachpit.com

To report errors, please send a note to errata@peachpit.com

Peachpit Press is a division of Pearson Education
Copyright © 2015 by John Batdorff

Senior Editor: Susan Rimerman
Senior Production Editor: Lisa Brazieal
Development/Copyeditor: Emily Wolman
Proofreader: Suki Gear
Composition: Wolfson Design
Indexer: Karin Arrigoni
Cover Image: John Batdorff
Cover Design: Aren Straiger
Interior Design: Mimi Heft

ISBN-13: 978-0-321-98823-2
ISBN-10: 0-321-98823-X

9 8 7 6 5 4 3 2 1

Printed and bound in the United States of America

Acknowledgments

My travel partners

Staci and Anna, the world is so much more interesting with the two of you by my side. Staci, you are forever the love of my life. You're the mortar that holds us all together. Anna, you're the brakes, slowing us down and making us enjoy every minute. We love you, we're proud of you, and watching you grow up has been the best journey of my life.

Mom

I was thinking of you the other day, and while looking through old pictures I found your daily planner. I couldn't help but smile when I came across your "100 goals," and photographing Yosemite and Lake Louise were at the top of the list. Thank you for placing the first camera in my hand and telling me, "We all need a hobby." I truly miss you and know somehow you've been with me for all my travels.

Dad

Thank you for your guidance and support. Your gift for storytelling and passion for writing have been an inspiration, and our trips together have meant the world to me.

The Peachpit crew

Thank you for your continued support. I've always respected your dedication to working with authors and artists in creating superior products.

Susan Rimerman

You make this job enjoyable, even when you're cracking the whip. I truly do appreciate your honest feedback and your ability to make me laugh.

Emily Wolman

Thank you so much for challenging me to make this book as good as possible. Thanks for putting up with my messy copy, dangling modifiers, and poor formatting. You did it all with a newborn…. You're the master multitasker!

Lisa Brazieal

You're a rock star, and your crew always puts together a wonderful-looking book. Thank you and your team for all you do.

To you, the reader

I want to sincerely thank you for giving me the chance to share my insights with you. I hope you enjoy the book, and as always, feel free to contact me at www.johnbatdorff. com if you have any questions.

Contents

Introduction

I've been taking photographs for as long as I can remember. My passion began when my mother handed me my first Kodak Instamatic in 1977. What started out as a way to keep a young boy out of mischief blossomed into a lifelong pursuit of personal expression. I've always been fascinated by people and by their relationships with others and their environment. It's this natural curiosity that has fueled my addiction to travel and to observing through the lens.

The Goal of This Book

The number-one goal of this book is to help you take your street and travel photography to the next level, and help you get the images you envision. Photography can be confusing at times, but the technical aspects of exposure and composition should never hold you back from getting the photograph you want. I made many mistakes early on with my photography, but through them I have learned a lot, and I'm happy to say I discover something new every day.

This book isn't intended to be the gospel of travel and street photography. Rather it's a guide that jump-starts your creative photographic endeavors while helping you avoid a few bumps and bruises along the way.

What You Will Accomplish

We'll start off by discussing potential camera kits, tips for planning a journey, getting a good exposure, and creating better compositions. It's important to note that I can attest only to what I use and how I do things. I'm not a fan of speculation or recommending techniques that I don't use every day. If you ask a group of 20 photographers how they would approach a photograph, you'll get 20 different answers. Photography should challenge you, and it should also be something we can all enjoy regardless of skill level. It's my hope that I have distilled my experiences into an easy-to-understand methodology that you can duplicate—and improve upon.

Once you've completed Chapters 1 through 4, you should have a stronger foundation in photography and be prepared to begin your journey.

Starting with Chapter 5, we'll discuss the pros and cons of observing and engaging your subject. Next we'll travel to the urban environment, where I'll share insights into getting the shots you want and using best practices, and give you some creative tips. Then we're off to the countryside, where we'll shift our focus to capturing sweeping vistas, rural communities, and road trips. I'll provide detailed information on how to get a great landscape shot as well as interact with people in more rural settings. Finally, we'll wrap up by discussing the legalities of street and travel photography and how to organize your post-processing workflow.

Make sure to download bonus Chapter 10, "Sharing Your Work." First login or join Peachpit.com (it's free!), then enter the book isbn (032198823X) on this page: peachpit.com/store/register.asp. After you register the book, a link to access bonus content will appear on your Account page in the Registered Products tab. NOTE: if you purchased an ebook, you're covered—the chapter is already included.

This book is a journey we will make together, and I will be there along the way, giving guidance and tips. At any point if you get lost or stuck, you email and I'll answer. Feel free to contact me at www.johnbatdorff.com.

How Much Experience Do You Need?

I wrote this book with the beginner–to–intermediate photographer in mind. Regardless of your level, my hope is you'll find the book to be a resource loaded with useful information, personal experiences, valuable assignments, and helpful tips.

Whether your passion is for travel photography, street photography, or both, your top goal should be to enjoy yourself. It's a gift to be able to follow a passion and create art at the same time!

As you work through the book, I strongly encourage you to share your images with me at www.flickr.com/groups/street_fromsnapshotstogreatshots.

If you don't enjoy the process, you won't be happy with the outcome—so relax, have fun, and create some art!

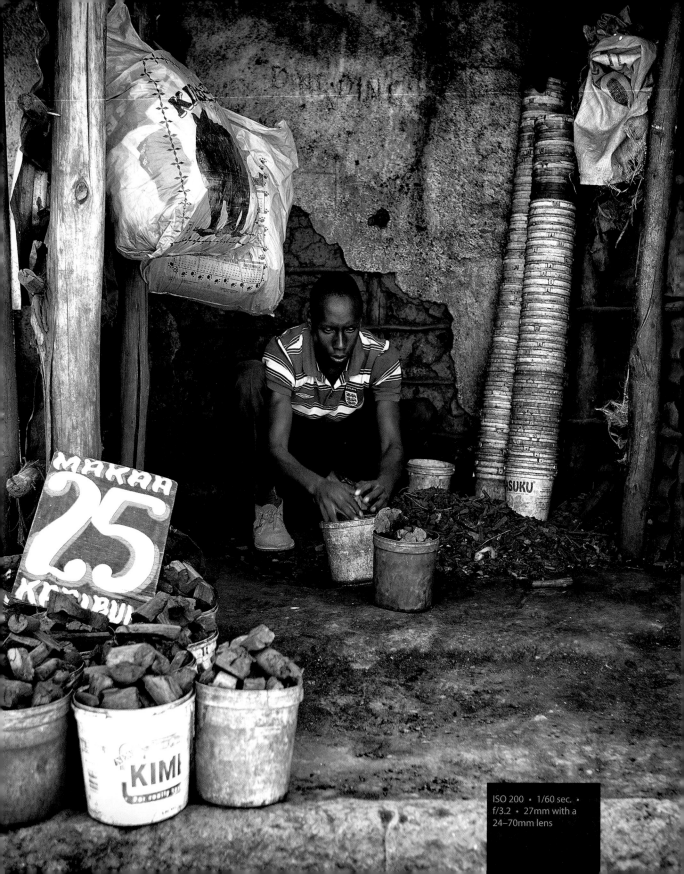

ISO 200 • 1/60 sec. •
f/3.2 • 27mm with a
24–70mm lens

1
Equipment

What's in my bag?

For even the savviest of photographers, packing your camera bag can feel a bit overwhelming. You try to pack light so you're not loaded down with too much gear, but you don't want to leave anything behind that would cause you to miss a great photo. Worse yet, the more equipment you own the more you want to bring! Even those weekend trips to NYC or San Francisco are tough as you try to decide what bag to use, which lens(es) to bring, or whether or not you'll need your tripod and external flash.

Poring Over the Picture

This image of Kilimanjaro was taken years after I hiked to the summit. I didn't get great photos of the mountain until this return trip to Amboseli National Park in Kenya, when the focus of the entire expedition was photography.

ISO 100 • 1/90 sec. • f/8 • 80mm Prime lens

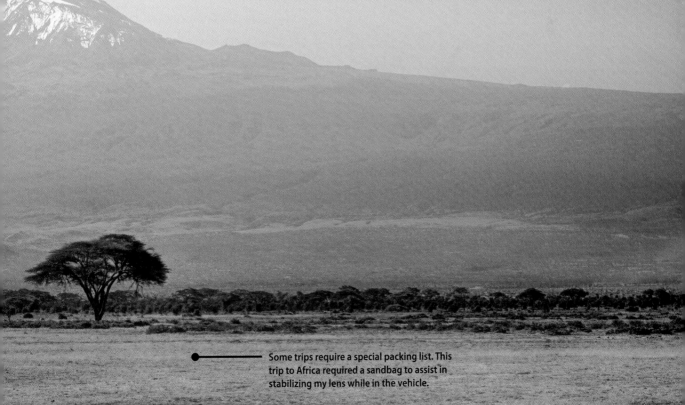

When I travel to remote locations, I always pack an extra camera body as a backup.

Using a neutral density filter allowed me to darken the sky while properly exposing the foreground.

Some trips require a special packing list. This trip to Africa required a sandbag to assist in stabilizing my lens while in the vehicle.

Years ago, I summited Mount Kilimanjaro on a guided trip, and I remember our guide barking during the pre-packing check to "Pack only what you need and only what you can carry!" Then he continued with a small grin, "But don't worry, I'll tell you what you'll need." My goal in this chapter is to help you prepare your gear for your next trip. While I won't be barking any orders, I will definitely be making a few suggestions. First I'll go over many of the options for gear, including cameras, lenses, tripods, accessories, and bags. Then at the end of this chapter, I'll show you how I go about selecting my kit based on different types of trips. Also, don't worry about the brand of gear I use; instead focus on its purpose and functionality. Honestly, I don't have strong feelings about the different brands, but when I find something that works for me, I typically stick with it.

What's the Best Camera?

I tell people all the time that I don't care what camera they use, whether it be a Nikon, Canon, Sony, Leica, etc. What I do care about is that you own a camera you're comfortable using, because at the end of the day that's going to be the best camera for you. All too often I hear of people buying cameras based strictly upon another person's work. ("I like John Doe's work, and he shoots with a Nikon full-frame, so I'm buying a Nikon full-frame.") Or they read a review about a camera and some sort of new feature, like super-high ISO ("No light needed, just a match and a fast lens"), and the next thing you know UPS is delivering one to the door.

All joking aside, I love it when people are enthusiastic about gear! I'm not the guy to tell you to avoid new equipment, but I always recommend taking a pause, assessing your needs, doing your research, and, whenever possible, holding it in your hands to evaluate it before making a purchase. A camera's ergonomics, shape, size, function buttons, menu operation, and weight should all be considerations. Some people don't mind drilling through menus to make adjustments, but I'm old-fashioned and still prefer my camera settings in the form of a dial or button. Is it *better* to have buttons than a digital menu? No. But in order for *me* to operate a camera with speed, that's the way it needs to be designed.

You need to know how *you* need a camera to be designed so that you're comfortable with it. I've witnessed many photographers operate their Micro Four Thirds menu-driven, touch-screen cameras without missing a beat, while I would be fumbling and frustrated. Street and travel photographers need to be able to react quickly to their environment, so it's imperative that a camera's operation feels like second nature.

To help find what may be right for you, let's review some camera choices as well as the pros and cons of each.

Phone and Tablet Cameras

Mobile phones with built-in cameras are compact in size and offer the convenience of always being handy, as very few people leave home without their phones. There's a lot of great work being created with camera phones—especially in tight public-transportation locations such as trains and buses—but for me they're my last resort due to low image quality and the risk of theft. There has been an increase worldwide in smartphone theft, and with all the concerns regarding identify theft, I think the risk outweighs the benefits in many situations. I will use my smartphone only when I'm familiar with my surroundings and have a strong sense of safety.

Tablets have become popular with travelers, especially for videotaping, but once again this is an instrument of last resort for anyone who is serious about street or travel photography. I would never say to forgo a shot if a tablet is all you have with you. But, much like a phone, a tablet is very easy to steal due to how we hold it, which is compounded by the lack of a strap. They also hold a high resale value, so are a desirable target for thieves.

Again, keep your surroundings in mind. It's one thing to be traveling through Yellowstone on a bus, getting out in a tourist-friendly environment, and using a tablet. It's yet another to be walking the streets of Nairobi at dusk photographing the city with one. You can find trouble anywhere in the world, but there's no need to wear your vulnerability so obviously, which is exactly how many people look when they're holding up tablets on a crowded street. Be smart with your gear, keep it close to you, avoid broadcasting your presence, and always remain aware of your surroundings.

Advantages of phone and tablet cameras:

- Readily available.

- Small size.

- People are desensitized to their presence.

- Work well in tight public quarters or in locations where larger cameras are not allowed.

Disadvantages:

- Expensive.

- Slow shutter reaction.

- Fixed focal range.

- Image distortion.

- Many are limited to only JPEG files.

- Cumbersome to operate with any speed.

- Easily stolen and often loaded with personal data—not a good combination. (This is my biggest hesitation with smartphones.)

Compact (Point-and-Shoot) Cameras

We're seeing great strides in compact (point-and-shoot) cameras with improvements in ISO, manual settings, raw file capture, GPS embedding, Wi-Fi capability, and the list goes on. This is the camera to own if you don't want to spend a lot of money but want better quality than most camera phones. I will use my point-and-shoot when I just want to slip a camera in my pocket for a casual stroll, when going to dinner, or when I need to leave things unattended (for instance, on the beach). It's also a great tool for scouting an area prior to breaking out your more expensive gear. I've been in situations where I've been unfamiliar with the surroundings and heard reports of theft, so I'll leave my larger kit behind and take just a small point-and-shoot to scout the area.

Advantages of compact cameras:

- Inexpensive.

- Small size.

- Often better quality files with RAW and JPEG options.

- Less distortion than from a camera phone.

- Variable lens.

- Fast.

- Easy to use and carry.

Disadvantages:

- Small image sensor is more susceptible to digital noise in low-light conditions.

- Built-in lens is limited.

- Often has a very menu-driven operation.

Mirrorless Cameras

This is probably one of the most interesting camera systems to enter the market in the last decade, and possibly the most influential since the single-lens reflex (SLR). In a nutshell, SLRs and digital SLRs (DSLRs) have a viewfinder that enables you to view your images through interchangeable lenses. The ability to compose an image through your lens was such a technological advance that it became mainstream, while the rangefinder became an outdated cult classic.

Now comes the *mirrorless* digital camera, which allows you to compose your image like you're using live view on a DSLR or via a digital viewfinder, which provides a more traditional feel, mimicking that of a mirrored system (**Figures 1.1** and **1.2**).

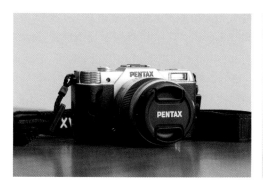

Figure 1.1 This Micro Four Thirds–style Pentax camera is an ultracompact mirrorless and extremely lightweight option. It has full manual capabilities and a good sensor, the lenses are interchangeable, and it makes quality images—but its greatest strength is its portability.

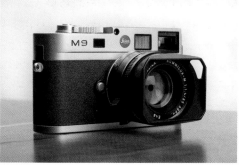

Figure 1.2 Although smaller than a DSLR, this large mirrorless Leica rangefinder has a more traditional size and look with a high-quality sensor. Its greatest strength is image quality.

You may be wondering what all the fuss is about with this mirrorless technology. The major benefit of a mirrorless camera is the ability to shorten the flange focal distance (**Figure 1.3**). And a major benefit of a shorter flange distance is the ability to use a host of different lens manufacturers, providing you can find the appropriate adapter. Also, by eliminating the mirror, manufacturers are able to shorten the lens to film (sensor) distance, which helps improve quality, and reduce the size of the lens, which results in a lighter-weight kit (an example of which also is shown in Figure 1.3).

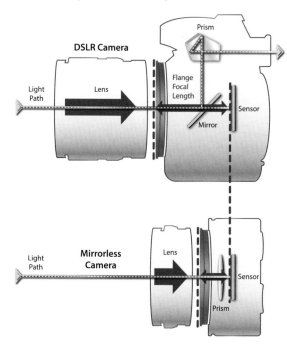

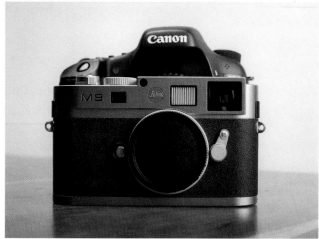

Figure 1.3 As you see from the graphic, the mirror requires quite a bit of space to allow us to see through the lens. Once you eliminate the mirror and reduce the prism (which reflects the image from the mirror to the viewfinder), your camera's footprint becomes much smaller.

Many would argue that Leica made the first mirrorless camera system with its rangefinder model. I suspect Cartier-Bresson had it right with his Leica M3 rangefinder, which allowed him to move around the streets photographing most everything with a 50mm lens. However, today there are many high-quality mirrorless systems, from those with a fixed lens (called digital single-lens mirrorless, or DSLM cameras) to those with interchangeable lenses (called mirrorless interchangeable lens cameras, or MILCs). Each system has a wide range of digital sensor sizes from which to choose, from the very popular Micro Four Thirds to the more traditional full-size sensor.

Advantages of mirrorless cameras:

- Small and discreet.
- Operation and feel are very similar to DSLRs.
- Quality sensors.
- Interchangeable lenses offer more creative options.

Disadvantages:

- More expensive than compact cameras, and in some cases as expensive as DSLRs— if not more!
- Most interchangeable lenses are not backward-compatible to nonmirrorless systems. A nontraditional viewfinder relying on back-of-camera LCD (liquid crystal display) for focus and composition may be a huge obstacle for some users.
- Putting a large telephoto lens on a small camera without a traditional optical viewfinder can make it very difficult to compose and hold the camera steady for a sharp image.

DSLRs

Chances are many of you who bought this book own a DSLR, and for good reason. These cameras are very reliable and offer the most lens choices of any of the previously discussed systems. Much like their film version (SLRs), DSLRs offer excellent-quality images with an easy operation that is familiar to most photographers. Plus there's a large array of new and used DSLR cameras on the market that meet any photographer's needs and budget (**Figure 1.4**). This has been my camera of choice for nearly 20 years because of its versatility and the speed at which I'm able to operate it.

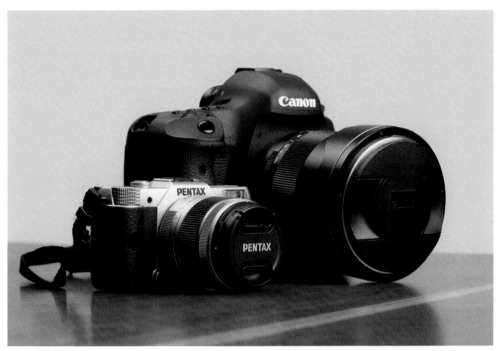

Figure 1.4
To get a sense of size difference between various DSLRs, check out this full-frame DLSR Canon body next to a Micro Four Thirds Pentax body, both with lenses.

Advantages of DSLRs:

- Wide range of models and lenses available.

- Ease of operation.

- Greater creative control.

- Excellent low-light shooting.

- Fit any budget. You can buy a cropped-sensor Nikon or Canon with a lens for less than $500 at nearly any camera store or outlet.

Disadvantages:

- Heavy.

- Not nearly as discreet as a compact or mirrorless system.

To Buy or Not to Buy?

Many photographers, including myself, have spent a lifetime building kits around our camera bodies. We've collected all the lenses, filters, tripods, and flash, and thus making a move to another camera system should be considered carefully. I always start by asking myself, "Is it a need or a want? And will I *really* use it?"

Years ago, when I tried to be a golfer, I remember convincing myself that I could probably play better with a new set of clubs, so I ran out and bought myself a brand-new set of beautiful Pings. Six months later my game didn't magically improve, and I never touched the bag again because I blamed the clubs. Now I don't golf at all!

My point: Realize your potential with your current gear. When you think that potential is truly limited, consider making equipment adjustments. You shouldn't buy new gear because you're frustrated; you should buy it because you've mastered what you've got.

Selecting Lenses

If you're shooting with a camera phone or a compact camera, your lens choices are already limited to the built-in lens. But for those of you who will be shooting with an interchangeable lens system, the sky's the limit (**Figure 1.5**).

Figure 1.5
While certainly not an exhaustive list of lens options, these are some of my favorites: a 15mm wide-angle, a 35mm street photography, a 50mm portrait, and my 70-200mm zoom.

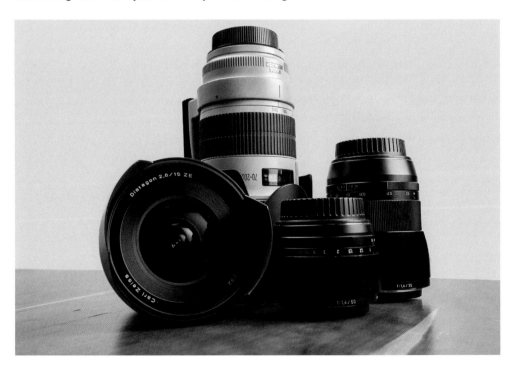

A good lens can really improve the quality of your images, so long as you're working with a solid foundation. When I have students who are debating upgrading their camera body to the latest and greatest, I'll first assess their lenses—or, as we say in the industry, their "glass." In many cases, it's not the camera that's holding back the photographer from shooting in low-light conditions, it's the glass she's using. Making a good investment in, and taking good care of, quality glass will help with your future camera upgrades.

Let's outline some of the advantages and disadvantages of the different lens types.

Wide-Angle Lenses

Wide-angle lenses are an essential part of a photographer's kit, especially for those who enjoy shooting streetscapes, architecture, and landscapes. A 15mm will give you 110-degree views on a full-frame (35mm equivalent) sensor, which is more than enough to capture most vistas.

Another very common and excellent wide-angle zoom is the 16-35mm, or similar focal lengths. This is the go-to lens for sweeping landscapes or cityscapes when you want to create a large depth of field, which means both the foreground and background are in sharp focus.

Avoid a wide-angle lens when shooting portraits, as it can create distortion (think of a house of mirrors).

Mid-Range Zooms

A mid-range zoom lens will give you ample opportunities to frame a shot properly. As a matter of fact, my first real street/travel lens was a 24-70mm. (I loved it and used it exclusively for years until I added to the kit with a wide-angle 16-35mm and eventually a 70-200mm long zoom.) Other than being a tad bulky, a mid-range zoom serves as a great multipurpose lens that covers an excellent focal range. The biggest advantage, of course, is you don't need to invest in several lenses.

The trade-off with zooms is they're not always very fast, and those that are tend to be very expensive. Moreover, regardless of size, a mid-range zoom lens usually has what is referred to as the "sweet spot" or "ideal focal distance" for that particular lens. It's at that focusing distance that the lens will perform the best and provide the best-quality image; more often than not, the sweet spot is in the middle of the focal range.

Long Zooms

I call street photographers with long zoom lenses "snipers." I know this probably isn't a politically correct term, but long-lens shooters generally set themselves up in a stationary location near bustling public havens and take photos from a distance without interacting at all with their subjects. There's nothing wrong with this approach, as it provides a different perspective all together, and in many cases, will yield a higher number of candid shots. The downside is that a long zoom lens can be very heavy to carry and draws a lot of attention. It can also create the assumption that you're a "professional," which in street photography can backfire on you very quickly. Being labeled a professional at a wedding opens doors, yet on the street being labeled a professional will close them! I rarely use my 70-200mm on the street, and when I do it's almost entirely to photograph festivals, parades, rodeos, or political events when I need the additional reach.

I also take my long zoom lenses if I'm traveling to a rural area or national park, as I would need that extra reach to get up-close photos of wildlife. If you need even more reach but don't want to invest in a 300-400mm lens, check out an extender, an inexpensive and lightweight travel option to boost your zoom.

Fixed-Focal-Length Lenses

Over the years, I've slowly adjusted my kit to mostly fixed lenses due to their higher quality, smaller size, and faster speed. Keep in mind that "fast" means the lens has a wider minimum aperture, such as f/1.2 or f/2, which allows for faster shutter-speed performance in low-light situations (**Figure 1.6**).

The 50mm fixed lens on a full-frame camera is considered the hallmark lens of a street photographer. I take nearly 80 percent of my images using a fixed 35mm, which generally is considered more of a photojournalist lens, as the wider view better accommodates environmental portraits. Both focal ranges have their strengths, but I find the 35mm serves my purposes better, and if I need to get tighter, I simply zoom in with my feet. (Note that these focal lengths are on a full-frame camera, so if your camera has a cropped sensor, a 35mm cropped = 50mm and a 24mm cropped = 35mm, approximately, based on an APS-C cropped sensor.)

The benefit of working with fixed lenses, especially if you're a street photographer, is the ability to minimize the size of your kit. Another big benefit is when you're working with only one or two lenses, you become very proficient in their use, so operation becomes second to composition. Cartier-Bresson photographed almost exclusively with a Leica rangefinder and a 50mm lens. That doesn't mean you need to follow in his footsteps, but it does beg the question, "How much gear do we really need?"

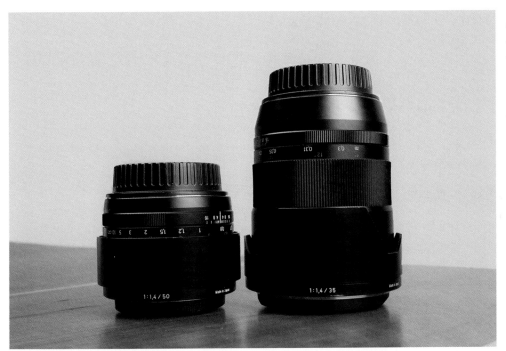

Figure 1.6
Throughout the years, I've moved to fixed focal lenses for my DSLR, working primarily with a 50mm and 35mm for most of my street photography.

Hot Tip: Moving to a Fixed-Lens Kit

If you're considering moving to a fixed-lens kit, I suggest sorting your images using the metadata to determine what focal range you use most frequently. Sorting your images can be done very easily using digital photography software like Adobe Photoshop Lightroom. The benefit of this is being able to determine what fixed lens would work best for you based on which focal length you are drawn to the most.

For example, for years I used a 24-70mm lens, but I had grown tired of carrying around such a large lens. I wanted to make a move to a fixed lens but didn't want to limit myself, so I reviewed my images and sorted them by focal range. After discovering that I took most of my favorite images between 30mm and 40mm, I made the move to a fixed 35mm—and I've never looked back.

Sturdy Foundations

I have a love-hate relationship with tripods: I hate using them, but I love my images when I do. Tripods are an essential part of any photographer's camera bag, especially if you intend on doing high dynamic range (HDR) work, which requires several exposures, or shooting video. I know a lot of people who never use their tripods because they're too heavy or too inconvenient to carry around. But if you're serious about photography, you'll get a tripod that you'll use. I own two tripods: one for landscape photography and one for street photography (**Figure 1.7**).

Photography isn't an inexpensive hobby, and it's a horribly expensive business, so invest in the things that make sense. I always suggest buying a tripod that is light yet very sturdy and rated for the weight of your camera and lens. Tripods manufactured using carbon-fiber materials will provide maximum strength with the least amount of weight. Moreover, having a solid tripod head with a quick-release plate is a must for those of us who want the flexibility of quickly removing our cameras from the tripod. If you're interested in shooting video, you'll want to research fluid head mounts that provide smooth panning motions.

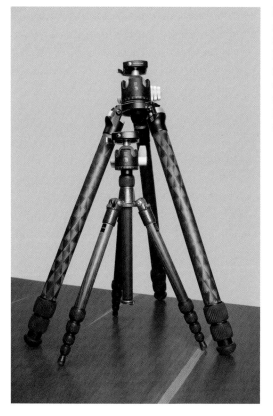

Figure 1.7 My larger tripod is much sturdier and a requirement when I need a tack-sharp landscape image. There's no use in using mirror lock-up (a feature on DSLRs that allows the mirror to be locked up to reduce vibration during exposure) and a shutter release if your tripod wiggles in the wind. On the other hand, if I need lightweight and small for foot travel, I use the travel tripod.

Street Tripods

A smaller tripod works well for street photography, providing you're not dealing with challenging winds or a long, heavy lens. I use a five-section carbon-fiber Gitzo Traveler for nearly all my street and international urban travel photography, as it's compact and very sturdy for its weight. But there are many tripods available for almost any budget.

I look for a tripod that, in addition to being light and sturdy, straps to the back of my bag so my hands remain free. When shooting on the street, it's a huge mistake to have your camera in one hand and a tripod in the other: If a photo opportunity presents itself, you're left fumbling around trying to find a location to place your tripod. The only time I have my tripod out is when I'm setting up for a shot; otherwise it's on my back, tied to my camera bag and out of the way.

Landscape Tripods

A few years ago, I realized that my Gitzo Traveler tripod just wasn't cutting it when I went to places like Death Valley, where the winds were very unpredictable. I would magnify my images in Lightroom to a 1:1 zoom and see a small blur from camera shake.

You can take all the necessary precautions to minimize camera shake by using a mirrorless camera or placing your mirror up and firing with a cable release. But the reality is that wind and unstable surfaces, such as loose soil and rocks, are image killers. Thus, for landscape shots, I suggest finding a tripod that is light but very sturdy. Here are some factors to consider:

- The fewer the leg extensions, the more stable a tripod is. These legs are designed to telescope out and lock in place at the joint. Some tripods also have a center section to allow for additional height. My lightweight travel tripod has five leg extensions with a center section.

- The more leg extensions, generally the more compact your tripod is—but also the less sturdy it becomes due to the increased number of joints and reduced diameter of tubing, allowing for the legs to collapse back into the previous sections. The sturdiest of tripods traditionally don't exceed three leg extensions.

- Try to find a tripod that comes close to your eye level when the head and camera are mounted.

- Last, and possibly most important, is transportation. If you're traveling via car, size may not be an issue, but if you're flying with a tripod, I suggest measuring your luggage to see what will fit. The TSA and airlines have been setting stricter guidelines for carry-ons, so many photographers check their tripods with their luggage. Knowing the dimensions of your luggage is a crucial factor when buying a tripod. (See "The Cargo Kit," below, for more on flying with your photo gear.)

Recently I've become a big fan of the Really Right Stuff TVC-33, which is a very sturdy and relatively lightweight tripod that comes in three sizes depending upon your height. I'm 5'8", so the TVC-33 (S) fits perfectly in my 22" carry-on travel bag and will easily fit into my 25" checked suitcase. That said, it's still a large tripod. I use it when I travel to places where I'm primarily traveling by car, like Death Valley, Montana, or Wyoming.

Stocking Up on Accessories

No kit is complete without a few accessories. From memory cards to filters to location reminders, don't forget all of the small things that are downright necessities, that can take your photos to the next creative level, and that are just plain helpful to have.

Memory Cards

It's essential to read your camera's manual and buy a memory (or flash) card that is rated for your camera. There's nothing worse than taking several photographs in rapid succession and then being unable to shoot because your camera buffer is maxed out. This can be critical when photographing sports or fast-moving subjects. Moreover, your cards are further taxed if you plan on shooting video, because of the fast write times needed by your flash card. So be sure to look for a camera-compatible and good-size card, and buy a couple—while card failures are less likely than they used to be, they happen, and having a backup card is critical (**Figure 1.8**).

> **Hot Tip: Back Up Your Cards**
>
> For big trips, I prefer buying several 16 or 32 GB cards, which I back up every night. This allows me to keep most of my trips on a couple of cards. If you're unable to perform backups nightly, I recommend splitting up your trip among several 8 or 16 GB cards, to minimize some of the risk of card failure.

Cable Releases and Remote Triggers

There are a lot of products that enable you to fire your camera remotely with a cable, wirelessly, or even with a smartphone app (**Figure 1.9**). The major benefit to using a cable release or remote trigger is to reduce camera shake, which can create blurry images. Avoiding camera shake is especially important for landscape and cityscape photography. A basic cable release shouldn't cost more than $20, and it is worth the investment. In lieu of a cable release or other trigger, I always recommend using the camera's self-timer to avoid handling the camera during the shutter release.

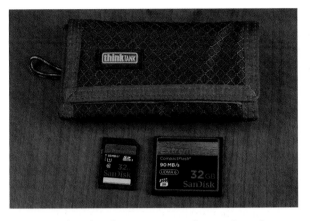

Figure 1.8 When choosing a memory card, remember to be sure that the size and the write speed align with your shooting needs and your camera's minimum requirements.

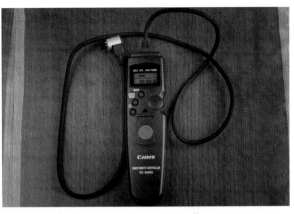

Figure 1.9 A standard cable release is a must-have for tack-sharp landscape and cityscape images.

Filters

While you can still do a lot to simulate filters in post-processing using programs like Adobe Photoshop, Lightroom, or Aperture, I have found that a good graduated neutral density (ND) filter is an essential tool for correctly exposing a landscape or darkening a sky (**Figure 1.10**). The filter is darker at the top of the glass and lighter at the bottom, which helps you get a proper exposure in the foreground without overexposing the sky. If you enjoy the look of long-exposure photography, owning a filter is a must.

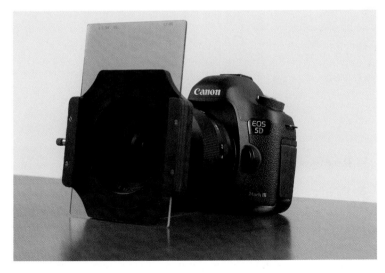

Figure 1.10
A graduated ND filter is a must if you want to create long exposures during the bright daylight.

One of my favorite filters is a 10-stop ND filter that allows you to greatly extend the time of your exposure. This technique can be very helpful when you want to eliminate people from a scene or create a ghosting effect (**Figure 1.11**). My preferred system uses 100mm filters with a holder that allows me to use one filter on a host of different lenses with the proper lens adapter.

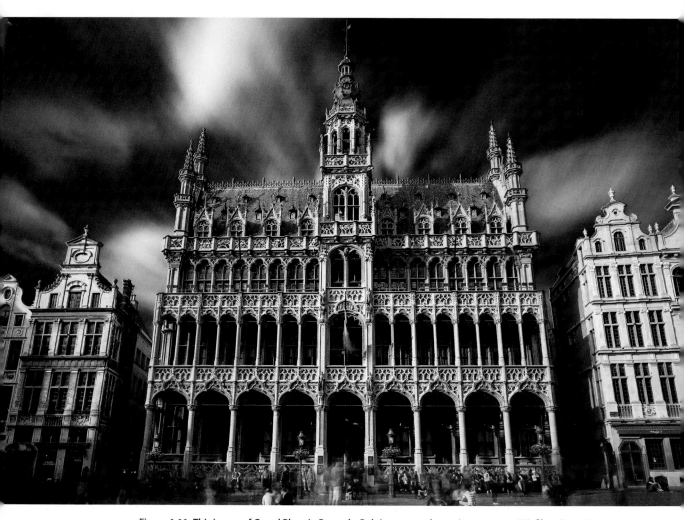

Figure 1.11 This image of Grand Place in Brussels, Belgium, was taken using a 10-stop ND filter. By using a long exposure, the filter helped create a ghosting effect of the people in the scene.

ISO 100 • 104 sec. • f/22 • 24mm with 24mm Tilt-Shift Lens

Lens Cleaning Solutions

Microfiber rags are great for lens cleaning, and they come in many sizes (**Figure 1.12**). I like a small cloth that is easy to clip to my strap or camera bag so I have easy access to it. There's no point in having a lens cloth that's tucked so far out of your reach that you never use it, or worse yet, you lose it. I then use a larger cloth for wiping down my kit at the end of the day.

LensPen (not pictured) is another convenient cleaning solution, with a nonliquid cleaning element designed to never dry out.

Figure 1.12 Lens cloths are handy to have when they're easily accessible.

Flashlights

I always pack a small flashlight or headlamp for all my photography trips. Headlamps are wonderful if you plan on doing any night photography because they allow both hands to be free to operate the camera (**Figure 1.13**).

Hard Drives and Adapters

Packing an external backup device can save a lot of heartache from card and hard-drive failures. Whenever I'm traveling for any length of time, I always perform a backup to an external drive. Don't forget your cables, adapters, and card readers (**Figure 1.14**)!

Figure 1.13 If I'm going to be photographing at night, I take a small pocket-sized flashlight or a headlamp.

Figure 1.14 I always pack an external hard drive for backing up on the go, as well as any electrical adapters, my card reader, a USB, and extra cables.

External Flash and Reflectors

An external flash can be an essential tool when you need fill light in a dark building, such as a church (be sure to check if flash is allowed before you start firing away!), or for back-lit subjects (**Figure 1.15**). If you plan on doing a lot of portrait work, I strongly suggest a small shoot-through umbrella that will clip to your travel tripod along with a remote flash trigger to allow you to control the light on your subject.

Also, while I don't do a lot of flash photography, I always try to pack a small 5-in-1 reflector that allows me to bounce light on my subject or to diffuse it when I'm dealing with very harsh light (**Figure 1.16**).

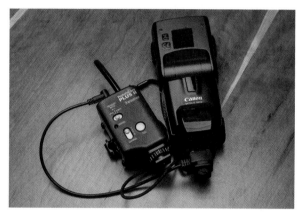

Figure 1.15 An external flash can be an invaluable tool when you just need a little extra light.

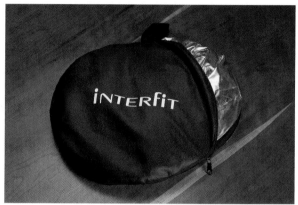

Figure 1.16 A reflector is lightweight, packs easily, and can get you just a little more light or soften harsh light for portraits.

External Microphones

Most of today's cameras allow for video recording, and many have built-in microphones, but oftentimes the quality they produce is poor at best. If you plan on shooting any video using the ambient sound from the location, you'll want to consider an external microphone. A directional mic is small, packs easily, and provides stereo-quality recording (**Figure 1.17**).

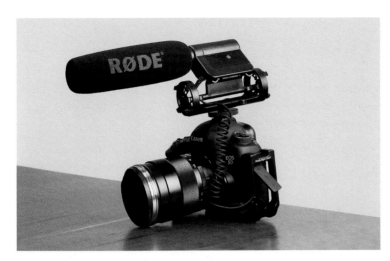

Figure 1.17
An external mic is easy to pack, and if you're doing any video, it will greatly enhance the sound quality.

Location Reminders

There are all kinds of accessories that you don't *have* to have, but that are fun and handy anyway. A location reminder is one of them.

Do you ever get so involved in your travel photography that when you go back and review your images after returning home, you can't remember for the life of you where you were when you took them? Here are two solutions to that problem! The first is definitely low-tech but inexpensive, and the second is pricier but requires less thought.

The first is to grab a small notepad or pad of sticky notes, write down each location and date, and then snap a photo of it before you take your images (**Figure 1.18**). This way when you're reviewing them, you'll always remember where you were and when you took them.

The second and higher-tech option is to use a GPS device that imbeds the positioning coordinates into the metadata (**Figure 1.19**). If I'm in the city or a familiar place, I'll often just remember where I took the shot. But when I'm traveling abroad, GPS is extremely helpful, especially if I ever want to go back to the same spot. Some of the newer cameras record location data automatically. But if you have an older model like I do, you can put this gadget on your hot shoe and it will take care of everything for you.

Figure 1.18
This is a quick trick I learned from one of my Death Valley Workshop participants. Great idea, Ken!

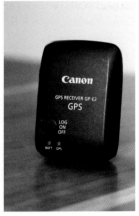

Figure 1.19
This GPS device records a very specific location and requires less thought.

Then, applications such as Lightroom versions 4 and newer can take the GPS coordinates and drop the location right into Google Maps for you!

Another handy device for those more remote locations where cell service is not an option is a satellite GPS messenger (**Figure 1.20**). This device will allow your friends and family to track your whereabouts (if you so desire) or enable you to signal SOS to the authorities in case of an emergency. This can be a very handy and essential tool for out-of-the-way destinations and has given me a sense of security when I travel to the very remote Racetrack Playa in Death Valley.

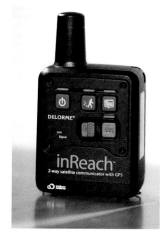

Figure 1.20 **This GPS messenger gives me peace of mind when I'm traveling to remote areas.**

Building the Perfect Kit

Choosing what gear to pack and into what type of bag is a daunting task. Here I hope to help you decide what to bring and how to carry it by taking you through my thought process when I'm preparing for a trip. As always, it's less about what brand or type of bag I like, and more about what bag(s) will work best for you, and which is the right bag at the right time (**Figure 1.21**).

Figure 1.21
These are the camera bags I've chosen for durability and practicality, but you should choose what's right for you.

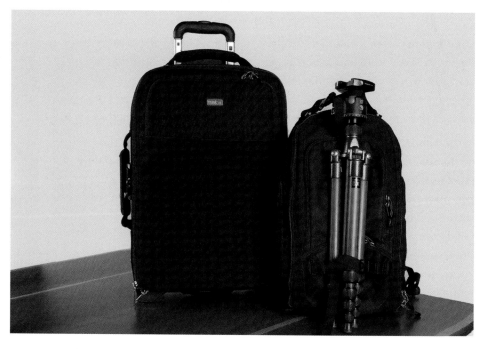

Ask the Right Questions

I always begin my packing process with two simple questions: What will I be photographing, and how will I be traveling? I know this might seem obvious, but knowing what you're going to photograph and how you're going to get there ultimately should determine what goes in your bag—and what is left behind. Your ability to answer these questions accurately is the key to your success in packing your bags properly.

Once I know what I'm photographing, I focus on building a kit that's best suited for my pending trip. Now, keep in mind, a pending trip can be nothing more than walking out my front door to take photographs in the park. Regardless of where I'm going, the second most important question is how I'm getting there. How you travel, whether via plane, train, automobile, or foot, will directly impact the size of your camera kit—and, in turn, limit your options.

We'll discuss ways to research trips as part of our trip planning in Chapter 2, "Planning the Journey."

The Street Kit: Traveling by Foot

Taking all your equipment in the car is one thing; hoofing it through the streets is an entirely different story. For me a good, long road trip is rare, so nearly all of my photography is done on foot, either leaving the front steps of my home in Chicago or those of a hotel. I'm a big believer that you need to go where the photos are, and for a street/travel photographer that means pounding the pavement.

Mountaineer rules apply when packing for the street: "Bring only what you can carry and only what you need!" My number one goal is to walk out the door with just the camera, but conditions need to be ideal for that to work: clear weather, a safe place to store the gear I left behind in a hotel, and no need for a tripod or external flash. However, if I anticipate needing to change lenses, or want my filters and my tripod for a long exposure, I'll pack my travel backpack, as I describe below.

Regardless of the packing situation, my camera is always at my side and never in my bag (unless it's pouring rain and I'm exposed). I tell my students all the time, "You can't quickly react to the world around you if your camera is hibernating securely in your bag!"

The minimalist

I prefer to do most of my street photography with just my camera and one lens. I'll use a crossbody strap because it provides me with maximum flexibility, comfort, and security. When moving about the streets, my hand is on the camera at all times to make sure it's secure. This is my ideal way to photograph, but it requires ideal conditions: The weather is good, I'm very familiar with what I'll be photographing so I already know what lens I'll

need, I have a safe place to leave the rest of my gear, maybe my travel partner is willing to carry a spare lens for me (I've never complained when Staci has wanted to buy a larger bag), and I have no intention of doing any work that requires a tripod.

If I need more than a camera-and-one-lens combination, or if conditions aren't perfect, my next step is to use a small sling-style pack (**Figure 1.22**). This protects my gear from the elements and gives me space for an additional lens or two, or a small second camera body, while still leaving my hands free.

Figure 1.22
Sling bags can be very compact and a wonderful option for a mirrorless kit or a small DSLR with one or two lenses, or when you don't need a tripod or external flash.

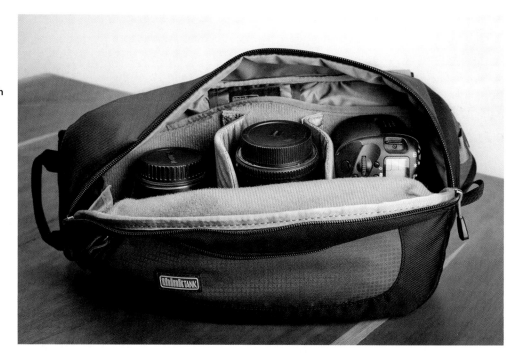

The generalist

More often than not when I'm traveling, at some point I realize that I need my tripod or to switch out my lens. I remember wandering the streets of Cusco a few years back with my 24-70mm, taking standard shots of the city, when all of a sudden I heard the sound of a band. Next thing I know, there's a small parade moving through the streets, so I quickly swapped out my lens for my 70-200mm, which allowed me to capture several shots I would have missed with my 24-70mm. The point is, when in doubt, I carry a case with a few select lenses, because there's nothing worse than missing a shot.

When I need a larger kit, my go-to street bag is a Think Tank Streetwalker (**Figure 1.23**). It's a tad larger than some, but it allows me to expand when necessary. My usual kit will include a DSLR body, 35mm, 24mm tilt-shift, 70-200mm, ND filters, cards, cable release, and cleaning cloth. Whenever possible I'll leave behind my 70-200mm to free up some weight. This is the bag I use almost exclusively, but there are occasions when I need to take two bodies and more lenses on street-photography missions. It can get tight, but it's what I've used for nearly six years!

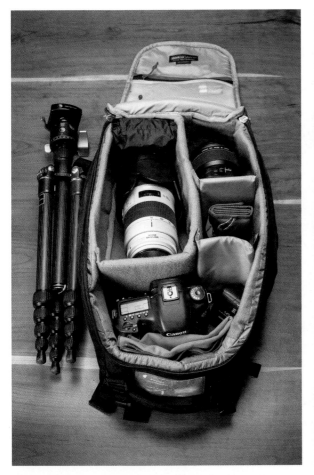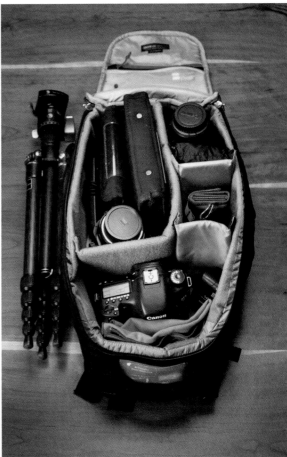

Figure 1.23 The configuration at left allows me to bring my long lens (70-200mm) and a wide-angle 17mm or 35mm lens. The configuration at right has a 24mm tilt-shift for architectural shots and 35mm for my street work. I'll forgo the long lens and pack my filter set for long exposure work.

The Cargo Kit

While it is entirely possible to travel to faraway places with only the kit shown above, sometimes you just need more. For example, when I recently traveled to New York City, I took only my sling pack. But if I were going on a safari or to the Galapagos Islands, I would want to take a much larger kit. So depending on your mode of travel, here are my solutions and recommendations when you need to take the whole kit and caboodle.

Plane travel

My number one rule when traveling is to always have my equipment near me, so I use one large bag to transport my gear. I never check any of it (with the exception of my large tripod, which fits nicely into my checked luggage). I figure I can live without my tripod and clothes if they ever get lost or stolen, but to live without my camera and lenses is another story.

Bag size is a major concern for air travel, and knowing the acceptable dimensions and weights for international and domestic flights is crucial to avoiding checking your gear last minute. In the 20+ years I've been traveling with my gear, I've had to check my camera only a few times, and only on very small planes (think 10 to 20 seats) where it was unavoidable because the cabin was too small.

I chose a rolling suitcase for my air-travel gear because I can get a lot into a small space, it meets the guidelines for carry-on sizes for both domestic and international travel, and it keeps my gear protected. Thus my preferred bag for moving my gear around an airport and abroad is the Think Tank Airport International 2.0 (**Figure 1.24**). I use this bag whenever I anticipate needing more gear than can be transported in the Streetwalker. The bag has hard sides and is well padded to prevent damage from occurring while traveling. I can fit two bodies, plenty of lenses,

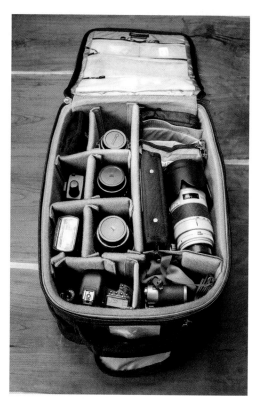

Figure 1.24 **When I'm traveling and need to pack a lot of gear, a bag of this size works well. It easily stores several bodies, four or five lenses, flash, and filters with room to spare.**

my filter kit, a flash, and my accessories, while sliding my laptop in the front pouch. Then, if I need my smaller backpack or sling pack while I'm out walking around, that goes into my carry-on luggage; once on location, I'll transfer my equipment as needed from my cargo bag to my street bag.

Train travel

You have more storage options on a train than on a plane, but I still employ the exact same rule of keeping my camera bag with me at all times. I've heard too many horror stories of people losing their camera kits because they placed them near the doors and/or out of sight. You can find clothing nearly anywhere, but finding replacement camera gear is a huge expense—and sometimes a downright impossibility, depending on your destination. Keep your gear close by, especially when the train reaches stations.

My partner, Staci, prefers to carry a smaller kit that allows her to bring a jacket, her laptop, snacks, and small bottle of water. She can also fit her laptop in the bag while on the plane or train, and then leave it at the hotel when we go out shooting. This kit is a nice medium size for day travel by train as well (**Figure 1.25**).

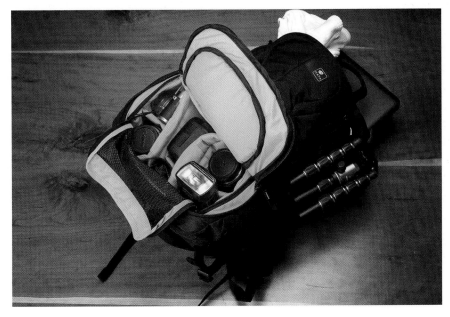

Figure 1.25 **Another option for packing a travel backpack, this is how my partner totes her gear. She doesn't have a very big kit, so this setup works great.**

Road tripping

I love road trips, especially those dedicated to photography, because it's the one trip where I don't find myself fixating on slimming down my equipment. I'll indulge my need to play and experiment by granting myself the right to pack more than I should. I'll take my full-frame body for landscape, my cropped sensor for the wildlife, my rangefinder for walking the streets, and my Hasselblad and film for those moments during which I just want to experiment. I bring my entire filter set, the big tripod, flash equipment, my GPS devices, and anything else I can think of. When I'm road tripping, I take it all.

Packing It Up

Now that we know what sort of kits we need to build for our adventures, we need to shift the focus to actually planning our travels and better identifying what equipment will be needed for them. I'll discuss lens, camera, flash, and tripod choices further in Chapter 2, as we review potential destinations and how I prepare for these trips.

Chapter 1 Assignments

Begin your shooting assignments by familiarizing yourself with your camera kit. Knowing your gear intimately, as well as your strengths and weaknesses, is critical to your development as a photographer.

Assess your gear

Place your camera equipment into two piles: essentials and potentials. Now, think about how you would pack your gear if you were traveling for a weekend. First, place your essentials into a pack. Now, take out everything that you've never used, then take out everything you've used only a handful of times. What remains is your essential list! Now, assess the bag's weight and size, and be sure you can carry it around for hours on end—street photographers need to cover a lot of ground in search of images. If I have room, I'll add some "potentials," such as a small flash for fill or add my filters for long exposure.

What's your sweet spot?

Quick, what's your favorite focal distance? Where are you most accurate and create your best work? Don't know? Well, spend time with your images and, using a program like Lightroom, sort through your metadata to determine what focal range you prefer. Once you know your favorite focal length, it's time to perfect it by honing your skills further with techniques you'll learn throughout this book. But don't get too comfortable! Artistic growth comes from experimentation, and my goal with this book is to push you outside of your focal comfort zone with creative exercises in future chapters.

Share your results with the book's Flickr group!
Join the group here: www.flickr.com/groups/street_fromsnapshotstogreatshots

ISO 500 • 1/250 sec. •
f/6.3 • 155mm lens

2
Planning the Journey

Your photography trip, from departure to arrival

For many of you, your next trip is an overdue vacation with the family; for others it might be a photocentric outing where your number one goal is getting "the shot." Regardless of your goals, the one thing I know for sure is spending a few hours researching your options and doing a little planning upfront will reward you in the end. And nothing makes a trip feel more real than when you start planning it, so let's get started!

Using a local guide was critical for the success of my India trip. He helped with communication, transportation, and getting me to the right spots.

Kumbh Mela festival, Varanasi, India

I chose a fixed 85mm focal length in advance for its low-light performance and opportunities for portraits.

Using a high ISO with a wide open aperture allowed me to capture this in very low light.

ISO 1250 · 1/60 sec. · f/1.4 · 85mm lens

Researching Your Trip

Researching a trip can begin many years in advance, and for most of us it usually starts with an article or blog post that piques our curiosity. I keep a digital folder of all the places I want to travel to in my lifetime—a bucket list filled with articles and images I have found throughout the years. This is my go-to file whenever I begin the planning stages of my trip. Let's discuss some of my favorite research tools.

Travel Books and Magazines

Whenever I have a trip to plan, I start by purchasing a reputable travel guide from Fodor's or Lonely Planet. While guidebooks can never be as up to date or in the moment as online recommendations, they are extremely thorough and can be invaluable trip-planning tools. (While the best restaurants in a city might change, generally the best sights don't.) These guides are usually chock-full of photos, transportation advice, walking tours, suggested places to visit or avoid, crucial travel maps, insider tips, and other essentials to help you make the most of your trip. When browsing for books, be sure to check the copyright dates to ensure you're working with the latest edition (**Figure 2.1**).

Figure 2.1
Travel books are a great resource for planning trips. My favorites are those that include maps.

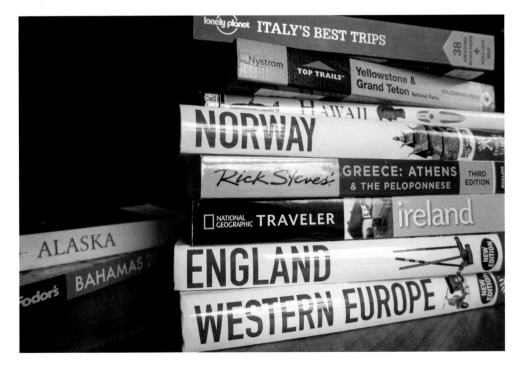

Blogs

There are many travel and street photographers who maintain active blogs and post to them frequently. Find a blog whose author you respect and trust: Blogs can be an excellent source of information about a location, so long as they're accurate. If you have questions, commenting on a photographer's blog is an excellent way to get answers. Bloggers love it when people ask questions, providing they're pretty straightforward! And whom better to get travel-photography advice from than a photographer who has been to the place you're going to visit?

Google Alerts

I like to work smarter, not harder. Thus I use Google Alerts, which allow you to establish search terms and then have the latest online information related to those terms delivered directly to your Inbox. Whenever I'm traveling abroad or beginning my research for a trip, I set up Google Alerts using key phrases such as "Rome, Italy," "Travel tips for Paris," or "Nairobi travel alert." Google's search engines troll the Internet for these terms or phrases, and then email the results, either in real time or as a daily summary. Not every result Google returns will be of interest, but on average the alerts do a great job of keeping you up to date (**Figure 2.2**).

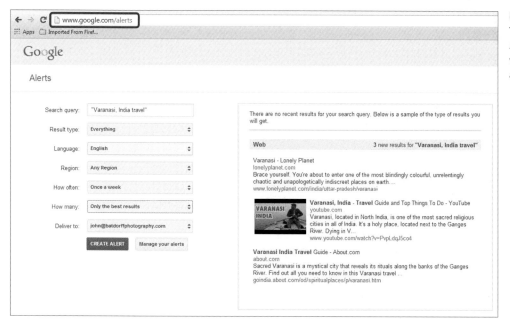

Figure 2.2
To set up Google Alerts, visit www.google.com/alerts.

Traveler Review Websites

There are two types of people in this world: those who like surprises and those who don't! Learning from past travelers' experiences is a great way to manage your expectations and increase your chances for a successful trip.

When it comes to lodging, most of us, including yours truly, fall into the latter camp. I'm a big fan of reading reviews, especially those that are well balanced. TripAdvisor (www.tripadvisor.com) does an excellent job of aggregating user feedback on hotels and bed and breakfasts as well as restaurants, tourist attractions, and sights. Sometimes I search TripAdvisor for suggestions on must-see or off-the-beaten-path destinations and places to avoid.

You can also research your trip using TripAdvisor's online community travel forum. Another excellent source is Lonely Planet's Thorn Tree (www.lonelyplanet.com/thorntree). These forums provide travelers with first-hand commentary on topics such as the best way to get to your hotel from the airport or train station, or the best time to see an attraction.

Google Earth

I have an uncle who has traveled around the world from his armchair via an iPad. He's been to the Eiffel Tower in Paris, the big skies of Montana, and my front steps in Chicago without ever leaving his house. His mode of travel is Google Earth (http://earth.google.com), an incredible resource for getting to know the lay of the land. You can see the streets using Street View or topography using Aerial View.

Google Earth is an essential tool for familiarizing yourself with an area as well as establishing a shot list. It can be very helpful in identifying city centers and major tourist locations that you may want to visit or avoid. Bonus: It's very photocentric, with millions of images that users have geotagged.

Government Agencies

Many nations, including the United States, have websites to help their citizens better prepare for traveling abroad (**Figure 2.3**). These government-sponsored sites provide critical information concerning entry and exit requirements such as visa and passport requirements, vaccine requirements and suggestions, currency restrictions, embassy locations, and emergency contact information.

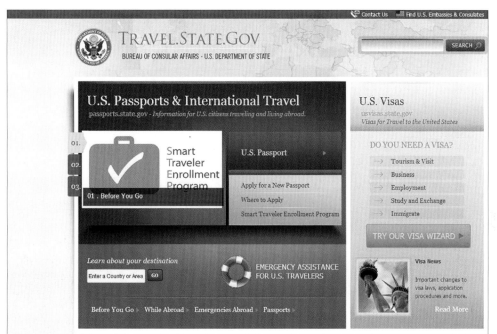

Figure 2.3
Before going abroad, always visit your government's travel website for the latest recommendations.

Moreover, these sites are very useful for learning more about a country's climate, culture, laws, and security risks or areas of concern. I highly recommend researching your government's travel website before going abroad. Finally, many foreign affairs websites such as Canada's allow residents to register their destination and contact information, so the government can provide them with critical alerts regarding their destination.

Here are a few major government travel sites:

- www.travel.state.gov (United States)
- www.travel.gc.ca (Canada)
- www.gov.uk/foreign-travel-advice (United Kingdom)

Creating an Itinerary

A detailed, well-organized itinerary is the cornerstone to an enjoyable, hassle-free trip. My partner, Staci, and I always create an itinerary that includes addresses and contact numbers for all of our destinations, as well as flight and train numbers, emergency numbers so family can contact us if needed, and any other notes (**Figure 2.4**). Once the itinerary is created, I print a hard copy and create a PDF with hyperlinks to our hotels' websites. The PDF is great to have on file because it allows us to click a link using a mobile device and have Google Maps direct us to our location.

But before you can create an itinerary, you have to know where and when you're going, how you're getting there, and with whom you'll be traveling. Here are some things to consider when making these decisions.

Figure 2.4
This is a sample itinerary template.

Detailed Lodging Info

Name of Lodging	Address	Phone/Website	WiFi Included?	Breakfast?

Notes and Shot List

Destination: _____

Desired Image	Location	Ideal Time of Day	Must-Have Equipment

Additional notes, transportation details, must-do's, restaurants to try, etc.:

Where to Go

Obviously this is the most important question of them all! You'll have a lot to consider, as we are fortunate that there are so many beautiful places to visit and photograph. Take time to determine what place best meets your goals, is within your budget, will have weather that suits your needs, and, above all, will provide the best photographic experience.

We usually make a list of the top three places we're considering for travel. Then Staci goes online and builds out the different trips to get an idea of cost, climate, lodging options, and current events in each place. Then we narrow it down from there. For example, we were recently deciding on a trip to Greece, Italy, or Spain. We looked at the countries' national holidays that were going on at the time we'd be traveling (near Easter), asked others who had traveled to some of these locations what they would recommend, weighed the aforementioned factors, and eventually decided on Italy.

When to Go

For some of you, this question is the easiest of all. You may have a designated time that you can travel due to work, kids' schedules, family travel, or assignments. Yet for others this can be a tough question, especially if schedules are flexible.

To help us decide the best time to travel, Staci and I usually seek the advice of guidebooks, a website called Weather Underground to check average climate information, and the holiday and festival schedule of our desired location. I always recommend trying to align your travel destination with your personal goals. For example, if we're going on a relaxing family vacation where we want to kick back and enjoy the sun, we may avoid a busy Carnival festival. But if our goal is to get great street photography, we'll book a trip during that festival.

Of course, consider that busy times may mean higher rates, so make sure you plan ahead and book early to avoid unnecessarily high costs. I'm a big fan of traveling during the low season when rates are lower and few tourists are present.

How to Go

How you decide to get to a particular destination can be limited by the specific location. Know how you can and like to travel, and make sure you can get to the location safely. In many less developed countries, you can spend a lot of time in cars that may or may not have heat or air conditioning, and the road conditions can be terrible. There isn't much worse than feeling carsick or seasick while on vacation, so make sure you choose your mode of travel accordingly.

You also need to consider how you can get your gear to your location. Will there be room? Are there weight restrictions?

With Whom to Go

This is a very important question. You need to decide if you'll travel with family, with a group, or all alone. Again, you need to be clear about your goals for the trip in order to make a good decision. I definitely get the highest quantity of photos when I'm traveling alone or with another serious photographer—but that's not always a reality. I love to travel with my daughter and Staci, and when I do, I have to realize that the entire trip can't be just about photography. Yet I always have my camera with me so I'm prepared if something catches my eye.

However, I'm a big believer in designating several hours a day strictly to my photography, devoid of family, friends, and fellow photographers. I find a time to go when it won't interfere with family time, such as early morning or late at night. Street photography is not a team sport; it's a very intimate experience that needs nurturing, so making time for it is critical to getting better. There are some people who love group tours because they enjoy the camaraderie and ease of traveling with a guided group. But in my experience, unless it's a photography group, it can be difficult to focus on photography without feeling like I'm slowing the group down.

Creating the Shot List

Every time I travel, I try to create a list of images that I want to capture at my destination. The shot list doesn't need to be exhaustive or set in stone, but it should be a set of goals that follows your itinerary. For instance, when I traveled to Africa I knew I would be visiting a Maasai village so I added "Maasai portrait" to my shot list (**Figure 2.5**). Keeping the shot list a bit broad helps: Rather than fixate on getting any one photograph, I focus on building a portfolio of images that best represent the destinations I'm visiting.

Here are some dos and don'ts of building a shot list:

Do:

- Ask yourself what images you want or need to bring home from your trip.
- Start visualizing what these images might look like and what equipment you might need to capture them.
- Create a shot list that follows your itinerary, or make sure your itinerary follows your shot list.
- Factor in plenty of time at the most important photography locations.
- Take into consideration the time of day when you need to get the shot. If your itinerary has you headed to a location first thing in the morning when your shot is a sunset shot, you'll waste time and miss opportunities elsewhere.

Figure 2.5
A shot list helped me visualize and prepare for this image of Maasia warrior in Kenya.

ISO 320 • 1/2000 sec. • f/4.5 • 40mm lens

Don't:

- Forget the opportunities that are off the beaten path. "Must-see" locations are low-hanging fruit, but don't miss an opportunity to create a unique perspective by venturing away from tourist locations.

- Let a missed shot ruin the entire trip. Remember, the list is just a guide.

- Try to mimic a shot you've seen exactly. Remember to put your own creative spin on a shot.

- Let the weather ruin an opportunity. Different conditions create unique looks and perspectives, so just go with it!

- Allow your shot list to cause you to miss a completely unique opportunity. If something wonderful is happening, forget the list and go with the flow. You'll never regret capturing a once-in-a-lifetime photo!

Images Search

No service aggregates and indexes photos better than Google, and for that reason, all of my trips begin with a Google Images search. The benefit of using Google Images is that it provides excellent leads to other websites that can further help you research your destination (**Figure 2.6**).

For example, when I first decided to travel to India, I knew very little about the Kumbh Mela festival other than it was the largest gathering of humans in the world. I had no real concept of what "the largest human gathering" would look like until I searched Google Images for the festival. The images I found helped manage my expectations, and created excellent leads to other travelers, photographers, and blogs that were fabulous resources prior to my departure. They also helped me figure out where I needed to be and when so I could get my shots.

Figure 2.6
To do a Google Images search, simply go to www.google.com, type your search term into the box, and then select Images.

Photo Sharing Sites

Whenever I'm getting ready to visit a destination, I always head over to Flickr, 500px, or SmugMug to perform a search on the place I'll be visiting. These websites provide excellent search tools that provide thousands of photos with a couple keystrokes. Remember, our goal isn't necessarily to copy other people's images, but to get an idea of what regions of your destination provide the best photo opportunities.

Social Media

How times have changed in the last decade! Years ago I would never have considered asking strangers for advice on travel, let alone someone I met on the Internet. But, leveraging the idea of crowdsourcing, I use my social media network to ask questions regarding upcoming trips on a regular basis. Because while my closest friends might not know the answer to these questions, there's a good chance someone in my social media network does.

A couple of years back, I was thinking of traveling to Ireland, so I posted on my Facebook page that I was looking for any feedback or suggestions. I was overwhelmed by the helpful responses and got lots of really great advice that I did end up using (**Figure 2.7**).

Figure 2.7 **By leveraging my contacts on Facebook, I was able to get essential tips for my trip to Ireland's Ring of Kerry.**

ISO 200 · 1/320 sec. · f/9 · 200mm lens

Of course, anytime you're dealing with social media, you need to use common sense and be careful you're sharing information with people you can trust. I don't recommend putting out exact travel dates or your lodging info, but something as easy as "I'm looking at a trip to Ireland this year—any suggestions?" can give you tons of leads.

Camera Clubs

Camera clubs are a wonderful way to get first-hand knowledge of destinations from people who share your enthusiasm for photography. Whether you're traveling abroad or visiting a nearby city, I always recommend reaching out to the local camera club for suggestions. Often the members will have insights into locations you should visit that might be overlooked by tourists, or must-see spots for someone on a tight schedule. I have even found some camera club members who have been willing to join me on location and show me around their wonderful city.

Hire a Guide

Some of the best money I've ever spent was hiring a local guide, especially in areas where there's a language barrier (**Figure 2.8**). And I always use local guides when I travel to third-world countries to ensure I have the best possible experience. A good local guide will make the best use of your time, get you into places that might otherwise prove difficult, and above all help keep you safe by keeping you out of places you don't belong.

The biggest question is always, "Where do I find a good guide?" Here are some suggestions:

- Use social media to ask for suggestions.

- Do an online search for the local tourism office in the city you'd like to tour. They will know who the professional, licensed, insured guides are.

- Hire a tour company for an individual trip. I have used Kensington Tours in the past.

- Make sure you go through a proper vetting process. Your guide should be able to show proficiency in the local language/languages as well as your language, have references, be educated in the area's history and culture, and be properly licensed and insured. Do your research, and don't be afraid to ask questions. Nothing will ruin a good trip like a bad guide!

Figure 2.8
Reuben was an essential guide for our trek along the Inca Trail to Machu Picchu.

ISO 400 • 1/160 sec. • f/3.5 • 40mm lens

Photography Workshops

Photography workshops are an excellent way to experience a location and increase your opportunities of getting "the shot." You not only get an experienced guide, but you get a professional photographer too! However, workshops aren't for everyone. Some photography workshops can be designed like vacations, while others are very intensive. I lead a handful of workshops each year, and I've learned managing expectations is key to everyone having a great time. Unfortunately, our industry isn't well monitored, and it takes only a few bad seeds to give us a collective black eye. Here are some suggestions to help you find a reputable photography workshop operator.

Appreciation of their work

Whenever I start looking for workshops to improve my own skills, I always look to photographers whose work I respect. I'm not interested in learning from someone whose work I don't take seriously.

Proper fit

Before you decide to sign up for a workshop, it's important to become familiar with the photographer. Luckily many photographers who operate workshops do a nice job of broadcasting their personalities on social media. If possible, spend some time getting to know your potential mentor before booking a workshop. It's one thing to be stuck with someone you don't like by mistake, but it's another thing to do it on your own accord, let alone pay for it! Any good photographer/guide should be more than willing to have one or more phone conversations with you to help you get a feel for what the trip will be like—and for what your guide is like.

Group size

If you like larger groups, chances are you're in luck because you'll find workshops at a lower price point. If you're like me and prefer a more intimate setting, you should be prepared to pay a bit more.

Familiarity with the location

A photographer's knowledge of the area is critical. Unfortunately, many less reputable photographers establish workshops in an effort to fund their travels, which can lead to poor experiences. Make sure your workshop leader knows the area or is partnering with another photographer who has intimate knowledge of the destination you'll be photographing.

Costs and extras

As a rule, photographers are lousy business people. So when talking to a workshop operator, make sure there's no miscommunication regarding cost of lodging, food, entrance fees, transportation, guide fees, etc. If it's not spelled out, ask for clarification.

Referrals

Don't trust everything you read online. Ask the workshop operator if he or she can provide a list of references, and be wary of anyone who cannot!

Agenda and packing list

One of the major benefits to a workshop is the ease. A good workshop should provide you with a detailed agenda and thorough suggested packing list. If you get these things, that's a sign of a well-organized workshop. You should also be able to ask the operator questions about gear and what to pack if you're unsure (another great benefit of a photography workshop!).

Make sure you are completely aware of the workshop's cancellation policy. Many photography tours never take place because of lack of participation. Of course this can be very difficult when planning trips and scheduling potential flights. So to minimize or avoid nonrefundable deposits and the like, make sure the workshop operator is crystal clear on the cancellation and refund policies.

Insurance

The term "trip insurance" gets thrown around quite a bit but varies greatly, and the devil is in the details. I don't know anyone who truly enjoys buying insurance, but the reality is it can be a downright lifesaver at times.

We're going to briefly discuss some common types of insurance you might want to consider before taking a trip. I'm not a person who buys insurance for every trip or extended warranties with every purchase. However, I do think understanding insurance, what it covers, and your potential risks is an excellent exercise for every traveler.

Travel Insurance

You should consider buying travel insurance to offset the potential cost of a canceled trip. It can also provide peace of mind in the case of an emergency. Often travel insurance will cover unforeseen medical expenses, lost or stolen luggage and/or passports, delayed or canceled flights, and even a cancelation of a trip by a vendor. While I've never had to cancel a destination workshop, I still encourage all my attendees to purchase travel insurance to cover the cost of expenses beyond what the workshop covers. Travel insurance can be essential to recover the cost of canceling due to illness or a death in the family, or natural disasters such as hurricanes that require the evacuation of your hotel. Did you know some insurance policies will provide you with funds in case of a lost or stolen wallet?

Before buying insurance:

- Always check your homeowners, renters, and auto insurance policies to confirm coverage while traveling.

- Some credit card companies provide basic travel insurance providing you use their card for the purchase of the travel.

- Check to see if your health insurance is accepted in your travel destination.

- Price insurance using aggregate search sites such as www.worldnomads.com or www.insuremytrip.com.

Medical Insurance

Most trip insurance policies cover some medical expenses. However, when it comes to medical evacuation or being flown to a hospital of choice in your home country, understanding your coverage is crucial. If you have a known health condition or are traveling to a very remote location, I strongly recommend doing your homework and making sure you have proper medical coverage.

While many countries have excellent hospitals, the reality is that language barriers can be a hurdle, and nothing beats the comfort of home. For example, a few years ago a very well-known Canadian travel photographer, David duChemin, blogged about falling nearly 30 feet in Pisa, Italy. Eventually he was flown back home to Ottawa for surgery. Fortunately his travel insurance, MedjetAssist, covered many of the expenses associated with his evacuation.

No one I know really enjoys buying travel insurance, but when it comes to traveling abroad, I consider it an essential expense. While you always hope you'll never need it, it comes in handy when you do.

Equipment Insurance

I highly recommend you check your homeowners or business insurance policy to confirm coverage of lost or stolen equipment while traveling. If you're using your camera gear for personal reasons, adding coverage to your policy should be fairly straightforward. However, if you're using your camera for commercial purposes, you will need a commercial policy. Keep in mind that even if your business is operating out of your home, you still might be required to have a commercial policy.

Not all equipment policies are the same, so make sure your policy meets your minimum coverage requirements. Some policies will cover you for theft only, while others will cover breakage as well.

If you rent equipment, I always recommend buying insurance from the camera rental company to avoid any delays or confusion on what is or is not covered.

Theft Prevention Tip

Create a list of all your equipment and serial numbers. If you don't have time or the patience to create a list, use your smartphone camera to take pictures of all your gear and serial numbers, then store them on a cloud server or email them to yourself. This can be useful in the case of something getting lost or stolen.

Traveling Workflow

Creating a system to organize and back up your images while on the road can be a challenge, but it's an essential detail not to be missed. Not all photographers will want to haul a laptop with them for processing, which will limit the ability to create backups while traveling.

My System

Typically I travel with my laptop and a small external drive that I use for backup. I prefer to process some of my favorite images while I'm traveling, and since I shoot in the RAW file format, it's much easier for me to use a laptop than a tablet for processing because of the better editing capabilities and robust storage. Tablets have come a long way in their processing, but I still think we're a few years off from using them as our primary editing platform.

I always start each trip by making sure I've backed up any old images from my memory cards. Once I'm sure they are properly backed up, I format the cards for my upcoming trip. This helps avoid any future confusion when I go to import images to my computer, because I know all the images on the cards are strictly related to my most recent trip. I'm a fan of using large-capacity cards so I can get several days' worth of shooting—sometimes an entire trip—on a single 32 GB card. The benefit of using a single card is it's typically in the camera, safe and sound, and I never worry about misplacing it. The downside is you have a lot of data on one card, and if it becomes corrupt, you can lose an entire trip's images. The key to avoiding losing any images, regardless of card size, is a very strict backup policy.

My Backup Plan

There's nothing worse than losing images, whether due to theft, loss, or file corruption. Flash card technology has really improved throughout the years, but files still become corrupt from time to time. One of the best ways to avoid problems is to format the memory card in your camera, never on your computer. Memory cards formatted on your computer may render the card unreadable by the camera and increase the risk for failure.

And forgive me for repeating myself, but this is important: Remember to back up your images! I mentioned earlier that I always travel with my laptop and a small external drive (**Figure 2.9**). After every day of shooting, the very first thing I do when I'm back in my room is boot up my computer and download my images into Adobe Lightroom, and then back up my laptop to my external drive. I never, ever, delete or format my cards until I have an offsite backup. You can create an offsite backup via a cloud service such as iCloud, Mozy, Carbonite, or Google+. Or use a homegrown system such as mine, where I use CrashPlan to back up files between my home and my studio; once the files are on my computer, my local external backup, and my offsite backup, then I'll reformat my camera cards.

Figure 2.9 Don't delete images from your cards until you have three backups: your computer, your local external drive, and an offsite backup.

Portable Backup Tip

You may not want to tote a laptop due to its weight, or power may be an issue due to extended stays in remote areas. It's during these times that I highly recommend investing in an external self-contained backup device such as HyperDrive. These devices are charged up ahead of time, and you can back up images in the field simply by inserting the card into the device. This is an excellent way to travel light and at least be assured that you have two solid backups of your images. Though I still recommend not deleting any of your images from the cards until you have an offsite backup.

Packing Your Gear

In Chapter 1, "Equipment," we spent a lot of time talking about gear and what camera kits to pack given multiple situations. In this section, I want to focus on preparation, testing, and packing. Just having the gear isn't quite enough. You need to make sure your gear is in working order, clean, and protected.

Testing

Make sure your camera is working properly. If you haven't photographed with your camera in a while, take some test shots to make sure it's functioning as it should. Some people will send out their cameras to be cleaned prior to a trip, which is fine, but don't assume when you get it back it will be functioning 100 percent. Before you go, always check all your gear.

Firmware

Have you ever noticed how your computer prompts you when an operating system update is available? In time I'm sure we'll see the same on cameras, but until that day comes, it's up to us to check manufacturers' websites to confirm we're using the latest firmware.

Many cameras—even the brand-new ones—ship with old firmware installed. If your camera is acting oddly, or doesn't appear to be performing as it should, make sure you're using the latest firmware. Remember, firmware is manufacturer dependent and varies by country, so make sure you're downloading the correct firmware for your model via the appropriate manufacturer's site.

Dust It Off

Dust is always an issue for photographers. If you use your camera enough, over time you'll deal with dust. But the good news is photographers have been dealing with dust since the advent of the camera, so we have some pretty good solutions. Generally we have to clean dust in four locations: the lens, the mirror (DSLRs only), the focusing screen, and the sensor. If you're using a mirrorless camera, focus on cleaning dust on the lens and sensor. Let's review where these dust bunnies hide and how to deal with them.

Lens cleaning

It's very rare that you will see dust on your lens show up in an image, because dust is often out of focus. However, a dusty lens can lead to poor contrast in your image and can adversely affect sharpness. You should clean your lens after every shoot, but I realize many people don't, so take this time to make sure everything is in A+ shape before heading out:

1. Use a blower to gently blow dust off the front and rear glass elements (**Figure 2.10**).

2. Use a microfiber cloth to clean the lens. If you have stubborn dirt or water spots, use a lens-cleaning fluid with the microfiber cloth. No visible streaks should be left behind after cleaning.

3. Check the contacts on the back of your lens to make sure they are clean. These contacts are how data about your photo is transmitted to the camera. If the contacts appear dirty, refer to your camera's manual for suggested cleaning techniques.

Figure 2.10
This tool, called a Rocket Air Blaster, is inexpensive but well worth its weight in gold. You can use it to blow dust particles off of lenses, the mirror, the focusing screen, and the sensor.

Viewfinder dust

Dust that is visible in your DSLR's viewfinder normally will not affect your image and generally is a result of dust showing up on your focusing screen. It's best policy to blow dust off your focusing screen and mirror using a rocket blower, so the dust doesn't work its way to your sensor. Here's how:

1. Power down your camera and remove your lens.

2. While facing the camera down, gently blow air on the mirror and the focusing screen. Do not touch or hit the mirror with your hand or the blower.

3. Using a soft synthetic camera brush, gently brush the mirror in a downward motion toward the camera and away from the sensor.

4. Place the lens or front cap back on the camera.

Sensor check

While far more maddening than operationally threatening, a dirty sensor can cause lots of headaches. Most of today's DSLRs come with a dust-preventative system that uses ultrasonic movements to shake dust off the sensor. However, I don't know a travel photographer who doesn't deal with a dirty sensor from time to time. Here's how to determine if you need to clean your sensor:

1. Set your ISO to its lowest possible setting while using the smallest aperture available, for example ISO 100 using f/22.

2. Take a photograph of a white piece of paper, a solid light-colored wall, or a clear blue sky. Make sure your image is slightly dark and not too light so that you can see the dust spots.

3. Import your image into your processing software to review it for dust spots. Increase the magnification to 1:1 (in Lightroom, you use Loupe View). You can also zoom in using your camera's LCD, but it won't be as easy to see dust spots.

4. Scan the image from left to right, looking for unnatural fuzzy dark circles. If you don't see any circles, you're in the clear and your work is done! If you see dark circles, chances are your sensor needs to be cleaned.

Cleaning your camera's sensor is a very straightforward process. If you have dust spots, you should start by using your camera's built-in cleaning options. To do this, follow your manual's directions. On occasion, stubborn dust may need to be gently blown out using an air blower such as a Rocket Air Blaster (shown in Figure 2.10). Never use canned air to remove dust from your sensor, as it could harm your sensor.

You'll need a wet swab cleaning kit for really stubborn dust and oil spots that can't be removed with the air blower. I have cleaned my sensor many times using Photographic Solutions Sensor Swabs with great success. However, some camera manufacturers frown upon having your sensor cleaned by a non-licensed technician and warn that any damage as a result of cleaning will void the warranty. Check your manual, read your warranty, and, when in doubt, contact the camera manufacturer for clarification.

> **Camera Manual Tip**
>
> Save time and space by downloading your camera's manual to your phone, tablet, or computer so that it's always with you when you travel.

Backup Camera Bodies

I try to make a habit of always packing a backup body for my camera kit. This is an essential requirement whenever I'm taking a trip to a remote destination. I have heard too many horror stories of someone breaking their camera or losing it to theft, and then having to buy a brand-new camera because they left their backup body at home. Keep in mind, a backup body doesn't need to be brand new or even the same model as your favorite. It can be a friend's camera, one you rented, or an older body that you have lying around the house.

Memory Cards

My number one rule when packing memory cards is to ensure I won't run out of space. Remember, your goal is to keep all of your images and videos on your cards until you have three solid backups. My recommendation is to spend time doing some basic math. How many images do you plan on taking per day? How many minutes of video per day? How many days will you be traveling? Most of today's manuals will outline your camera's card capacity needs. For instance, the Nikon D7100 shooting full-size RAW files will fill an 8 GB card with 191 images. Of course you can increase this number of images by using a lower-quality file format such as compressed RAW or JPEG. However, if your goal is never to sacrifice quality, you'll always want to shoot in the highest-quality file format.

Beyond knowing the basic math, you need to consider your shooting style. Do you typically take a lot of photographs, or are you very selective? I can easily shoot between 400 and 600 frames in a day, depending upon the subject matter and time in the field. Err on the side of caution and double whatever you anticipate.

Finally, while memory card failures have vastly decreased throughout the years, I still recommend breaking up your memory needs into several smaller cards. If you need 32 GB of space, consider buying two 16 GB cards or four 8 GB cards to help spread risk of failure among the cards. It's one thing to have one of your four cards fail and potentially lose a few images, but it's another to have your only card fail and lose all your images.

Prevent Image Loss

Card failure is rare, but it does happen. Sometimes one corrupt file can create a problem for the entire disk. If you just started using a card, I would format it and use it as a last resort. If your card fails in the field with images on it, do not format it. Instead, mark it and put it in a secure location. Years ago, I had a card fail on me in Africa. I set the card aside for the rest of the trip; once I was back home I successfully used flash card recovery software to retrieve most of my lost files.

Technology

While I rarely use my iPhone or tablet in the field for photography, I do use them quite a bit for research and for on-the-go answers to my questions. There are a number of applications I strongly suggest loading onto your device to help with your trip preparations and while you're on the road. Here are my top 10 travel apps:

- **Google Maps:** Allows for easy planning before the trip and navigation during the trip.

- **City Maps 2Go Pro:** If roaming fees are an issue, consider downloading this app, which keeps the maps on your phone so you don't need to download data to use them.

- **Easy Release:** This model release application can be handy if you want to get a model release signed on the spot.

- **LightTrac:** This is a great application for planning around sunset, sunrise, and moon phases, as well as providing angles of the sun from any location.

- **Packing Pro:** Helps you plan your trip, and keeps a digital checklist of things to do and pack.

- **XE Currency:** Helps to ensure you are getting the correct foreign-currency conversion rates. Can be used offline.

- **TripAdvisor Offline City Guides:** These guides provide excellent information about hotels, restaurants, attractions, and more in several cities around the world.

- **Skype:** When you travel abroad, phone communication can be difficult, but an application like Skype allows you to make calls home as long as you have Wi-Fi.

- **WhatsApp:** This is an excellent (and free) way to communicate via text with friends and family while traveling.

- **Translator apps:** If you're traveling where there is a language barrier, download an app that will help you communicate in a pinch. Make sure it doesn't require an Internet connection to work. For example, when we went to France, we had SpeakEasy French on our phones.

Arrivals and Departures

If there's one thing I've come to grips with it's that I seriously dislike the "journey" part of this business. I know the old adage is that it's not about the destination, it's about the journey. But when you're a nervous flyer, that doesn't help! Truth be told, I'm a bit of a control freak, and flying tends to make me slightly anxious (**Figure 2.11**, on the following page). The only problem is swimming across the Atlantic isn't really an option. Being prepared and organized is the number one way I avoid being anxious about my trips. Here are a few tips for keeping calm:

- Always keep a photocopy of your passport separate from your actual passport.

- Whether you're traveling by plane or train, make sure you know how early you should arrive, and always build in an extra 30 minutes if the location is unfamiliar to you.

- As photographers, we have a lot of gear, so prepare to be searched due to the density of electronics in a camera bag. Be courteous when with customs, TSA, and other officials who are just trying to do a good job.

- Organize loose items: Zippered pouches, bag compartments, and Ziploc bags are our friends. When packing, try to keep everything as organized as possible. It's a lot easier to make sure you have everything when you can find your things easily.

- Fill out all customs documents in advance and read them carefully. There's nothing more frustrating than finally getting to the front of the line and being told your forms are incomplete.

- I'm a to-do list sort of guy, so having a working packing list is an excellent way to avoid forgetting anything. If you're traveling with a partner, I recommend sharing the document or using a service like Google Docs, because it allows real-time edits between parties. The master packing list should contain information regarding equipment, clothes, required documents, valuables, electronics, and so forth. Then use that same list for packing when you head to your next destination or home.

Figure 2.11 I always recommend arriving at an airport two to three hours prior to departure to avoid any delays with ticketing or security screening.

ISO 500 · 1/320 sec. · f/11 · 35mm lens

Chapter 2 Assignments

Now that you're getting organized, here are a few things for your to-do list to make your trip go a little smoother.

Let's back up!

If you don't already own a good portable external backup device, I strongly urge you to buy one before your next trip. A small external drive, such as a Passport, comes in a wide array of sizes and prices. Determine your needs and add an external backup device to your travel kit.

Take inventory

Go to www.johnbatdorff.com/traveltips and download my master spreadsheet for equipment inventory and packing. Gather your equipment and fill out the required blanks for the equipment.

Download your manual

How often have you wished you had your camera's manual with you but left it behind because it's too big or you simply forgot to bring it? I keep my camera's manual on my smartphone so it's readily available for those hard-to-remember camera settings. Head to your camera manufacturer's website and download a PDF version of the manual so you have it at all times!

Upgrade your firmware

Many people buy their cameras and never upgrade the firmware. It's much like owning a computer and never running an update. Not all updates are essential, but many are, so check your camera manufacturer's site to confirm you are using the latest firmware. Follow the directions in the manual to update.

Share your results with the book's Flickr group!
Join the group here: www.flickr.com/groups/street_fromsnapshotstogreatshots

ISO 100 · 30 sec. ·
f/18 · 15mm lens

3

Finding the Light

Understanding exposure

I don't know many people who truly enjoy talking about exposure, but understanding the basics of exposure is essential to creating a strong foundation for photography. My goal in this chapter is to show you how to expose a frame properly in any type of light. I'll start with the basics of exposure, including shutter speed, aperture, and ISO, how to use your histogram, and some of my preferred camera settings. Finally, I'll share some of my favorite techniques to finding good light and working with bad light when you can't avoid it.

Poring Over the Picture

I rarely remove objects from an image. In this case I decided to leave the jet trail because it added depth and character to the image.

Florence, Italy

A tripod is a must whenever you're taking long exposures and is highly recommended for HDR photography.

I took three exposures and merged them to create a high dynamic range (HDR) image.

ISO 100 ·
1/6, 1/50, 1.3 sec. ·
f/20 · 24mm lens

Exposure Exposed!

Understanding exposure can be a bit overwhelming at first, but the basic concepts are very simple and exactly the same for a film or digital camera. In a nutshell, we're trying to expose photosensitive material (film or a digital sensor) to the correct amount of light. The combination of the size of the lens opening, the shutter speed, and the sensor's (film) sensitivity to light is what determines a proper exposure value (EV) for the scene. The relationship between these factors is often referred to as the exposure triangle (**Figure 3.1**).

Figure 3.1
The exposure triangle is the foundation for all exposures. Review the diagram to better understand the relationship between ISO, aperture, and shutter speed.

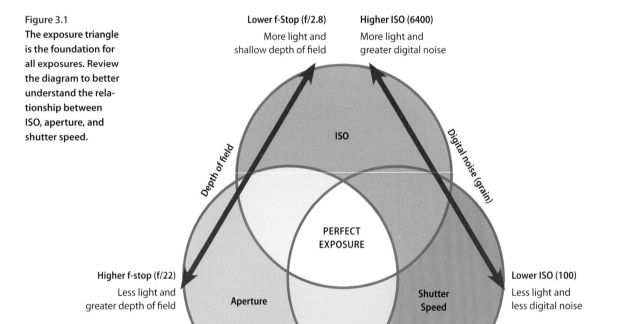

Let's start with how exposure is created. First, light reflects off your subject and enters though the camera lens's opening to expose your sensor or film for the defined period of time that the shutter is open. Simply put, a perfect exposure is created when the right amount of light exposes a sensor for the correct amount of time. The sensor's sensitivity to light (ISO), the amount of light (aperture), and the length of time light is allowed to reach the sensor (shutter speed) determine an exposure.

The ISO setting determines the camera sensor's level of sensitivity. The higher the ISO number, the more sensitive the sensor becomes to light. To get a well-balanced or proper exposure, the lens needs to adjust the aperture diaphragm (size of the lens opening) to control the volume of light entering the camera. Then the shutter opens for a period of time to allow the subject's reflected light to hit the sensor long enough for it to record the image on the sensor. If the sensor isn't exposed to enough light or for a long enough period of time, the image tends to be darker or underexposed (**Figure 3.2**). If the sensor is exposed to too much light or for too long, the image appears very light or overexposed (**Figure 3.3**). Keep in mind that when you change any one of the variables, the other two will change as well. These changes can be out of necessity due to changing lighting conditions or based upon creative goals, which we'll discuss next.

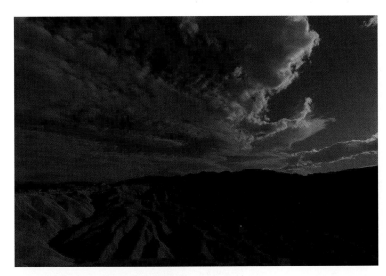

Figure 3.2
The image is under-exposed because the shutter speed of 1/2000 of a second was too fast.

ISO 100 · 1/2000 sec. · f/9 · 15mm lens

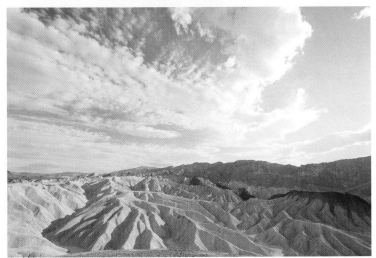

Figure 3.3
The image was over-exposed because the shutter speed of 1/125 was too slow.

ISO 100 · 1/125 sec. · f/9 · 15mm lens

Nature vs. Nurture

You might be wondering why we can't just use the same exposure for every shot. Well, not every shot has the same light or artistic goal. The quality and quantity of light changes throughout the day at Mother Nature's discretion. Then there are our creative goals, which can range from photographing a sporting event where we need to freeze motion with a fast shutter speed to creating a beautiful portrait with a creamy smooth bokeh (blurred background) by using a wide aperture (lower f/stop) (**Figure 3.4**). Exposure plays a roll in our vision and creativity.

If everything were static, I suspect there wouldn't be any confusion regarding how to achieve a proper exposure. But Mother Nature and our own personal goals are ever changing. Thus let's spend some time on the predictable aspects of the exposure equation: ISO, aperture, and shutter speed. Then we'll explore how we can adjust these to achieve our creative goals or deal with challenging environments. As we proceed, I recommend referring back to Figure 3.1 to understand the reciprocal relationships between these three components of the exposure triangle.

Figure 3.4
The creative goal was to create a very shallow depth of field using a wide aperture and fast shutter speed.

ISO 320 · 1/2000 sec. · f/1.4 · 35mm lens

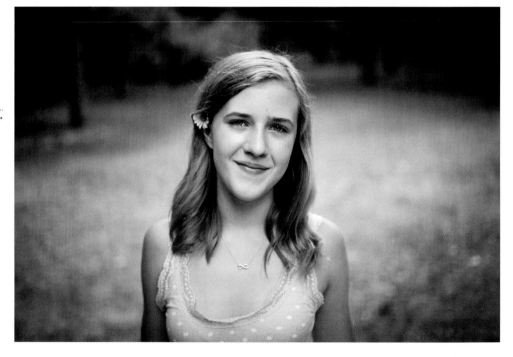

ISO

The first part of the exposure triangle is the ISO, the sensitivity of the camera's sensor to light. As you increase the ISO, the sensor becomes more sensitive to light, and less light is required for an appropriate exposure. The typical ISO range on modern DSLR (digital single-lens reflex) cameras is 100 to 6400 (**Figure 3.5**).

Figure 3.5 **The ISO setting appears on the top of your camera's LCD or on the monitor.**

Your camera's sensor is twice as sensitive to light at an ISO of 200 than at 100. If you increase the ISO from 200 to 400, the sensor's sensitivity to light doubles again (**Figure 3.6**). It may seem that a more sensitive sensor would be a good thing to have all the time and that it would simplify things in the exposure world. Yet the problem with using a high ISO is that it results in lower-quality image files. The higher the ISO, the greater the risk of introducing digital noise into an image.

Figure 3.6

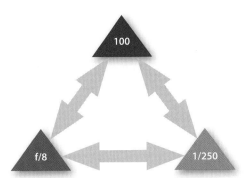

If your ISO is set at 100 and your aperture is f/8, the resulting shutter speed will be 1/250 of a second.

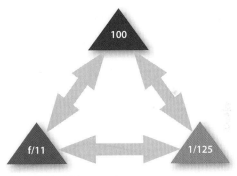

If your ISO is 100 but you change to a narrower aperture of f/11, the shutter speed reduces from 1/250 to 1/125.

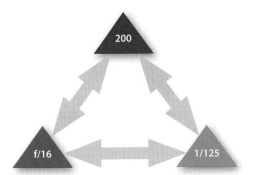

If your ISO is 200, your aperture is f/16, your shutter speed is 1/125, and you want to photograph at f/16 but need a faster shutter speed, you'll need to increase your ISO.

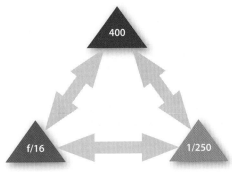

By increasing the ISO to 400, you can maintain f/16 as well as increase the shutter speed to 1/250.

The ISO Balancing Act

In sum, the lower the ISO number, the better the quality of the image. But then the sensor is less sensitive to light, meaning you must have adequate light or a long enough shutter speed to get a proper exposure. It's a balancing act, with the main goal always being to keep the ISO as low as possible without compromising your artistic intent.

When you're shooting freehand, without a tripod, a too-low ISO might not allow for a fast enough shutter speed, and may create camera shake and a blurry image. On the other hand, shooting with too high of an ISO may introduce an unacceptable amount of digital noise, which is a common problem when shooting in low-light conditions (**Figures 3.7** and **3.8**). While many of today's cameras produce amazing images at higher ISOs, there's still a limit on how far we can push a sensor before noise is apparent. Experiment with your camera at different ISOs to determine your acceptable threshold for noise. While my camera has very high ISO capabilities, I don't like to push it beyond 3200 because of the noise it introduces to the image.

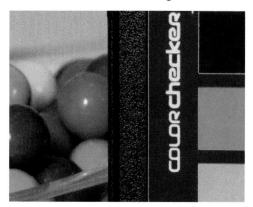 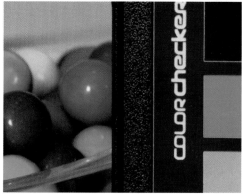

Figure 3.7 This image was taken at ISO 6400. Look closely and you'll notice digital noise: The image is grainy (has small pixels).

Figure 3.8 The same image as Figure 3.7 taken at ISO 100. Notice the details in the black plastic and how little noise is in the image.

Aperture

 The terms "aperture" and "f-stop" are often used interchangeably. Aperture is the actual opening in the lens, exactly how a pupil is the opening that allows light into your eye. It determines the volume of light that will pass through a lens at once. Your pupils open wider at night to let more light into your eye, and they get smaller in the sunlight so as not to allow in too much light.

The f-stop is a number that describes the size of the opening as it relates to the lens's focal length. Lens f-stops vary depending on which lens you are using, because different lenses have different maximum apertures. The typical f-stops are f/3.5, f/4, f/4.5, f/5.6, f/6.3, f/7.1, f/8, f/9, f/10, f/11, f/13, f/14, f/16, f/18, and f/22.

Let's review the aperture chart below (**Figure 3.9**). You'll notice that at f/2.8 the diaphragm is very wide, so it allows a lot of light into the camera sensor. Meanwhile an aperture of f/16 allows very little light to reach the sensor.

 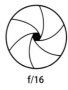

| f/2.8 | f/4 | f/5.6 | f/8 | f/11 | f/16 |

Figure 3.9
This is a typical aperture range. Note that the smaller the number, the wider the aperture.

To further help you visualize how aperture works, let's look at an older-style lens. Notice the hole is much more open at f/1.4 and much smaller at f/16 (**Figure 3.10**). Aperture directly affects the speed in which a shutter can operate.

Figure 3.10 The lens on the left has a much wider aperture of f/1.4 than the lens on the right, which has an aperture of f/16.

Photographers often refer to their lenses as "glass," and often the faster the glass, the more desirable the lens. A fast lens is typically one with an aperture of f/2.8 or wider. This wider aperture allows a greater volume of light to enter through the lens to expose the sensor. The lens is called fast because if the ISO doesn't change, less time is needed to expose the sensor at f/2.8 than at f/5.6. Therefore it's very beneficial to have a fast lens in low-light conditions, because you're able to photograph without needing to increase the ISO or use flash.

Typically a fast lens is more expensive and heavier due to the increased amount of glass needed for the optics. One of the major benefits to a prime lens, also called a fixed-focal-length lens, is its very fast speed. Often these lenses are equipped with apertures as low as f/1.4. In most standard zoom lenses, the maximum aperture will change based upon the focal range. A zoom lens will be fastest at its widest angle (zoomed out) and slowest at its narrowest angle (zoomed in).

How Fast Is Your Zoom Lens?

You can check your zoom's maximum aperture by looking at the lens and finding the associated focal range and apertures (Figure 3.11). In this case the focal range is 18 to 105mm, and the aperture range is 3.5 to 5.6. At 18mm the widest aperture is f/3.5; at 105mm the widest aperture is f/5.6.

Figure 3.11 Nearly all zoom lenses are marked with the widest aperture for a given focal range.

Depth of Field

My favorite use of aperture is to control depth of field (DOF), or the amount of sharpness surrounding a focus point. A small or shallow DOF is when a small area is in the frame is in focus and everything surrounding is out of focus. You can create a shallow depth of field by using a very wide or low f-stop such as f/2.8. A large or deep DOF is when the entire range of the image is in focus. To create a deep depth of field, typically you will use a narrow or high f-stop such as f/16.

I cover depth of field in great detail in Chapter 4, "Composition," but for now let's review the ruler example below. In **Figure 3.12**, I focused on the center of the ruler and used a very wide aperture of f/1.4. Notice how shallow the DOF is, as defined by everything being blurry except for the area of focus. Now let's narrow our aperture down to f/10 (**Figure 3.13**). Notice how DOF increases as numbers become sharper outside the area of focus. This is a very basic demonstration of depth of field; in the next chapter I'll explore how to use DOF when composing images.

Figure 3.12 A wide aperture such as f/1.4 creates a very shallow depth of field.

Figure 3.13 A narrow aperture such as f/10 creates a deeper depth of field.

Shutter Speed

Shutter speed controls the length of time that light is allowed to pass through the lens and expose the sensor. The duration of time your shutter remains open is determined by a combination of ISO and aperture. Typically you will work with a shutter speed range of 1/2000 of a second to about 1/30, but cameras can range from 1/8000 of a second up to 30 seconds. Some cameras can go even longer if you place them in Bulb mode and use a cable release; I cover this in Chapter 6. The chart in **Figure 3.14** gives a graphical representation of how long the shutter will stay open, with f/2.8 being the shortest length of time and f/16 being the longest.

Figure 3.14
Reciprocal exposures: A wider aperture decreases shutter speed.

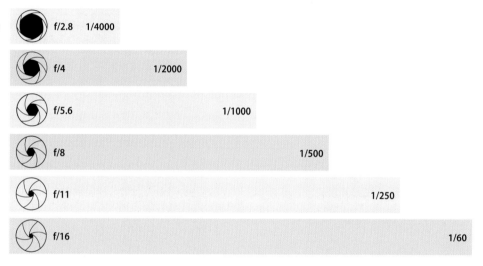

The other variable that affects shutter speed is creative intent and your desire to show or freeze motion. A fast shutter speed such as 1/1000 of a second will freeze most motion (**Figure 3.15**), while a slow shutter speed such as 1/40 of a second will show motion. Of course, this depends on the subject's range of motion and speed (**Figure 3.16**).

Shutter Speed Tip

You can freeze most motion coming straight toward you by using a shutter speed of 1/250 of a second or faster. Motion moving across the frame typically can be frozen at 1/1000 of a second or faster.

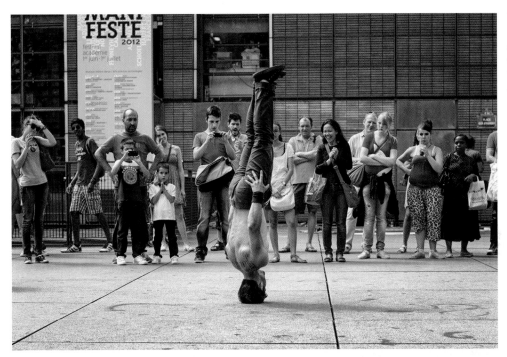

Figure 3.15
Using a fast
shutter speed
freezes motion.

ISO 160 • 1/800 sec. •
f/3.2 • 35mm lens

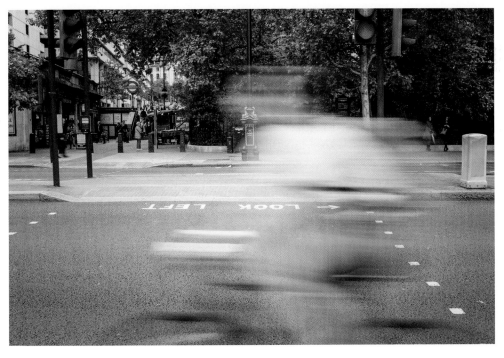

Figure 3.16
Using a slow
shutter speed
shows motion.

ISO 125 • 1/25 sec. •
f/13 • 35mm lens

Working the Histogram

Simply put, a histogram is a two-dimensional representation of an image in graph form. For each image you take, there are two histograms you should be concerned with: luminance and color. Luminance, or brightness, is most valuable when evaluating your exposures. I rarely use the color histogram, though it can be useful in determining if the red, green, or blue channels have experienced any clipping (loss of data), and when you need to dig deeper into the histogram for detailed color information. For practical purposes, the luminance histogram is the best tool for determining an image's overall exposure.

For example, in **Figure 3.17** you see what looks like a mountain range. The graph represents the entire tonal range that your camera can capture, from the whitest whites to the blackest blacks. The left side represents black, the right represents white, and the peaks indicate the number of pixels that contain those luminance levels. A tall peak in the middle means your image contains a large amount of medium-bright pixels, otherwise known as mid-tones.

Figure 3.17 **This is a typical histogram, where the dark to light tones run from left to right. The black to white gradient represents the tonal range of the image.**

When looking at an image, it can be difficult to determine its tonal range without reviewing its histogram. In this case, the histogram shows a tonal range with a large peak in the middle that trails off as it reaches the edges. This histogram tells me we've captured most of the tonal range with no clipping in the shadows or highlights, which is a good thing. However, no two histograms are exactly the same, and fixating on the perfect histogram can create missed opportunities. Instead, use the histogram as a tool for assessing your images toward a creative goal.

A histogram with a pike or peak riding up the far left or right side of the graph means you are potentially clipping detail from your image. In essence, you are trying to record values that are either too dark or too light for your sensor to record accurately. This is usually an indication of an over- or underexposed image, which means you're losing details in the image. The question, of course, is whether the lost detail is acceptable or intentional. If you are photographing a scene where the sun will be in the frame, you can expect to get some highlight clipping because the sun is just too bright to hold any details (**Figure 3.18**).

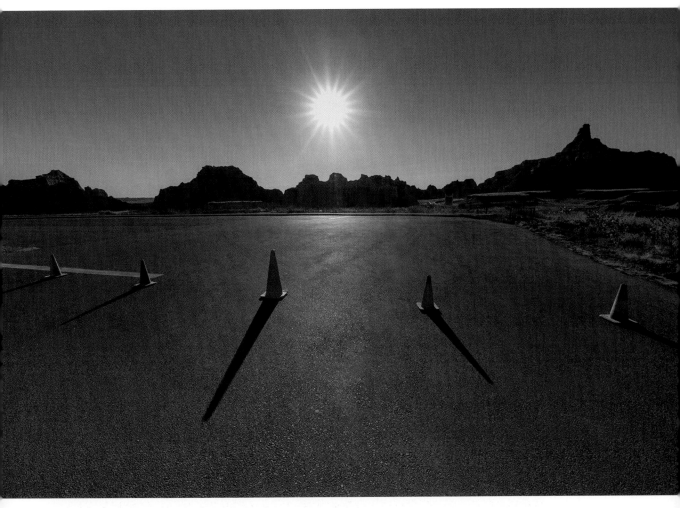

Figure 3.18 This image was taken at Badlands National Park, South Dakota, during the government shutdown of 2013. The roads were closed with cones, so I wanted to document the time. The starburst is too bright to have details, but that's to be expected and doesn't take away from the image.

ISO 160 · 1/160 sec. · f/13 · 15mm lens

Likewise, if you're shooting something that has true blacks in it—think coal in a mineshaft at midnight—there is most certainly going to be true black with no details in your image. The main goal is to ensure that you aren't clipping any important visual information, and that can be avoided by reviewing your histogram.

Figure 3.19
The histogram is
skewed heavily to
the left, indicating
that the image is
too dark.

Take a look at **Figure 3.19** on the following page. The histogram shows a heavy skew to the left, with almost no part of the histogram data (mountain) touching the right side. This is a good example of what an underexposed image's histogram looks like. If I was trying to create a low-key (darker) image, it might be completely acceptable to have a histogram that is pushed to the left. However, the intent was to have a properly exposed image, so we need to make an adjustment to the exposure.

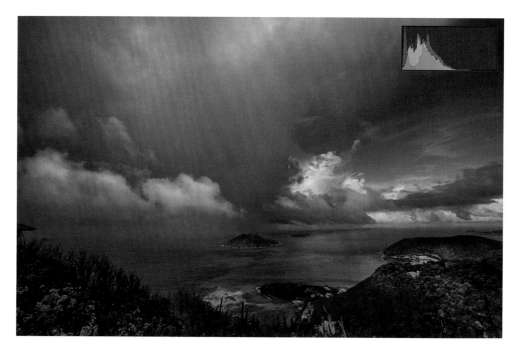

Now look at the histogram in the correctly exposed image (**Figure 3.20**), and compare it to that in Figure 3.19. Notice that even though the histogram in Figure 3.20 has distinct peaks, there is a fairly even distribution across the entire histogram.

Viewing Your Histogram

Bright days can make reviewing an image on your LCD very difficult because of glare. I recommend turning on your camera's histogram display alongside your preview so that you have a quick graphical reference to confirm exposure.

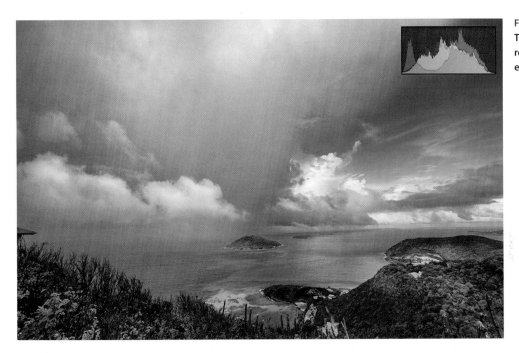

Figure 3.20
This histogram reflects a correctly exposed image.

Camera Setup

Today's cameras are engineering marvels rich in features, but at the end of the day I worry about only a few settings. I'm a big believer in keeping things simple so that I can focus on my creative goals. It's one thing to know how to use your camera and another to fixate on its abilities and lose sight of your own. The following are the four basic settings I use for nearly all of my photography.

RAW

I've been shooting in the RAW file format for more than a decade now and haven't looked back. It provides the most flexibility with the highest quality of all file formats. RAW is essentially a digital negative, which allows for non-destructive editing. The draw-backs are the files tend to be larger (because they contain more information) and they require processing with software. Most of today's cameras come with free RAW editing software. I also recommend using Adobe Lightroom because it provides the most power-ful set of RAW processing tools available in the current market (**Figure 3.21**).

Figure 3.21
I shoot only in RAW
and use Lightroom
to edit nearly all of
my images.

White Balance

Another benefit of shooting in RAW is you can use auto white balance (AWB) and make adjustments as needed in post-processing. The white balance is never "baked into" the file, so you can make non-destructive edits to the white balance as often as needed. In recent years, this has become a favorite creative tool among photographers trying to establish interesting styles or retro-looking images.

Low ISO

I set my ISO manually depending upon available light, and I always try to set it for the lowest possible setting. That said, many of my street photography images are shot at ISO 250 because I have found it provides the most flexibility from morning to late afternoon. Come early evening, I might find myself increasing the ISO anywhere from ISO 400 to 1600 as available light starts to fade.

You may wonder why I don't use auto ISO and set an acceptable ISO range for my camera to operate, such as 100 to 3200. I prefer to control the ISO setting and make the decision myself versus having the camera do a "best guess" adjustment. Remember, the higher your ISO, the more likely you are to introduce noise.

However, for those of you who have a hard time remembering to change the ISO in the field, I recommend setting up auto ISO for your acceptable minimum and maximum range (**Figure 3.22**). Keep in mind, the downside to doing so is you might end up using a higher ISO than you really intended, ending up with more digital noise.

Figure 3.22 Refer to your camera's user manual to help set your auto ISO.

Aperture Priority

Aperture Priority mode is probably the most widely used mode among professional photographers, and a personal favorite. The benefit of Aperture Priority is it allows us to control the aperture while the camera adjusts shutter speeds automatically to create the correct exposure. The creative benefit is that this allows us to focus on the depth of field and relative sharpness without fixating on shutter speed.

Aperture Priority mode is great for landscapes, portraits, and even street photography. However, when objects are moving fast and my goal is to control motion, I'll switch over to Shutter Priority mode, which I'll cover in Chapter 6.

Metering Modes

Your camera has multiple metering modes, but each of them works very similarly. A meter measures the amount of light being reflected off your subject and then renders a suggested exposure value based on the subject's brightness and the sensor's ISO setting. To establish this value, the meter averages all of the brightness values to come up with a middle tone, sometimes referred to as "18 percent gray." The EV is then rendered based on this middle gray value. This means that a white wall would be underexposed and a black wall would be overexposed in an effort to make each one appear grey. I know your head might be spinning a bit, but thankfully the camera is computing all this for you. The only thing we need to decide is how we want the camera to compute the exposure, and that's why we're given three metering modes.

Matrix/Evaluative Metering

I take most of my photographs using the Matrix (Nikon) or Evaluative (Canon) metering mode, because it breaks the frame into segments and uses the subject's location in the frame to determine the image's exposure. On most cameras this is the default metering mode. The process is also considered the most advanced technique for metering, as it's incredibly accurate and uses a complex algorithm to determine the correct exposure. When used with focus points, it further refines its exposure based upon the segment on which the focus point is located. In a nutshell, this is the metering mode I use, and the one I suggest to my clients.

Matrix metering mode

Spot metering mode

Center-weighted metering mode

Center-Weighted Metering

This metering mode has been around for quite some time, is very predictable, and works great when your subject is in the center of the frame. Center-weighted metering uses 60 to 80 percent of the center of the frame to determine exposure, with the remaining 20 to 40 percent of the calculation coming from the edges. This metering mode works well when areas on the perimeter of the frame hold less value and metering correctly for them is not important.

Partial Metering

Use partial metering when spot metering is too narrow and you need to expand the area being measured. Partial metering uses a larger circular measurement of anywhere from 7 to 14 percent of the frame. This is my preferred setting when I have a backlit subject (**Figure 3.23**).

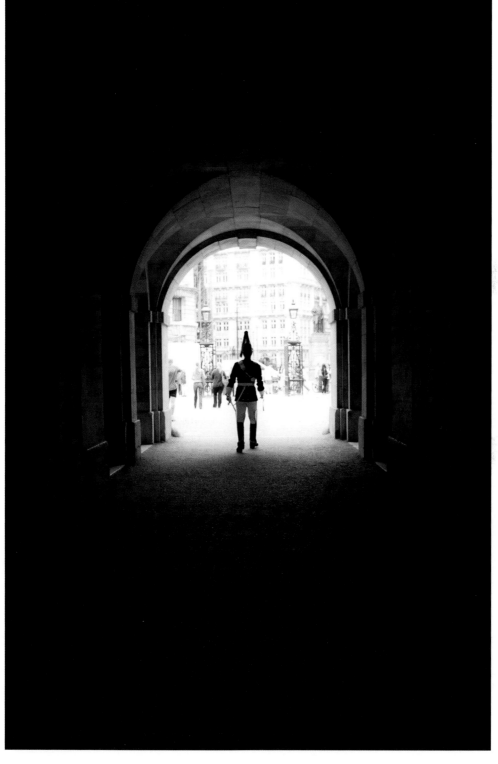

Figure 3.23
Using partial metering, I was able to expose for the guard as he walked into the light.

ISO 250 · 1/250 sec. · f/3.5 · 35mm lens

Spot Metering

Use spot metering when there is a very small part of the frame that needs to be exposed correctly. It's most useful when the subject is significantly lighter or darker than the background. Keep in mind, the area the meter is reading is a very small circular region comprising anywhere from 1 to 5 percent of the frame.

Now that you understand the basics of exposure and the tools at your disposal, it's time to pull it all together. Let's review some of the best and most difficult lighting situations, and the techniques you can employ to improve your odds of getting a great exposure.

Finding the Light

Landscape photographers know all too well what it means to be on the hunt for the perfect light. They chase the golden hours by waking up before sunrise and often staying out way past sunset. I know because every November we chase the light all around Death Valley looking for the perfect sunrise and sunset (**Figure 3.24**). It's a luxury to have a trip dedicated solely to being in the right place at the right time. Often we're traveling to destinations where we have limited time and access, so we need to make the most of the conditions. The following are a few of my favorite times to seek out images as well as my suggestions for dealing with challenging environments.

All Light Is Good!

Remember, without light there is no photography! So I have come to embrace the mantra that "all light is good," but my affection varies greatly depending on its quantity and quality. Best practice is always to seek ideal light conditions, but when those options are limited, you need to adapt to what is available. The ability to adjust and the speed at which you do so are hallmarks of becoming a great photographer.

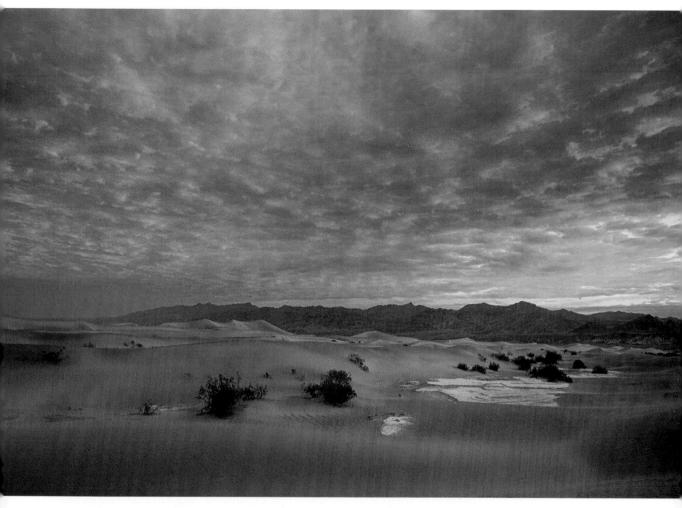

Figure 3.24 The active sky really made this amazing sunrise in Death Valley, California, special.

ISO 100 • 2.5 sec. • f/18 • 24mm lens

Sunrise and Sunset

The golden hour is the brief period of time surrounding sunrise and sunset when the sun's angle to the Earth is low and casting a beautiful soft light. It's during this time that highlights are less likely to be overexposed (too light) and shadows underexposed (too dark). Images are often rich in color and texture, and the shadows are long and dramatic.

As a travel photographer who enjoys street *and* landscape photography, I need to create opportunities where I can do both in great light. It's about being efficient with my time and capturing images that would otherwise go unclaimed. And when traveling, the best way to get great light—and avoid tourists and see a different side of a city—is to get up before the sun rises and the city wakes. For instance, while traveling in Italy recently, I had only a few days at each location, so I had to make the most of my time. Florence is a beautiful city of stunning cityscapes with colorful buildings reflecting off the Arno River. It's also a wonderful place for street photography, but it's a very busy city packed with tourists, traffic, and school children visiting local museums. So I woke up at 4:30 a.m. to capture images of the city coming to life as I made my way to capture a sunrise on the river. By waking up early, I was able to see another side of Florence through the eyes of a street photographer, and then witness a beautiful sunrise as a landscape photographer (**Figure 3.25**).

Figure 3.25
Waking up early allowed me to see another side of Florence as I photographed a sunrise over the Arno River.

ISO 100 ·
1/6, 1/50, 1.3 sec. ·
f/20 · 24mm lens

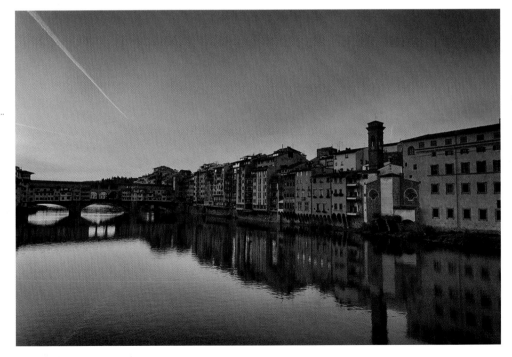

High Sun

Every photographer loves the sun during the golden hour, but when it's high in the sky the harsh sun creates what many of us in the trade refer to as "crappy light." The soft, diffused light of sunrise and early morning gives way to midday, when the sun is at a high angle and casts a very direct, harsh light on its subjects. Some photographers will avoid shooting at this time of day altogether, but when you're traveling, you don't have the luxury to be so choosy. Making the most of the light is your only option. Here are a few of my favorite approaches to dealing with harsh light.

Go where the people go

High sun affects people in one of two ways: They either avoid it like the plague or bask in it like there's no tomorrow. Both of these situations provide excellent opportunities for photographers to capture the human element. If you're on location for several days, make a point of documenting both sides of this human behavior, whether it is on a beach, at a water park, or under a shady tree.

Into the shadows

As I mentioned earlier, a blazing sun creates opportunities that wouldn't otherwise exist, such as dramatic shadows. Architecture provides a great resource for geometric shapes and unique shadows. Be on the lookout for buildings that might produce interesting shadows so that you can return to their location during high sun.

Go black and white

Harsh light provides great opportunities for black-and-white images, especially as it relates to shadows and geometric shapes.

Use your flash

I don't use my flash very often and try to leave it behind whenever I can, but there are moments when nothing works quite as well as a flash. Hats are very handy for keeping the sun out of your eyes and off your face, but they're also a photographer's worst enemy because the brim casts a shadow directly on the subject's face. Using a flash will help lighten— or, as we say, "fill"—the shadows so the subject's face is visible (**Figure 3.26**).

Figure 3.26 Using my camera's flash, I was able to expose the woodworker's face despite his hat.

ISO 160 · 1/125 sec. · f/8 · 50mm lens

Guided by the Light

Light is always changing, and to make matters worse, our subject's orientation to the light cannot always be controlled, so we need to be able to adapt quickly. There are three major types of lighting you'll need to deal with.

Frontal Lighting

Light coming from your back and directly onto the subject is referred to as frontal. The problem with your subject being lit from the front is it will often be washed out, creating an image that will appear very flat and less three-dimensional because it lacks shadows. Portrait photography can be difficult in this situation because people tend to squint, or as I mentioned above, people wearing hats tend to have strong shadows cast on their faces.

The best way to deal with frontal lighting is to try to minimize the amount of direct light falling on the subject. Whenever possible, I try to diffuse the light by either moving the subject to a location where the light isn't nearly as direct, or if I'm in the field shooting a single portrait, I might use a small diffuser to help create a softer light.

Side Lighting

Side lighting offers all the texture that frontal lighting lacks. What I love most about side lighting is its ability to create very moody and dramatic images. Yet it can be tough to get a good exposure. Typically, one side will be well exposed and the other poorly exposed, so pay attention to your highlights and shadows. You don't want the highlights overexposed or the shadows underexposed.

A classic example of side lighting is when a subject is close to a window, and half the body is well lit while the other is in the shadows. Side lighting can create a very moody feel, and can be particularly dramatic when converted to black and white (**Figure 3.27**). In this situation, we can increase the effect of side lighting by rotating the subject toward the window. Further, we can control side light by using either a reflector to bounce light back on the subject or fill flash to soften the shadows.

Figure 3.27 Side light from a window can create dramatic lighting, especially when converted to black and white.

ISO 400 · 1/500 sec. · f/2.4 · 50mm lens

Back Lighting

Backlit subjects are some of the most difficult to photograph because the light background tricks the camera's meter into underexposing the subject. However, this is a perfect scenario for creating a silhouetted image because the front side of the subject will be underexposed or, as I say, "in the shadows." If the goal is to create a well-exposed image of the subject, you need to change your metering technique.

Note that being backlit doesn't necessarily mean that the subject has bright lights behind it. It simply means that the background is brighter than the foreground or subject. Your meter does its best to expose the frame correctly, but that often results in an underexposed subject because it doesn't know what's more important, foreground or background. We can help the meter make a more informed exposure calculation by using spot or partial metering; in many cases this results in the correct exposure.

Exposure Compensation

If there's one camera setting I truly think will help you achieve your desired exposures, it's exposure compensation. Meters do a great job of creating an overall good exposure, but what if you want to darken or lighten the exposure? What if your histogram shows that your highlights are blown out (clipped) so you need to darken the exposure just a tad to bring detail back into the highlights? Then exposure compensation is your go-to tool.

Exposure compensation works by using your camera's meter reading to make adjustments to either your aperture or shutter speed. If you're in Aperture Priority mode and want to lighten an image, exposure compensation will slow down the shutter speed. If you want to darken an image, it will increase the shutter speed. If you're in Shutter Priority mode and want to lighten an image, it will use a wider aperture (lower number); if you want a darker image, it will use a narrower aperture (higher number). These adjustments are very small, one-third of a stop of light difference, so it's a way to get ultimate control over your exposure without having to be in manual mode. It's a very efficient way to take control of your camera's exposure without sacrificing your creative goals such as depth of field or motion blur. I highly recommend becoming familiar with your camera's exposure compensation settings (see the manual) and how to make quick increases or decreases in exposure.

Chapter 3 Assignments

Freeze and show motion

Set your camera to shutter speed priority and practice trying to freeze motion. Remember, objects coming at you will require a shutter speed of 1/250 or faster, while objects passing across your field of view typically will need a shutter speed of 1/1000 or faster. To show motion, use a slow enough shutter speed to allow for motion blur. A great place to practice this new technique is on passing vehicles. Use a fast shutter speed to freeze a vehicle in motion as it drives by, and then use a slower shutter speed to show the blur of vehicles passing.

Practice using fill flash

On a bright, sunny day, have a friend wear a hat while facing the sun. Use your camera's flash to fill in the shadows under the rim. You may have to force your camera's flash to fire during daylight, so refer to your manual for directions (though most DSLRs have a flash button located near the flash to force it to fire).

Experiment with meter modes

Practice changing metering modes to better understand how your camera meters a scene. Have a friend stand in a doorway that is well lit from outside. Now practice using matrix, partial, and spot metering to see which technique produces the best exposure.

Share your results with the book's Flickr group!
Join the group here: www.flickr.com/groups/street_fromsnapshotstogreatshots

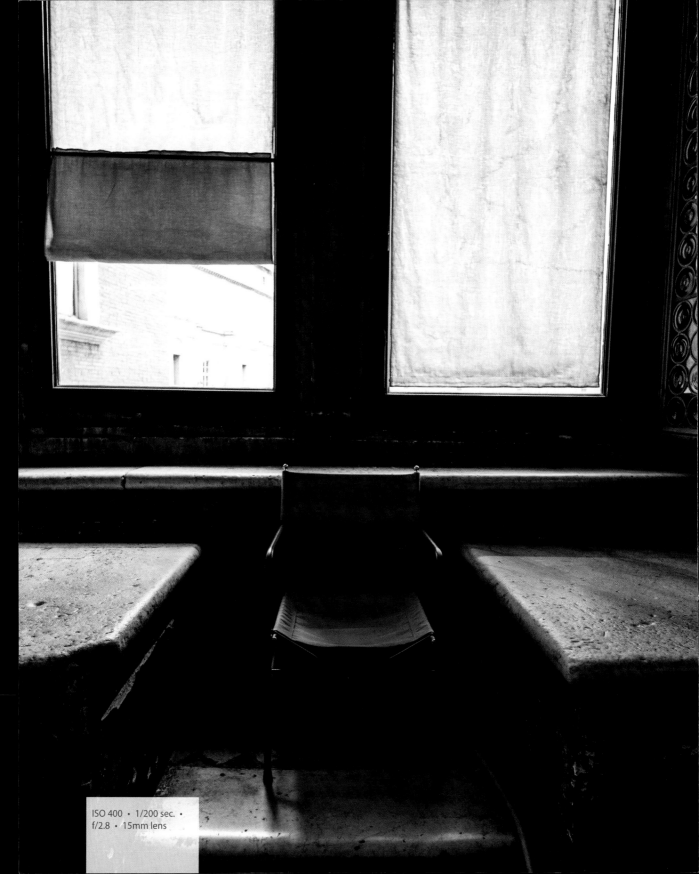

ISO 400 · 1/200 sec. ·
f/2.8 · 15mm lens

4

Composition

Creating with intention

This book is appropriately titled "From Snapshots to Great Shots" because our main objective is to take your everyday images to the next level. One of the surest ways to achieve this is to have a better understanding of composition.

For most of us, including myself, a snapshot is a quick click of the shutter button without much consideration for composition or exposure. Every once in a while we get lucky and a snapshot is a great shot, but it's rare. Thus the word I want you to focus on in this chapter is *intent*. In previous chapters we started removing luck from the equation by exploring our technical intent for creating a better exposure by using ISO, aperture, shutter speed, exposure compensation, and metering. In this chapter we will explore our creative intent by focusing our efforts on making a stronger and more compelling composition. We will learn to use the rule of thirds, lines, curves, patterns, layers, color, and other compositional tools to create more captivating images. Remember, as we move through this chapter, there is no right or wrong way of doing things—but whatever you do, it should be intentional!

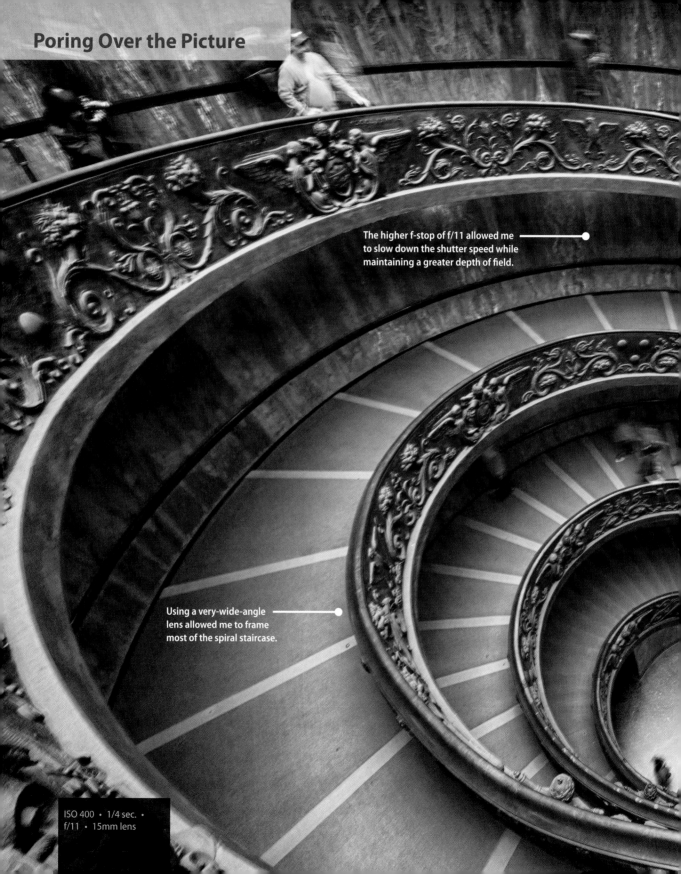

Poring Over the Picture

The higher f-stop of f/11 allowed me to slow down the shutter speed while maintaining a greater depth of field.

Using a very-wide-angle lens allowed me to frame most of the spiral staircase.

ISO 400 · 1/4 sec. · f/11 · 15mm lens

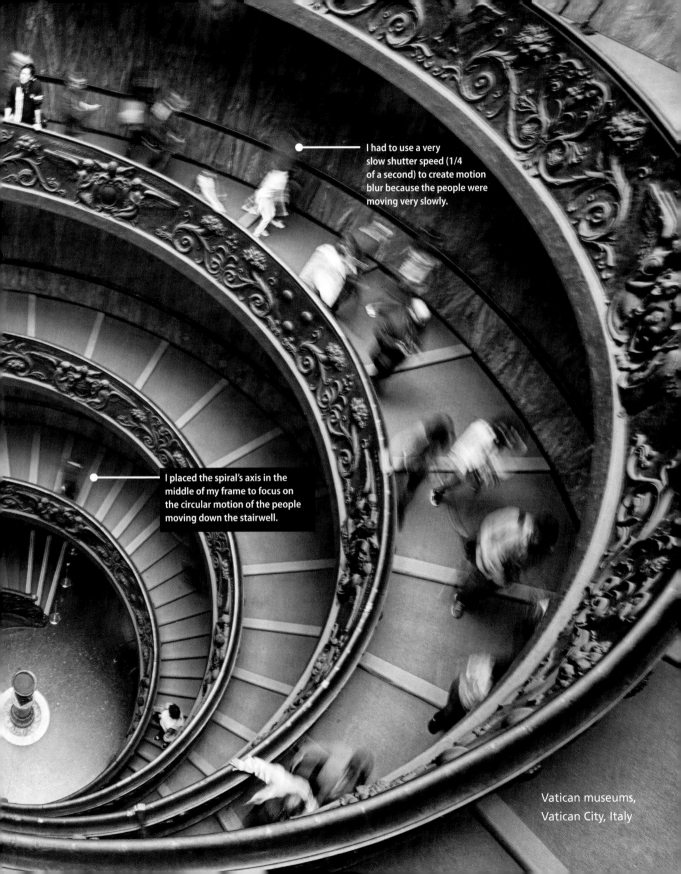

I had to use a very slow shutter speed (1/4 of a second) to create motion blur because the people were moving very slowly.

I placed the spiral's axis in the middle of my frame to focus on the circular motion of the people moving down the stairwell.

Vatican museums,
Vatican City, Italy

Rule of Thirds

There are many philosophies concerning compositions, which are often referred to as rules. These "rules" exist because they create images that generally are pleasing to the eye and provide a framework for consistent compositions. However, I think of composition rules as guidelines that should be understood as well as challenged from time to time as part of your creative maturation. It's only through creative exploration that we grow as artists. However, before we go intentionally breaking the rules, first we must understand them!

The most fundamental of composition rules is the rule of thirds. Using this principle, you simply divide your frame into thirds by imagining two horizontal and two vertical lines that divide the frame equally. The key to applying this rule is to have your main subject located at or near one of the intersecting points. By placing your subject near these points, you direct the viewer to what you feel are the important elements of the frame.

The rule of third's horizontal lines provide an excellent guideline for landscape photography. When photographing landscapes, you should generally position the horizon at either the top third or bottom third of the frame (**Figure 4.1**). Splitting the frame by placing the horizon in the middle is considered less dynamic and doesn't lend a sense of importance to either the sky or the foreground.

Figure 4.1
Placing the focal point of your image near one of the intersecting lines creates a balanced image, giving your viewer an idea of what is important in the frame while also giving the eye room to roam.

ISO 500 · 1/125 sec. · f/13 · 125mm lens

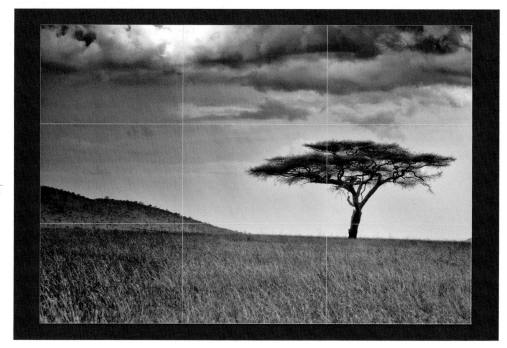

Lines

Lines work like roads in an image, directing visual traffic to what the photographer feels is important. Our goal as visual artists is to use these lines to direct the viewer's attention to the intended subject, not away from it. Moreover, lines are a powerful way for photographers to establish the mood of an image. For instance, vertical lines feel bold and rigid, while S-curve lines usually create a relaxed feeling of going with the flow.

When you are visualizing your image and preparing your composition, try to strike a balance between your intentions and your composition. Ask yourself how you felt when you were compelled to take the image. If the scene is relaxing, such as a brook flowing through a field, look for gentle S-curve lines to compose your frame. On the other hand, if the scene is imposing or hectic, such as a downtown New York City shot, look for vertical lines such as tall buildings to help convey what you're feeling.

We use six basic lines in photography: leading, vertical, horizontal, diagonal, curved, and converging. I know this sounds like a lot, but once you train your eyes you'll start noticing lines all around you. This image of the Brooklyn Bridge (**Figure 4.2**) is a classic example of all six basic leading lines.

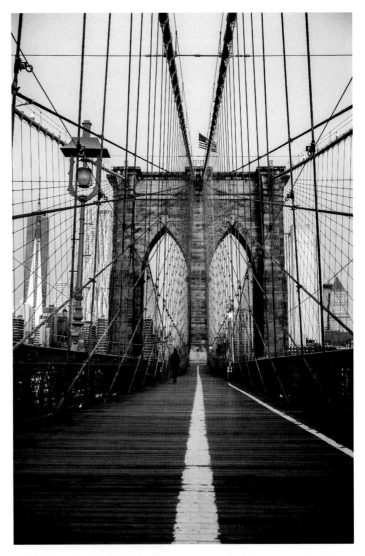

Figure 4.2 The Brooklyn Bridge has a line leading you through the frame and converging in the distance, which is the actual walkway. There are vertical, horizontal, and diagonal lines in the many wires that crisscross through the main wires for support. Finally, there are curved lines in the main support wires that scallop through the frame.

ISO 800 • 1/60 sec. • f/4.8 • 35mm lens

Leading Lines

A leading line is any line that draws you to a particular point of interest within the frame. Vertical and horizontal lines are usually easy to recognize in an image. Vertical lines can be manipulated in an image to imply height and greatness, and tend to be a natural composition for a vertical-framed image (**Figure 4.3**).

Figure 4.3
Getting low to the ground and using a wide-angle lens allowed me to accentuate the building's strong vertical lines.

ISO 400 · 1/80 sec. · f/6.3 · 15mm lens

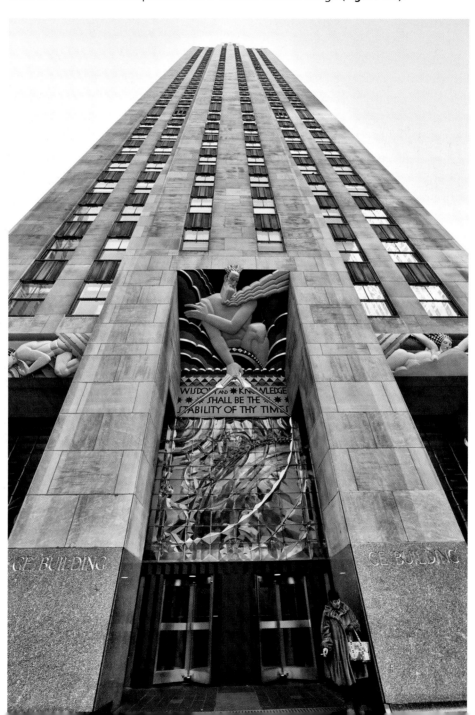

Vertical Lines

Vertical lines in a horizontal image can be less natural and create a sense of tension. For instance, Pastor Cory Brooks, of Chicago's South Side, gained national attention for camping on the rooftop of an old hotel that was located directly across from his church and frequented by prostitutes and drug addicts (in an effort to raise money to tear it down). I took an environmental portrait of the pastor but added tension by using the vertical bars of the railing to frame him (**Figure 4.4**). The vertical lines serve two purposes: to add tension and to convey a symbolic meaning of being imprisoned by his surroundings.

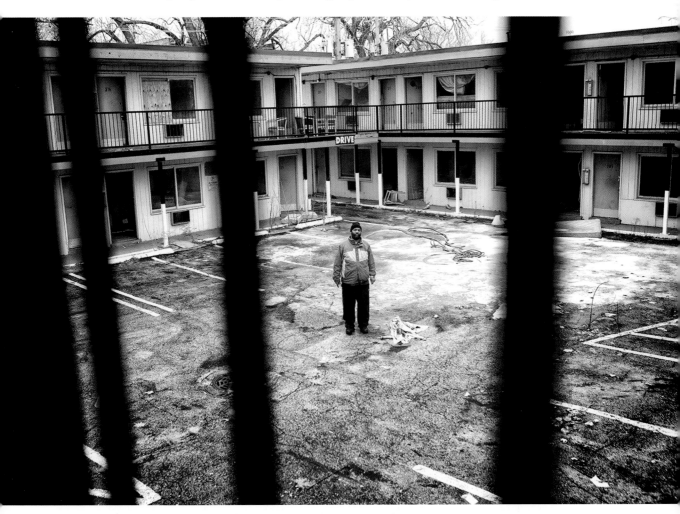

Figure 4.4 **This image's strong vertical lines portray the pastor and his community as prisoners in their own neighborhood due to crime.**

ISO 640 · 1/200 sec. · f/5 · 34mm lens

Horizontal Lines

Horizontal lines can help convey a sense of structure and calm. The long exposure in **Figure 4.5** illustrates this point by creating a long horizon line, which works in conjunction with the soothing colors to create a very calming abstract image. A skyline is another example of an easy-to-identify horizontal line: Even though the buildings are vertical, when viewed from a distance a horizon becomes clear, which in this case works to add a sense of structure and organization to the image.

Figure 4.5
A ten-stop neutral density (ND) filter was used to create a long exposure of Lake Michigan and intensify the horizontal line.

ISO 100 · 131 secs. · f/7.1 · 35mm lens

Diagonal Lines

Diagonal lines cross an image from opposite corners of a frame. They work wonderfully as leading lines and can also provide a sense of movement through the frame. If the diagonal line begins at the left corner of the frame and crosses toward the bottom right, it appears as though the subject is entering the frame. If the opposite occurs, it appears as though the subject is exiting the frame (**Figure 4.6**).

Curved Lines

S-curves, or curved lines, help to guide a viewer's eyes through the frame. An S-curve line should be balanced and create a sense of tranquility or refinement (**Figure 4.7**). Common places to find S-curves are roads, trails, and rivers.

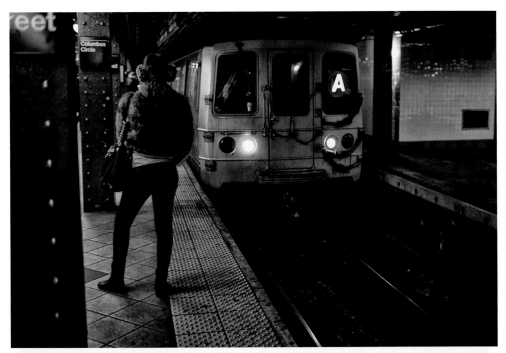

Figure 4.6
The train and tracks create a diagonal line from top left to bottom right of the frame.

ISO 320 · 1/60 sec. · f/1.4 · 35mm lens

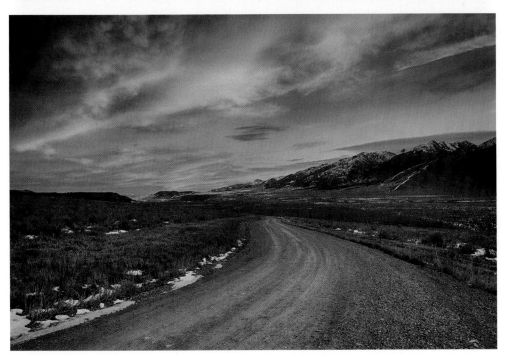

Figure 4.7
Curved lines should draw the viewer into the frame toward the subject and create a sense of calm.

ISO 100 · 1/60 sec. · f/22 · 24mm lens

Converging Lines

Converging lines merge together, giving a sense of dimension to an image. A classic example of a converging line is a vanishing-point image, where the lines lead off into the distance and eventually converge at one point. My favorite use of converging lines is to create a sense of depth, which I'll explore next.

Creating Depth

Because photography is the art of turning our very three-dimensional world into a flat, two-dimensional image, you need to use elements in a scene to establish a sense of depth. Photographers accomplish this by using the contrast of light and dark, and including different and distinct spaces for the eye to focus on: a foreground, a middle ground, and a background. By using these three spaces, you draw in the viewer and give your image a three-dimensional feel.

You don't have to travel around the world to practice creating depth in your images. Growing up in northern Michigan, I spent a good part of my youth traversing dirt roads with one goal in mind: to get lost. Now, 20 years later, I'm still attracted to the notion of the unknown, and for that very reason I'm attracted to photographing dirt roads with vanishing points (**Figure 4.8**).

Creating a Vanishing Point

Converging lines make for great vanishing points, and when used with a wide-angle lens, they can create a sense of depth by distorting distance. In Figure 4.7, I placed the road in the middle and bottom third of the frame. This tells the viewer that the road is the focus point, and the road starting in the bottom third of the frame allows the eye to follow it all the way through the frame. This composition was further assisted by adding a bit of dynamic light, splitting the sun in the arch of a tree, and creating a sunburst effect by using a higher f-stop (at least f/16). All of these factors helped give the image a sense of depth (**Figure 4.9**).

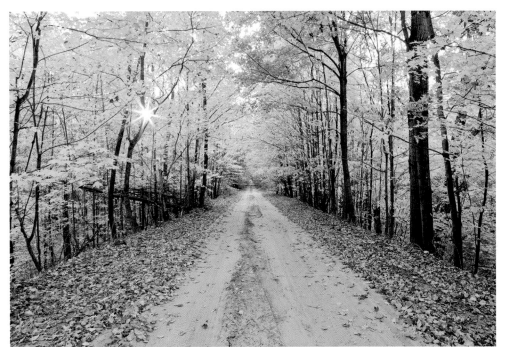

Figure 4.8
A vanishing point
is an easy way to
create depth in an
image.

ISO 125 • 1/80 sec. •
f/16 • 24mm lens

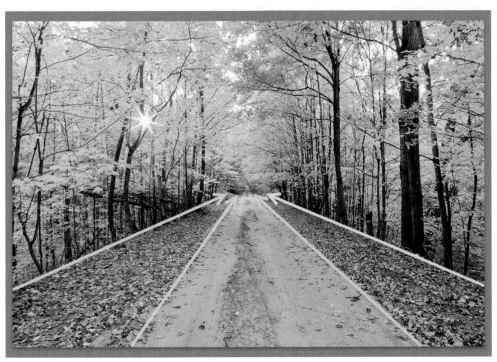

Figure 4.9
Notice how the con-
verging lines create
a vanishing point.

Shapes

Shapes—circles, squares, triangles, etc.—are easy to identify, and when used as compositional elements they can create simple but very pleasing images. We can find shapes in nature as well as man-made objects. In **Figure 4.10**, the famous Vatican museum stairwell demonstrates a classic seashell spiral otherwise known as a logarithmic spiral (**Figure 4.11**). Many architectural structures borrow their shape from naturally occurring forms.

Figure 4.10
The spiral staircase shares the same form as a spiral seashell.

ISO 400 · 1/4 sec. · f/11 · 15mm lens

Figure 4.11
The logarithmic spiral is a great example of a leading line that defines a shape.

Color

Color is a strong compositional tool that can be used to create contrast or harmony within an image. Colors are said to be complementary when they are directly across from one another on the color wheel (**Figure 4.12**). For instance, purple and yellow are complementary colors and, when used together in an image, add contrast to the image. To create harmony, use colors that are near one another on the color wheel. Images with adjacent colors that lean toward blues, purples, and greens are said to be cool images. Warm images have more red, orange, and yellow.

Sometimes color makes the image! While wandering the streets of Tulum, Mexico, I noticed an apartment building with brightly colored balconies (**Figure 4.13**). In this case, color added an interesting compositional component to what otherwise would have been a boring image.

warm

cool

Figure 4.12 **Keep the color wheel in mind when using color as a compositional tool.**

Figure 4.13 **Look for interesting use of color that adds to your composition.**

ISO 100 · 1/80 sec. · f/6.3 · 46mm lens

Color Temperature

Color temperature is another important compositional tool for conveying time of day or emotion. As shown in Figure 4.12, an image is said to be "cool" when it has a blue or green tone, and "warm" when it has a yellow or orange tone. While some images inherently have these tones, you can also creatively manipulate an image in post-processing to create a warm or cool feel.

Color Tip

Many times, images that are very high in color contrast make for excellent black-and-white conversions.

In two photos of an African rhino, I used the same image but used Adobe Lightroom's temperature slider to change the color temperature. You can see that the cooler image reads with more blues and greens (**Figure 4.14**), while the warm image has more red and yellow undertones (**Figure 4.15**).

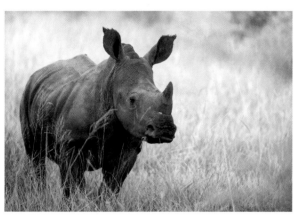

Figure 4.14 **This image has more blues and greens, which create a cooler feel.**

ISO 640 • 1/200 sec. • f/2.8 • 300mm lens

Figure 4.15 **This image has more reds and yellows, which create a warmer feel.**

ISO 640 • 1/200 sec. • f/2.8 • 300mm lens

Patterns

The human eye is naturally drawn to patterns, which is why images that show patterns are so pleasing to view. Be on the lookout for repeating lines, shapes, colors, or tones. Remember, to compose your frame to emphasize the pattern's repetition, consider the depth of field. When photographing repeating lines or shadows, I often convert my image to black and white to add emphasis to the pattern (**Figure 4.16**).

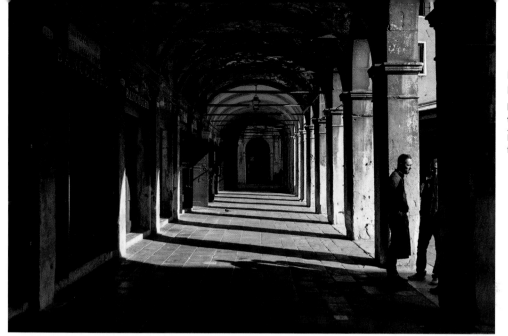

Figure 4.16
Look for interesting patterns in architecture and landscapes.

ISO 100 · 1/125 sec. · f/11 · 105mm lens

Layers

Layers and patterns are similar, but layers have a slightly different element: dimension. While layers can also be repeating, they show depth and shadows as well. In my landscape photography, I often look for lines to help create dimension as layers are stacked one on top of the other (**Figure 4.17**).

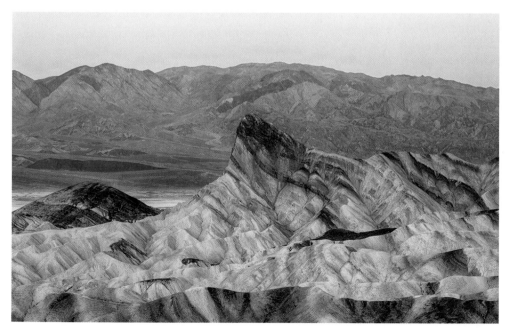

Figure 4.17
Notice how the layers are outlined by lines stacked on one another.

ISO 100 · 1/30 sec. · f/8 · 100mm lens

Frames Within Frames

The outer edge of a photograph acts as a frame to hold all of the photo's visual elements. One way to add emphasis to your subject is through the use of internal frames. Internal frames are basically openings that allow us to frame our subjects; they're backdrops that add depth and sense of perspective to an image. What I love most about a frame-within-a-frame composition is it provides the viewer with a strong sense of observation (**Figure 4.18**).

Figure 4.18
I used the arch of a nearby mosque to frame the Taj Mahal.
ISO 100 • 1/250 sec. • f/7.1 • 35mm lens

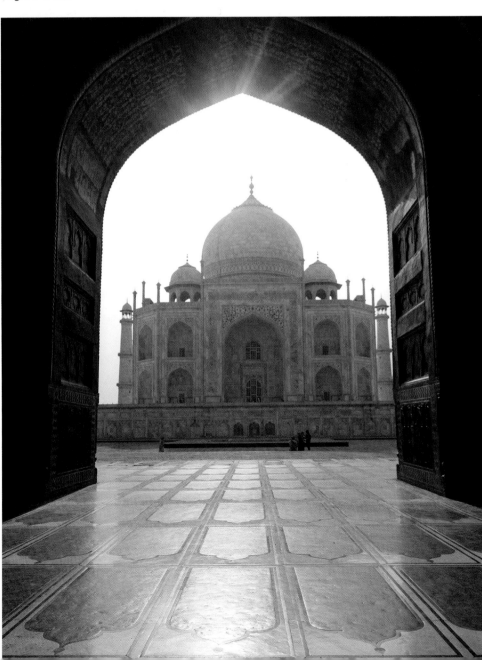

Motion

Motion blur can be a strong tool when composing images. Essentially, you have two different techniques for conveying speed or motion in your image. The first is to choose a shutter speed that creates blur in the movement. The best shutter speed for showing motion depends on the rate at which the subject is moving. A shutter speed of 1/15 to 1/30 of a second generally works well when showing motion with people. Furthermore, using the rule of thirds, consider framing the fast-moving subject in the far right or left third of the frame, allowing visual space for the subject to move through the frame (**Figure 4.19**).

Another way to convey speed is to use panning techniques. Although difficult to master, by panning your camera at the same speed as your subject, you can freeze your moving subject while blurring the background. This technique is often used for capturing athletes or running wildlife.

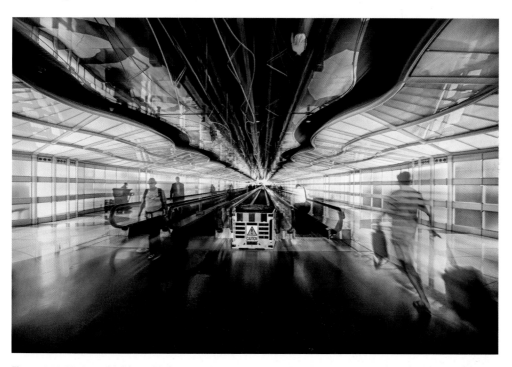

Figure 4.19 Motion adds life to this frame and creates a sense of urgency as travelers move through the airport.

ISO 1250 · 1/15 sec. · f/4.5 · 16mm lens

Shadows

Shadows provide depth and add mood to an image. If you photograph shadows during the golden hours (sunrise and sunset), when the sun is low and the shadows are long, you give your image a sense of still and calm. If you photograph shadows when the light is harsh and the shadows are strong, it creates tension in the image (**Figure 4.20**).

Figure 4.20
Shadows can add drama to a frame, even when it's high noon in NYC.

ISO 200 • 1/500 sec. • f/7.1 • 15mm lens

Reflections

Photographers love finding reflections; it's almost like a scavenger hunt, seeking out as many reflective surfaces as possible. You can find reflections in windows, lakes, shiny metal, water puddles...the list goes on.

The key to photographing a reflective surface while achieving an acceptable level of sharpness is to use a high f-stop, such as f/12 or higher. A higher f-stop is necessary because, although the reflective surface is close to the camera, the subject being reflected is farther away. You need a long depth of field to get the entire reflection sharp and in focus (**Figure 4.21**). Also, changing your angle to the reflection will help minimize the chances of your own reflection being the image—unless, of course, the intention is to capture your reflection for a self-portrait.

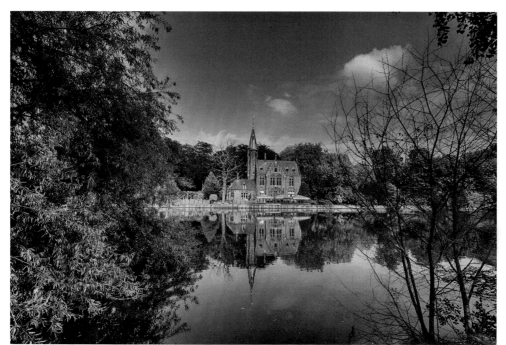

Figure 4.21
I used the trees to frame the reflection and a higher f-stop for maximum depth of field.

ISO 100 · 1/250 sec. · f/16 · 15mm lens

Reflections can be a great way to tell a story, and they allow us to frame our images in a creative manner. When you're traveling to a city, see if you can photograph architecture reflected in another building's windows. If it rains, use the wet streets and puddles to take reflection photos of the famous buildings, monuments, and sculptures. And don't forget to use mirrors to take unique self-portraits while you're traveling!

Perspective

One way to create perspective in an image is to use a human to give scale. This is a wonderful technique for street photographers. When you're traveling and you want to capture an interesting building or monument, stand back and wait for an individual to enter the frame. This adds the human element to your photo while providing perspective, scale, and movement (**Figure 4.22**).

Another way to create a unique composition is to change your perspective. Move around, get closer to your subject, then step farther away. Take the same image early in the morning and again late at night. Change the angle of your view, get down on the ground, or climb up high. In other words, manipulate your perspective by using your feet and changing your physical location (**Figure 4.23**).

Figure 4.22 The human element can add scale and perspective to an image.

ISO 125 • 1/200 sec. • f/20 • 16mm lens

Figure 4.23 Photographing the same location at a different time of day adds a unique perspective.

ISO 160 • 25 secs. • f/13 • 48mm lens

Juxtaposition

Juxtaposition is when you compose a frame with two or more objects that create an obvious comparison and add contrast. When a photographer uses juxtaposition intentionally, the goal is to express a thought or make a point. Common juxtapositions are young and old, big and small, dark and light, and natural and man-made. I'll often use juxtapositions to add humor or opinion to an image (**Figure 4.24**).

Figure 4.24
The painting of a man saying "Shhh" contradicts the young kids playing loudly in the street.
ISO 160 · 1/400 sec. · f/4.5 · 35mm lens

Humor

Humor is one of my favorite compositional tools and often one of the most difficult frames to capture. Funny moments tend to happen quickly, so you've got to be quick on your feet when it comes to capturing them—and sometimes you also have to be bold. Practicing street photography techniques—such as always having your settings ready, and keeping your eyes open and your ears listening—will help you be ready when a funny moment strikes (**Figure 4.25**). When it does, get your photo quickly and move on, as nothing takes the fun out of a funny moment more than someone having to hold on too long while you get your settings right!

Adding Local Flavor

When you're visiting a place, try to use composition to capture the true essence of the location. I always try to add local flavor by framing an image in a way that gives a sense of time and place. When Staci and I take a group of photographers to New Orleans, we encourage them to capture the local flavor by creating a contest. We give prizes for the best musical photo, best bicycle photo, best food photo, etc. (**Figure 4.26**). This forces the photographers to keep an eye out for the things that really capture the place, even if they may or may not be drawn to them normally. It's a way to expand your visual horizons while you're traveling.

Figure 4.26 Look for opportunities that give a sense of time and place. In this image, I wanted to capture the festive feel of the New Orleans Jazz Festival.

ISO 160 • 1/180 sec. • f/11 • 35mm lens

Composing with Intention

The most important compositional tool of all is your intention. The aforementioned rules are the basic building blocks for an aesthetically pleasing image, but over the years I've come to grips with the fact that a good image is less about meeting the standards of what is "right" and more about what is intentional: What is the photographer trying to tell me? What mood or feeling is she trying to convey? What story is he trying to tell? So when creating an image, ask yourself, what is your intention with this image? What are you trying to convey to your viewer? As it has often been said, "A picture is worth a thousand words." In the end, for me, a good image is one that I'll remember for some time, but in order to do so, it needs to go beyond the fundamentals and evoke an emotion or tell a story.

If you ever visit Bruges, Belgium, you'll witness a quaint little town known for its horse-drawn carriages, bicycling commuters, wonderful chocolates, and beautiful churches. When touring the city, I found myself in an archway that opened up to a beautiful view of the Church of Our Lady. The view was majestic, and my intent was to create an image that evoked that feeling (**Figure 4.27**).

Figure 4.27
To create an ethereal feeling, I used a frame in a frame and slightly overexposed the top of the image.
ISO 250 · 1/250 sec. · f/8 · 15mm lens

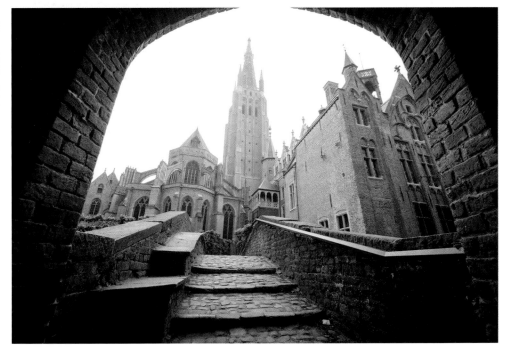

Chapter 4 Assignments

It's time to work on creating images with intention. These next assignments will help you gain a better foothold as you take your photography to the next level.

The Crayola challenge

Grab yourself a box of Crayolas, any size or variation. Pick one crayon per week and take photos that highlight that color. You might think this is easy, but wait until you start selecting colors from the box like eggplant, hot magenta, or screamin' green.

Frame it up

A frame within a frame is a fun and interesting way to compose an image. I recommend practicing with easy-to-frame locations such as doorways, arches, and windows. Once you've mastered the composition, consider using people, buildings, or reflections to frame your subject.

Build a leading-line portfolio

Some of the strongest compositional elements available to a photographer are lines, and it's time for you to find a few of your own. Build a small portfolio of 10 to 20 images using leading lines, such as vertical, horizontal, and converging. Next, look for images that are more complex, with two or more lines dominating the image. Make sure to compose your frames so the lines lead viewers' eyes to—not away from—the subject.

Apply the rule of thirds

The rule of thirds is probably the most fundamental of all compositional rules, and for that reason it's important to set up your camera to help you achieve the best results. Most cameras ship from the manufacturer with the viewfinder or live-view grids enabled. However, if you're unable to see the grid through the viewfinder, refer to the camera's user manual to learn how to turn on the feature. The grid can be extremely helpful when composing images using the rule of thirds.

Share your results with the book's Flickr group!
Join the group here: www.flickr.com/groups/street_fromsnapshotstogreatshots

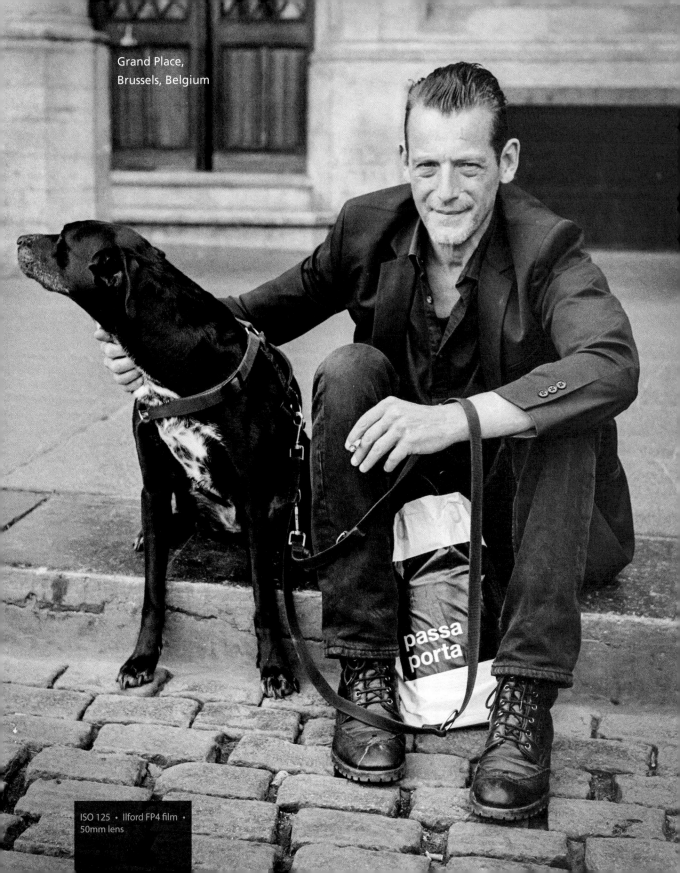

Grand Place,
Brussels, Belgium

passa
porta

ISO 125 · Ilford FP4 film ·
50mm lens

5
Observation vs. Engagement

How to approach street and travel photography

Up until this point we've focused on building a strong foundation for your photography: equipment, planning, exposure, and composition. Now comes a bit of the classroom discussion before we head into the field. In this chapter, we'll focus on the merits of observing versus engaging with your subjects, and we'll review some of my real-life field experiences. The goal is to set the scene for future chapters, where we'll dig into the specifics of getting the shot in both cities and rural destinations, and cover the legalities of street and travel photography.

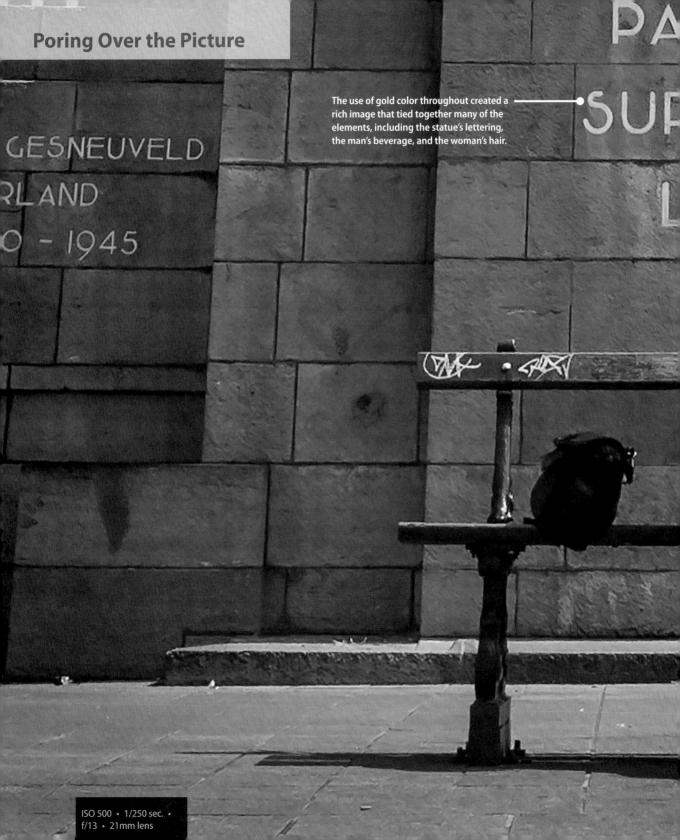

GESNEUVELD

RLAND

0 - 1945

PA

SUP

L

The use of gold color throughout created a
rich image that tied together many of the
elements, including the statue's lettering,
the man's beverage, and the woman's hair.

ISO 500 • 1/250 sec. •
f/13 • 21mm lens

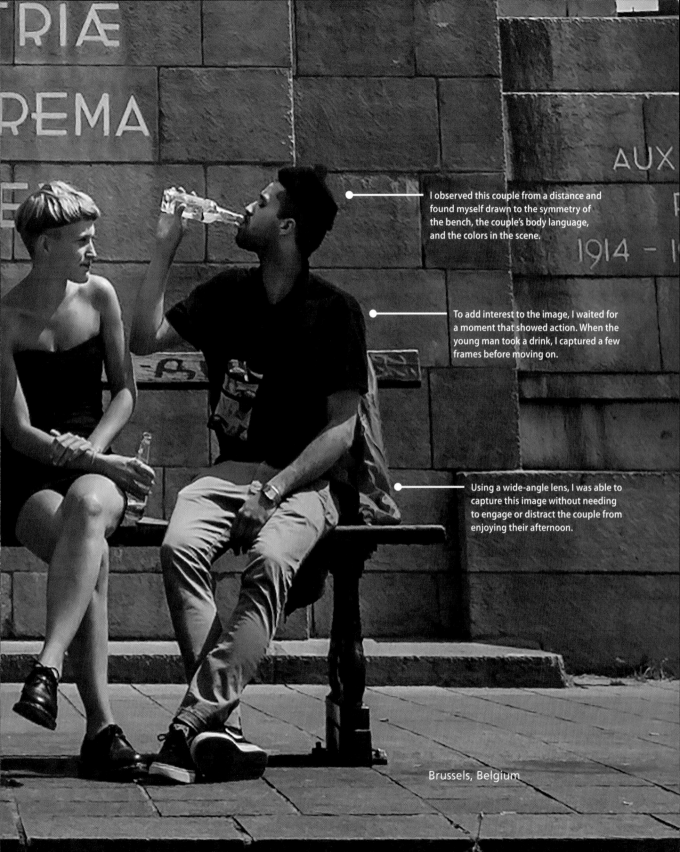

I observed this couple from a distance and found myself drawn to the symmetry of the bench, the couple's body language, and the colors in the scene.

To add interest to the image, I waited for a moment that showed action. When the young man took a drink, I captured a few frames before moving on.

Using a wide-angle lens, I was able to capture this image without needing to engage or distract the couple from enjoying their afternoon.

Brussels, Belgium

Are You a Street Photographer or a Travel Photographer?

The focus of this book is travel and street photography because when traveling we're often shooting images that would be considered street photography. I don't get too caught up in titles or labeling oneself as a street photographer or travel photographer, but understanding how these types of photography are defined helps us understand the role we play in each category. The important thing to remember moving forward is these roles are not reserved for "professionals"—they apply to everyone, regardless of skill level.

Travel Photographer Defined

A *travel photographer* spends time documenting the world by capturing different cultures and foreign landscapes. Her goal is to learn more about other cultures while sharing this newfound knowledge with others. When you think of a travel photographer, you may think of Steve McCurry or other *National Geographic* photographers, but you don't think of your Aunt Margie who has traveled the world posting a daily blog of her latest trip to Myanmar. Professionals may balk at this comparison, but fame, income, and intention may be the only things separating Aunt Margie from a professional travel photographer.

Street Photographer Defined

The label *street photographer* tends to leave people scratching their heads, and there are many misconceptions about this type of photography, so let's spend a little time reviewing what has become a very popular and widely debated genre of photography.

By its purest definition, street photography is the photography of people in candid situations in public settings. In the most rigid form of the definition, the emphasis is placed on the word "candid," meaning without the subject's knowledge. This is important because purists will argue that once the subject is aware of your presence, a photo can no longer be truly candid—thus it is not street photography. So what is it when a subject is well aware of your presence, if not street photography? Many would argue that it's a form of documentary photography.

A documentary photographer's emphasis is on recording history and telling a story, while a street photographer strives to capture candid moments with no agenda other than getting the shot. I recognize that this seems like mere semantics, but a photographer's intention truly defines this distinction. It might be safe to say that a street photographer is the ultimate creative narcissist: obsessed with getting the shot, void of historical reverence, fixated on capturing a fleeting moment anchored in a well-composed frame. Meanwhile

the documentary photographer's purpose is centered on the story and recording a specific time and place, and his ultimate goal is to communicate this story via images. Many times a documentary photographer will dedicate extended periods of time to one subject matter to create a cohesive statement and record of history. These types of photographers are similar to photojournalists, who are driven to cover current events.

Another misconception is that all street photography is taken in the streets, which is not the case. Street photography needs to be taken in a public area or space, which is what the word "street" implies, but there's no need to limit yourself strictly to images from the streets. As I said earlier, don't worry too much about labels, but understanding the narrative serves as a helpful foundation for clarifying your role as a photographer.

To Observe or to Engage?

Regardless of what type of photographer you identify with, the one question you should always ask yourself is whether the photo would be more interesting from the perspective of an observer or a journalist who engages. Many times I'll try to capture both perspectives by taking a candid shot, then later approaching and engaging the subject to get a portrait and the story (**Figure 5.1**).

Of course, the number-one question I receive from budding travel/street photographers is, "Can I take a person's photo without asking per-

Figure 5.1 I saw this gentleman from a distance and took a few candid shots. But I knew that in order to get the shot I wanted, I'd need to approach and engage. He was very open to letting me take his photo, as long as he didn't miss his cab.

ISO 400 • 1/250 sec. • f/3.5 • 35mm lens • New York City

mission?" Chapter 8, "The Legalities," is dedicated to the legalities and ethics of photographing people in public. But for our purposes in this chapter, let's assume you're within your rights so we can tackle the issue of when and how to approach people.

The idea of taking a photograph without someone's knowledge might make you uncomfortable, perhaps because it feels sneaky, awkward, or even unethical. I have had to overcome these same concerns as my style has developed over the years. By reviewing best practices, in time you will develop your own comfort zone and ethical boundaries. Now let's discuss a few of these best practices so you may begin formulating a strategy of your own.

Observing

Observing and photographing a subject from a distance allows you to capture a truly candid moment. People have a tendency to change their behavior when they know they're being observed. In many ways it's a bit of a social experiment to watch people interact with others and their surroundings. My number-one goal when I'm photographing people in their environment is to minimize my influence on the subject and to create a frame that is truthful above all else (**Figure 5.2**).

Figure 5.2
If these girls knew they were being photographed, they likely would have posed, and the irony of the shot would have been lost.
ISO 200 · 1/60 sec. · f/5 · 35mm lens · London, England

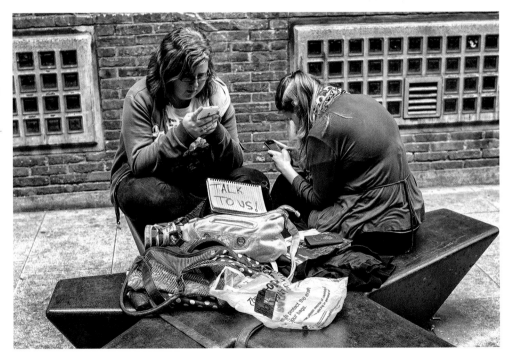

Here are some benefits of an observational approach:

- You get to capture an authentic, candid moment.
- You can document a story without influencing it.

But there are also some things to be aware of with this style of photography:

- You need to feel confident that what you're doing is within your rights.
- Speed is the name of the game. Taking too long to take a photo leaves you exposed, and you could blow your cover. If you want to observe, don't run the risk of being seen (more on this later).
- Always being alert can be exhausting, and it is a very easy way to lose track of what's going on around you.
- You'll need to seek out shots alone to avoid drawing too much attention to yourself. Street photography is not a team sport.

Staying Under the Radar

The trick to capturing candid moments is being able to photograph others without being detected; you can't photograph a parade if you're leading it. In the long run, keeping a low profile and learning to blend in will create more photographic opportunities. Your clothing and equipment are one part of the equation, and your ability to observe from a back-row seat is the other. Improving the speed in which you take a photo will also minimize your chances of being detected. It's the photographers who fumble and outstay their welcome who run the risk of being detected by their subjects.

Here are some tips for staying under the radar:

- Keep your equipment to a minimum. Toting more than one camera body and a host of lenses will make you stand out.
- Check your camera settings in advance. That way, when the moment strikes, you don't lose time fumbling with exposure.
- Pre-focus whenever possible.
- Take note of your surroundings. Sometimes you can act like you're taking a photo of a building or something else when you're actually composing with your subject in the frame.
- Avoid the "creep factor" by carrying yourself with confidence. If you're uncertain about what you're doing, people will read that in your body language and it will make them feel uneasy.

Getting Caught in the Act

At some point, most of us will get caught in the act of photographing a subject. Knowing how to react can save you major headaches, and preparing for these situations will ensure you handle them with dignity. Keep in mind, we're talking about images being taken in public settings, where you are within your legal right to be taking them (see Chapter 8). In the years I've been shooting street photography, I have yet to have a bad experience. I find that a quick and disarming smile and a compliment tend to settle most concerns. If approached by a person, always remain calm and polite. And again, knowing your rights as a street photographer will help you build confidence in these matters.

During a workshop in Belgium, we were photographing a small market of used booksellers in Ghent. I saw an interesting-looking gentleman wearing a captain's hat, so I quickly snapped his photo (**Figure 5.3**). Just as I did, he looked up and caught me. Knowing I was busted, I instantly smiled, and he responded with a wink. I winked back—no harm, no foul, and I ended up with a good image.

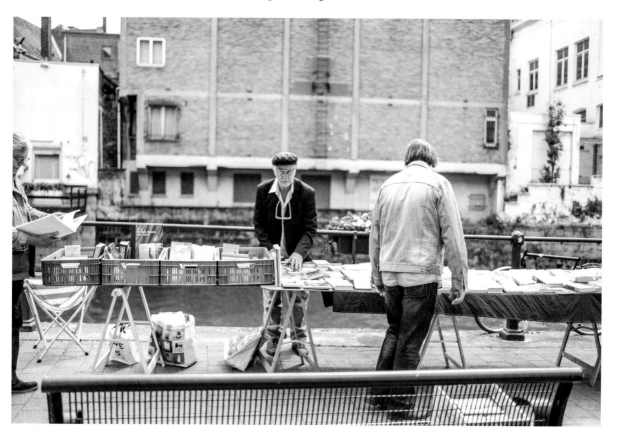

Figure 5.3 I was caught red-handed when this man looked up right as I was taking his photo. Thanks to a smile and a wink, I didn't have any trouble.

ISO 320 • 1/250 sec. • f/8 • 21mm lens • Ghent, Belgium

A long lens, such as a 70–200mm, allows you to capture candid images while keeping enough distance to go unnoticed. Locate a comfortable place to sit, such as an outdoor café, where you have a clear view of a busy intersection or square. Avoid drawing too much attention to yourself so when a desired subject enters your field of vision, you're able to get the shot without the person being aware.

The long-lens approach isn't for everyone, and at times can come off feeling a bit sneaky, but it's an excellent technique for learning street photography. I recommend it for people who have difficulty walking or standing for long periods, or who require more time to get a shot.

Engaging

Photography can be a very intimate process, and the camera is a tool that's easy to hide behind. Throughout the years, I've found that putting down the camera is every bit as important as knowing when to raise it. Interacting with people and working on your social skills will create more opportunities for you to get memorable shots.

The role of a travel photographer is to learn more about a culture, and communication is an important part of this equation. Street photographers come in all flavors, but my approach has always been that if I need to get within a few feet of a subject to get the shot, I'll ask for permission. I also ask when there is any doubt about my intention. Remember, people don't want to look like fools or be teased, so when in doubt I explain why I am taking their photo and reassure them that I'm not teasing or being mean (**Figure 5.4**).

Figure 5.4
During a World Cup soccer match I noticed this man's huge mustache— I had to get a photo. I approached him and compli- mented his amazing mustache, and then asked for a photo. He obliged without any trouble.

ISO 250 • 1/180 sec. • f/4 • 35mm lens • Brussels, Belgium

If I think someone is doing something funny, I'll smile or give a thumbs up to let her know I'm taking the photo in the spirit of fun. In regard to travel photography, you need to remember that you're not just representing yourself but your home country and photographers as a whole, so be a good ambassador.

Here are some pros of an engaging approach:

- It's the only way to get an authentic close-up portrait.

- You are less likely to insult your subject.

- It's a wonderful opportunity to represent photographers and your home country with pride.

But here are some cons:

- It can be a bit awkward until you learn how to have a successful interaction.

- It requires a thick skin because you may get turned down.

Don't Be Paparazzi

There's a growing trend that I find alarming, and I feel it will eventually put street photographers at odds with society: the indiscreet and invasive practice of forcing a fast, up-close portrait onto an unwilling subject. In my opinion, these images are inappropriate, and often the subject's reaction reflects his or her disdain for the practice.

In an age when privacy and safety concerns are at an all-time high, it goes against the grain to participate in these quick-and-easy images. I say easy because it's much easier to force yourself into people's personal space than to ask permission and allow a person to assess your integrity. Those who give typically get in return, and those who take tend to look for the easy way.

Don't be like the paparazzi. Always respect people's space, especially if the person is disabled or otherwise might feel physically vulnerable. Use your judgment when taking photos of these folks; you may just want to skip images of them altogether. Ask yourself, am I taking this photo because this person is an easy target? Or do I truly have a greater purpose here? Be honest with yourself, and make sure the answer to the second question is yes.

- Be confident and mindful of your body language; self-deprecating humor goes a long way.

- Show an honest and sincere interest in the world around you.

- Be prepared to field questions, and always be respectful with your reply.

- Respect personal space.

- No means no.

Effective Communication

A quick case in point before moving on: I do a night photography workshop in Chicago. A very small group and I were photographing at the El stairs as people came and went. I noticed a police officer staring at me from across the street, but we continued to shoot. Next thing I knew, there was another officer. Obviously something was on their radar, so I calmly walked over and, with open body language and polite tone, asked if there was an issue. The officer said that the building behind the El was the Federal Reserve Bank, which I didn't realize at the time. I explained our purpose, thanked them for doing their job, and gave them a time frame for when we would complete our work. The officer thanked me for addressing the issue and told me I was free to carry on, but to finish within my stated time frame.

Was I acting outside the law? No. But regardless, clear, calm, and honest communication went a long way. I have no desire to lose time on the street by ticking off a cop!

Case Studies: Portraits

By definition, a portrait is a photograph of a person or a group of people. As a street photographer, your goal should be to expand beyond the basics of what defines a portrait by capturing what defines the *individual*. Therein lies the difficulty: A quick snapshot doesn't tell a person's story like taking your time with an intentional portrait does. When you authentically engage, you get a better portrait. In the following chapters, I'll address techniques and considerations for approaching strangers in the field, whether you're walking the streets of New York City or visiting rural Montana. Right now, I want to share some of my real-life experiences, starting with my goals and process for getting the images.

Group Portraits

Don't think of a group portrait in the same terms as a family portrait in a studio. When taking a group portrait in the field, your goal is much different from that of a studio photographer. In the studio, sharpness, creative posing, and perfect white balance are the goals. In the field, we aim for compelling content and visual transportation of the viewer to the scene.

In 2013, the family and I traveled to Stonehenge to watch the summer solstice. Twice a year at solstice, the park allows people into the center of the site to celebrate the ancient Druid holiday. On these special days, when the sun sets, it shines through a narrow opening in the stones, perhaps acting as a type of calendar to the ancient people who architected the structure. There was a low cloud ceiling the day we were there, and the sun didn't shine through the stones. I was left to photograph all of the interesting people, which was just as fun.

I approached a group of Druids and asked politely to take a photograph. At first they were hesitant, but when I explained I was a photographer visiting Stonehenge for the first time, they seemed to relax. One of them said it was up to the guy in white, and I made a joke about him being the boss. They laughed and someone asked me for a "fiver," which I took to mean money. I joked that photographers don't have any money. They laughed again, and I got the nod to take the image (**Figure 5.5**).

Figure 5.5
It took a little bit of work, but I eventually got this group to let me take a portrait during a solstice festival at Stonehenge.
ISO 400 • 1/200 sec. • f/1.6 • 35mm lens • Stonehenge, England

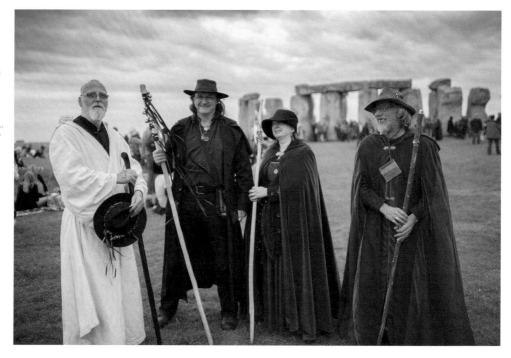

This was a tough group, and the immediate vibe was trepidation, but by making a few jokes and keeping it light, I won them over. As I said earlier, you need to be prepared to hear no, but by sticking with it, you'll be surprised how people will change their minds.

Individual Portraits

Getting a close-up portrait of a stranger can be nerve-wracking for some photographers. It's completely natural to feel nervous, because it means you care about how others feel and don't want to offend anyone. I still get nervous when I approach someone for a portrait, but not as much as I used to. With practice, you'll find asking gets a lot easier.

The best approach to take with any stranger is honesty. The number-one question I get is, "Why do you want my photo?" I'm drawn to people because they either look interesting or they have a unique presence about them. People are very self-conscious about their looks and often are worried that the photograph will show them in a bad light. Having empathy for your subject will build rapport. Reassure your subject that you find her unique or interesting, and be complimentary so she doesn't feel like you're just using or making fun of her.

I was visiting Belgium and enjoying the atmosphere of the Grand Place when I saw this gentleman with his dog. He was smoking a cigarette and people watching—much like I was watching him. I took my time, meandered over, and sat down near him. Initially, I took a few candid shots of him interacting with a couple of children who were interested in his dog (**Figure 5.6**).

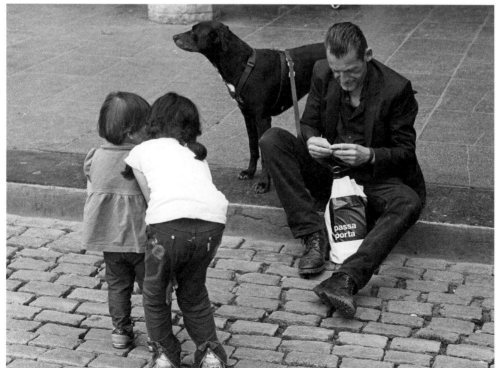

Figure 5.6
I took a candid shot of this gentleman interacting with some children who were interested in his dog.

ISO 125 •
Ilford FP4 film •
50mm lens •
Brussels, Belgium

After a while I made my way to petting his dog and chatting with him about her. Finding a common ground can help quell uncertainty, and the fact that I love dogs probably helped my cause. I asked if I could take a photo of him and his dog. He said yes, so I took a few photos and then returned to petting his dog (**Figure 5.7**). I went back to my place on the curb, joined him in people watching for a few minutes, and eventually said goodbye and moved on. The takeaway: Taking your time, not seeming in a hurry, and being sincere will create photo opportunities.

Field Notes

A long lens such as a 70–200mm is an excellent lens and recommended when you want to photograph from a distance. But up close, a big zoom like that can be downright intimidating to your subject. Instead, I recommend a focal length between 35mm and 85mm for portraits. My favorite lens for travel and street photography is a 35mm, with my 50mm coming in second. Each of these lenses is very compact and performs well in low light.

Figure 5.7
After finding common ground by chatting with him about his dog, I asked for a photo, and he obliged.

ISO 125 ·
Ilford FP4 film ·
50mm lens ·
Brussels, Belgium

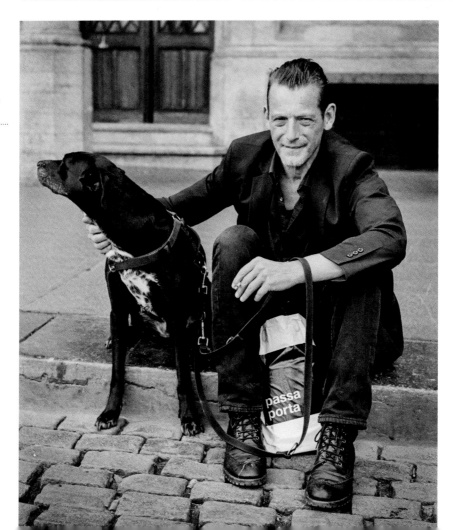

Chapter 5 Assignments

It's time to go out and practice taking photographs of people with and without their knowledge. Then have someone take your photo!

Observe, then engage

Observe a likely portrait candidate from a distance and capture a few candid frames. Once you've captured a few good shots, approach the subject and ask politely if you can take a photograph. Assuming the subject gives permission, take the photo.

Back at your computer, pull up the images side by side and note how the subject interacted. Was she smiling when it was a candid? What was her general demeanor? Does the close-up portrait tell a different story? Decide which image you feel tells the better story.

Put yourself in your subject's place

It doesn't feel natural to look into a lens while trusting someone to photograph you. When someone is photographing me, I feel every twitch in my face, I don't know where to put my hands, I'm sure my fly is down and my hair is sticking up, and the list goes on. Empathizing with your subject will help you connect and overcome objections.

So here's the assignment: Have someone you don't know well—maybe even a complete stranger on the street—take your photograph. Take note of how you're feeling and what sort of communication you want in order to feel more comfortable. Then next time you're taking a portrait, employ the same methods and communication style to help put your subject at ease.

Share your results with the book's Flickr group!
Join the group here: www.flickr.com/groups/street_fromsnapshotstogreatshots

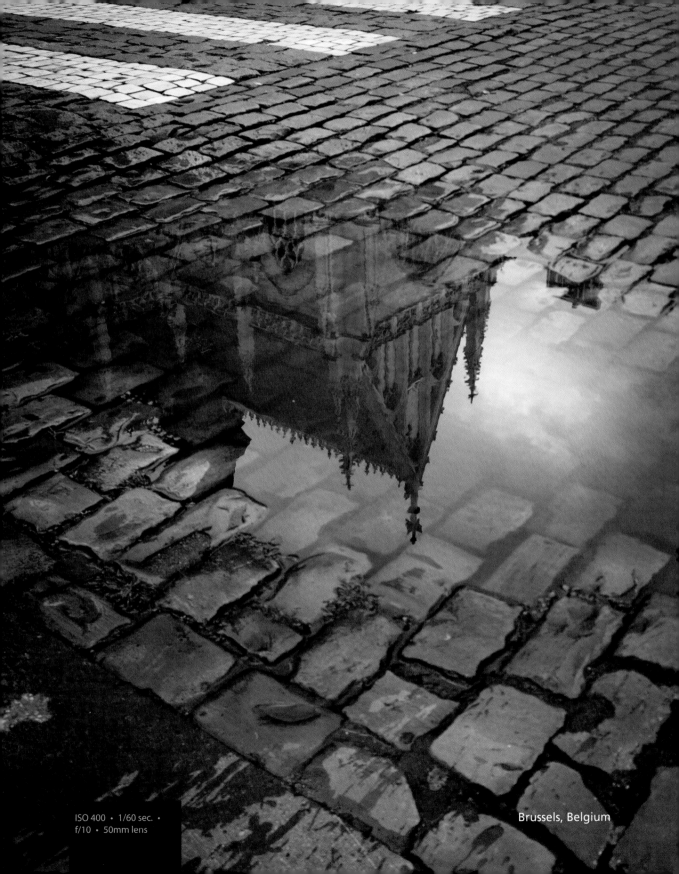

ISO 400 • 1/60 sec. •
f/10 • 50mm lens

Brussels, Belgium

6
Cities and Streets

Getting the most out of urban travel

A city's buildings and streets remain static, but it's the ebb and flow of its tenants and the rhythm they create that captivates a street photographer. What I love about photographing urban environments is the endless variety of photographic opportunities, from cityscapes to street portraits. The other fantastic element of urban photography is that nothing is predictable other than opportunity. We know what time the sun will rise and set, we know the streets will fill with city dwellers, but what we don't know is how all the people will interact with one another or their environment.

We will cover a lot of ground in this chapter and discuss the best ways to maximize your time in the city. We'll build upon the previous chapter's discussion of engagement and observation by identifying locations that promise photographic opportunity. I'll also share some of my favorite tips for getting a shot and some of my own experiences. Let's begin our urban adventure and delve into the opportunities that await!

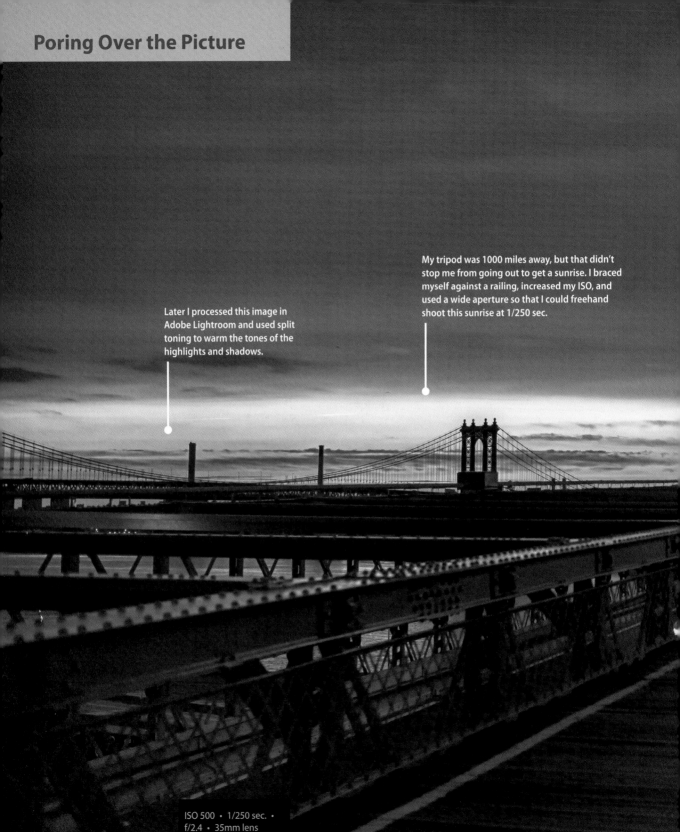

Later I processed this image in Adobe Lightroom and used split toning to warm the tones of the highlights and shadows.

My tripod was 1000 miles away, but that didn't stop me from going out to get a sunrise. I braced myself against a railing, increased my ISO, and used a wide aperture so that I could freehand shoot this sunrise at 1/250 sec.

ISO 500 · 1/250 sec. · f/2.4 · 35mm lens

This image was about getting the shot even when I didn't have all the necessary gear.

I talk ad nauseam about planning your shots, but never let the lack of planning hold you back from last-minute opportunities to get a great photograph.

New York City

Gear Suggestions

The best way to make sure you get the most out of your urban adventure is to have the right gear. While we covered what to pack in Chapter 1, "Equipment," here I'll highlight some of the things to consider when you're traveling in the city.

My number-one goal when traveling to an urban environment is to minimize my load. In the next chapter, where we discuss landscape photography, you'll notice things are quite the opposite: You often have room to pack the best gear. However, street photography is about being nimble and quick with your camera, which means paring down and making do with what you have.

Go Lightly

When I'm on location for a few days, I can break my time in the field into two categories: street and architecture. If my goal is to get "traditional" street images, I'll try to leave the tripod behind. However, if the goal is to capture architecture or long exposures, then the tripod is a necessity. For me, a usual day of city walking includes 5 to 12 miles, so keeping my load to a minimum is critical. However, there are times when you have no choice but to take your tripod, so packing wisely becomes the rule of the game.

I like to do most of my street photography with a 35mm lens, with a 21mm in my kit for those times I need a wide angle. As I mentioned in Chapter 1, a 24–70mm focal range will work for 95 percent of your street images. You'll need to assess your own goals, but remember, the less gear you carry the lighter you become, and the quicker and more efficient you'll be at getting the shot.

Becoming Street Smart

In Chapter 5, "Observation vs. Engagement," I discussed the merits and drawbacks of keeping your distance and going in for the shot. But now it's time to shift your attention to creating opportunities on the street and beyond, regardless of whether your intention is to engage or observe your subjects. Remember, your top goal is to increase the likelihood of taking interesting photographs of people in an urban environment, so you'll need to scout locations that will be the most fruitful for your endeavors.

Let's start by covering how to use interesting backgrounds to frame your street photography. Then we'll explore many unique urban situations where you can find opportunity, and the best way to get the shot in each scenario.

Interesting Backgrounds

One of my favorite techniques for taking candid photographs is to find a location that has an interesting background and wait for people to enter the frame. I like to think of it in terms of setting the stage and waiting for actors to show up, in hopes of photographing some intriguing characters.

Interesting backgrounds can range from murals and street art to colorful walls, signs, or buildings. Once you've located a desirable background, the trick is getting a good vantage point without drawing attention to yourself. Often I'll place myself in a doorway across the street from the intended background so I'm somewhat hidden. Other times I'll cross the street and pretend to be photographing the backdrop, when I'm actually waiting for the subject to enter the frame. It might feel sneaky—and I guess it is—but the reality is if you plan on getting candid street shots, you'll need to be covert. See Chapter 5 for more on this.

Street art

Graffiti can make a very interesting backdrop and is easy to find in many urban environments all over the world. Colorful street art makes a statement, adds a dash of color to an otherwise boring frame, and even helps identify a neighborhood in an urban setting (**Figure 6.1**).

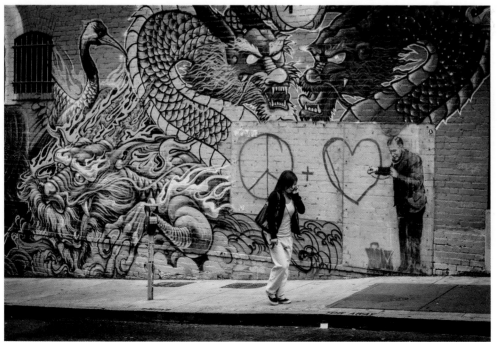

Figure 6.1
In San Francisco's Chinatown, I noticed this mural with graffiti by the famously elusive street artist, Banksy. I crossed the street and waited for this woman to enter the frame before taking the photo.

ISO 250 · 1/400 sec. · f/5.6 · 50mm lens · San Francisco, CA

A Sense of Place

Creating images with recognizable buildings, parks, streets, monuments, and so on will give your images a location stamp. Another technique to giving your image a sense of place is to look for city workers, such as police officers and firefighters. Their vehicles and uniforms can give away what city they're in, and they give an iconic look and feel to your shot (**Figure 6.2**).

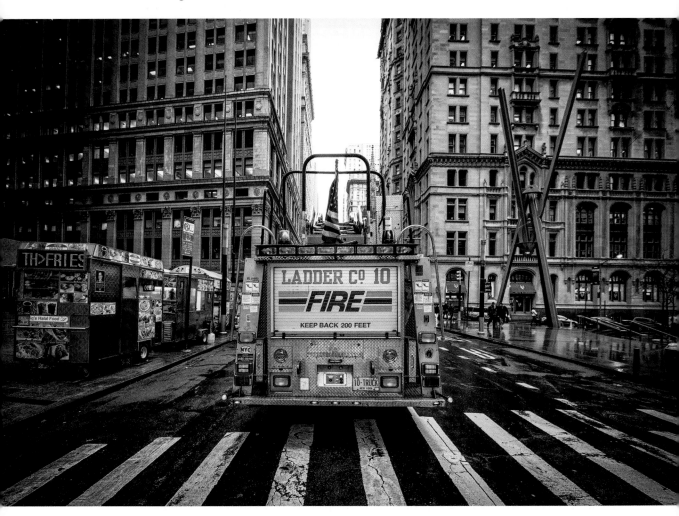

Figure 6.2 This New York City fire truck gives the image a sense of place.

ISO 320 · 1/60 sec. · f/4.5 · 15mm lens · New York City

Storefronts

Storefronts create a great stage for candid images, and the best part is they draw people like bees to honey. In **Figure 6.3**, I found myself attracted to this location in Florence, Italy, because it was a busy intersection with a bustling shop. When I find a location I like, I'll settle in for a bit and wait for a moment to present itself. Sometimes it pans out, as it did in this case, when a dapper gentleman entered the frame. He just stood there, looking onward, and it was his stillness that I wanted to capture among the chaos of the street. I used Shutter Priority mode and set my camera to 1/15 of a second to create motion blur. I was able to capture only one frame with enough people in it before the moment passed and he slipped into the store.

Figure 6.3
I set up my camera and waited across the street from this busy storefront for just the right moment to snap the shutter.

ISO 500 · 1/15 sec. · f/4.8 · 35mm lens · Florence, Italy

Right Time, Right Place

Much of street photography is about getting yourself to the right place at the right time. Getting a sense for the rhythm and pulse of a city will yield opportunities for creative shots. Whether it's finding workers when they're taking a break or unique faces at a trade show, seek out different situations—and always have your camera in tow and ready to go.

Break time

Employees tend to congregate near their places of work so they can enjoy their break without running the risk of getting back late. Restaurant employees typically take their breaks after the breakfast, lunch, or dinner rush. Others tend to take breaks during the normal lunch hour. Remember to take note of the culture you're in, as some cultures don't take a typical lunch break, instead opting for a long afternoon siesta.

While walking through Paris's Parc du Champs de Mars at midday, I noticed several locals enjoying their lunches. Keeping my eyes peeled as we continued our walk, I came upon a woman in a nice black business suit napping on a park bench (**Figure 6.4**). While I felt somewhat uncomfortable taking the shot given her unusual resting position, my desire to document the unique napper was stronger, so I went ahead and photographed her. I'm glad I did, because I would have regretted walking past this!

Figure 6.4 While Paris isn't exactly known as a siesta city, this woman must have been tired because she was taking her own park-bench siesta in the middle of her workday.

ISO 200 · 1/400 sec. · f/5 · 35mm lens · Paris, France

Markets

When traveling, I often photograph local markets because I can really capture the local flavor there. Markets are usually busy places where you'll find lots of people who are out and about, relaxed, shopping or displaying their wares, and often open to having their photo taken (**Figure 6.5**). Remember, as I point out in Chapter 8, "The Legalities," in many cases you're allowed to photograph in stores unless otherwise posted or until you're asked to stop.

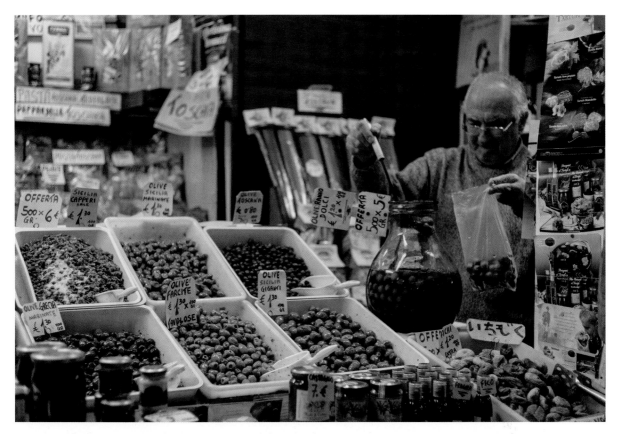

Figure 6.5 There's an amazing food market in the center of Florence. This man was selling a local favorite: olives.

ISO 400 · 1/90 sec. · f/3.4 · 50mm lens · Florence, Italy

Special events

Street festivals, parades, and other special events make for great street photography because people are usually in a good mood—and open to having their photo taken. Knowing where to go, and anticipating how people will act after a big event, opens up photographic opportunities. I was in Brussels when Belgium won their first soccer match of the 2014 World Cup. The streets erupted as people left nearby pubs and flooded the main square, festive (and drunk) and loving having their photo taken (**Figure 6.6**).

Trade shows

To those of you who travel for work to conventions or trade shows: If you're leaving your camera behind, you're missing out. Many might think the only thing worth photographing at the Chicago car show are the cars, but they are very wrong (**Figure 6.7**). You always want to fish where fish are, so whenever possible, visit events that draw in large numbers of people (sometimes surprisingly interesting people).

Figure 6.6
I was in Belgium when they won their first 2014 World Cup match. The crowds were ecstatic, and there was a lot to photograph.

ISO 400 • 1/500 sec. •
f/2 • 35mm lens •
Grand Place, Brussels

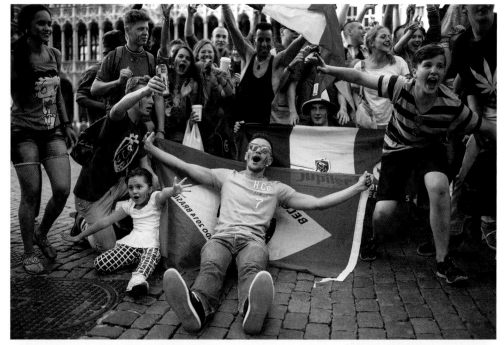

Figure 6.7
While I wasn't very interested in photographing the cars at our local annual car show, I was highly interested in photographing people. I came across this man who was gathering attention for the Red Cross Blood Bank.

ISO 500 • 1/60 sec. •
f/4 • 35mm lens •
Chicago, IL

Creating a Classic Image

Sometimes a city's streets are famous because of the terrain, such as the canals of Venice or the streetcars in New Orleans. When you want to get a classic shot that truly encompasses what a city is known for—whether it's Chicago's El, Paris's Eiffel Tower, or London's Big Ben—scope out a good location near one of these landmarks and wait until you get your shot. Any time spent scouting will pay off.

I don't get to travel to San Francisco very often, so when I went last time, I wanted to capture that classic photograph of a cable car coming down one of the city's famous angulating roads. Eventually I came to a perfect hill with a classic old Ford to help complete the frame and patiently waited until a cable car entered the scene (**Figure 6.8**). For me, this was a quintessential San Francisco moment.

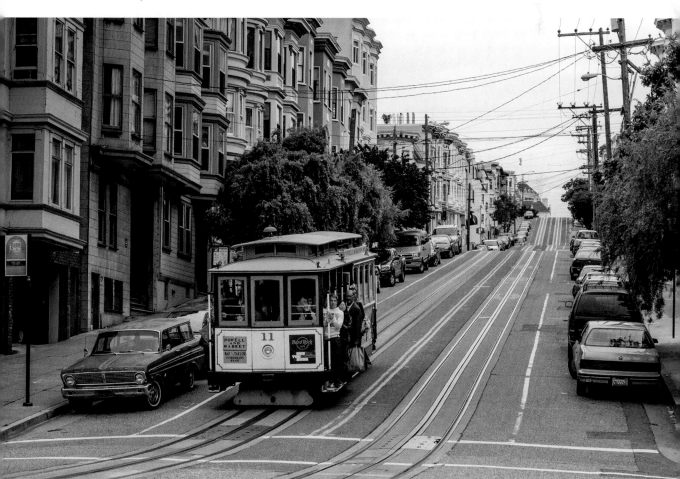

Figure 6.8 While I had to wait over 20 minutes to get this image, it was worth it to capture a classic San Francisco street shot.

ISO 200 · 1/250 sec. · f/8 · 50mm lens · San Francisco, CA

Using Unique Features and Props

Always be on the lookout for props or things that add an interesting dimension to a photo. For instance, when I was walking around New York City on a cold January afternoon, I noticed a steam vent near a crosswalk. The steam was filling the streets, creating an eerie feeling as people walked in and out of the fog. I took a few test shots, checked my exposure, and took photos of random subjects for nearly 30 minutes (**Figure 6.9**).

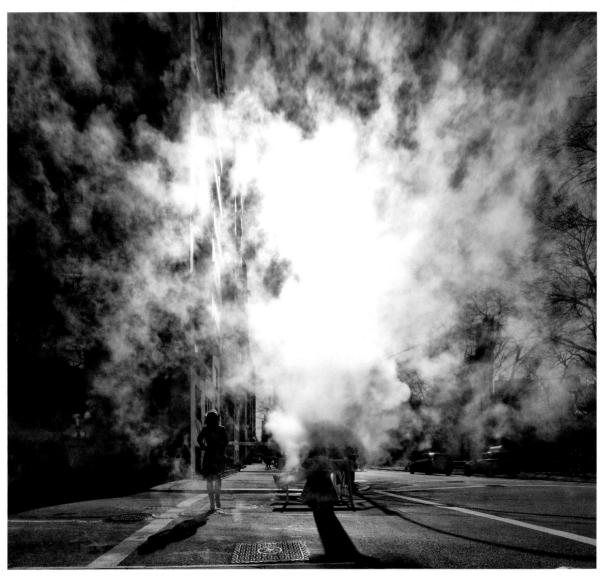

Figure 6.9 I liked how this steam vent was creating a unique scene and diffusing the daylight. I waited for almost 30 minutes at this location until I got the shot I wanted.

ISO 200 · 1/500 sec. · f/13 · 15mm lens · New York City

Juxtaposition

In Chapter 4, "Composition," I covered composing a frame with two or more objects while showing an obvious comparison or contrast. One day in Brussels, I noticed this large window decal that I thought would make a good prop if the right subject entered the scene. My goal was to use the juxtaposition of the decal and the subject to create a humorous setting. Once again, finding the props and working the scene paid off after nearly 20 minutes of waiting for the right person to enter the scene (**Figure 6.10**).

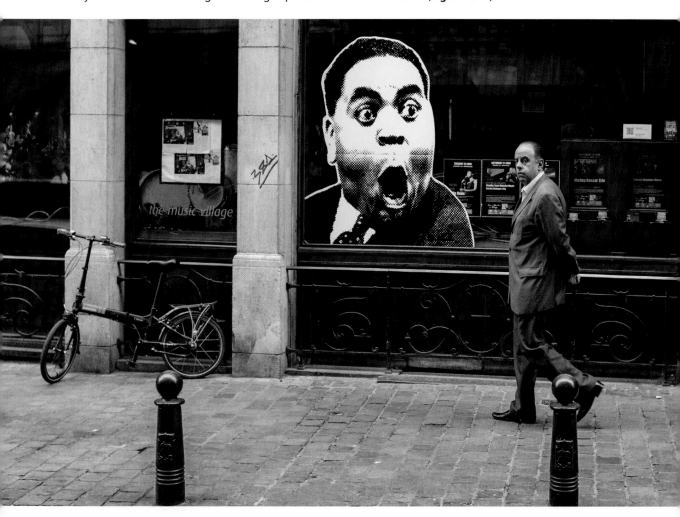

Figure 6.10 I saw this interesting decal on the window, crossed the street, and waited in a doorway until the right person entered the frame.

ISO 250 · 1/180 sec. · f/4 · 35mm lens · Brussels, Belgium

Finding Higher Ground

Our tendency is to take streetscapes from the sidewalk or the road, but changing your perspective can put a lot into focus. When I was visiting Jaipur, India, life on the streets seemed very chaotic to my foreign eyes, but there was a rhythm to the madness as people, vehicles, mopeds, and cattle moved in and out of the scene. The photographs I was taking from the street just weren't conveying the overwhelming sensation I was feeling. It wasn't until I took this image from an elevated position that I was finally able to tell the story (**Figure 6.11**).

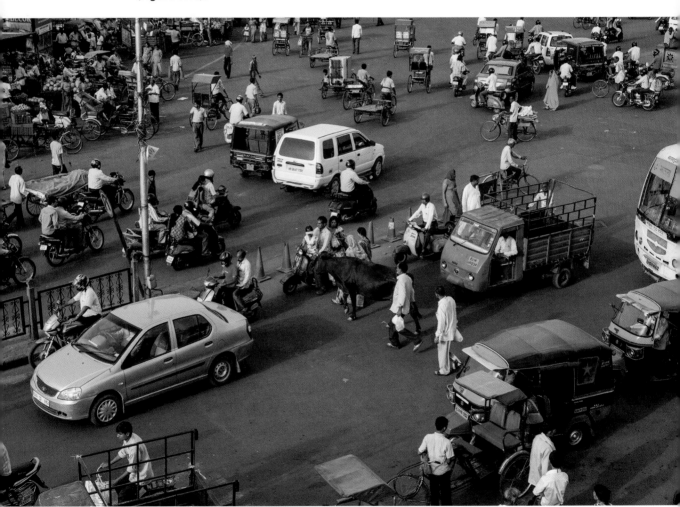

Figure 6.11 There was no way to document the chaotic nature of Jaipur's streets while in the street, so I found higher ground to gain a better perspective that really told the story.

ISO 160 · 1/250 sec. · f/6.3 · 57mm lens · Jaipur, India

Capturing Special Moments

The heart of street photography is capturing the human condition: showing everyday people in their everyday lives, experiencing the emotions and moments that make us human. While it's always interesting to capture big moments, news stories, or special occasions, it's just as important to document the small moments and interactions between us. Look for moments between people that stir emotion and allow you to connect to them. Whether it's laughter, affection, distress, or just plain silly behavior, seek it out and capture it.

Affection

There are photographers who have dedicated entire portfolios to recording public displays of affection (PDAs). Urban environments tend to be more liberal than their rural counterparts, so we tend to see more kissing, hand holding, and other PDAs between partners in cities. Europeans are even more open with affection than Americans, but if you want to increase your odds no matter where you're traveling, I recommend photographing in a park on a weekend afternoon. Couples adore benches and often can be found in the throes of passion with little concern for nearby people (**Figure 6.12**).

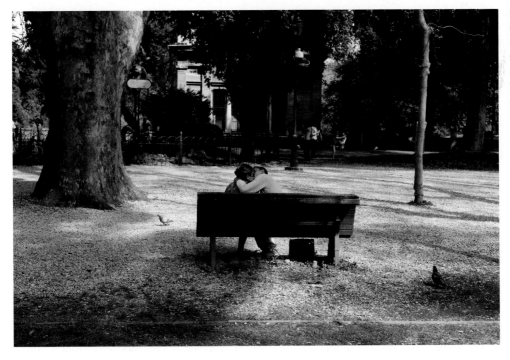

Figure 6.12
Italy is known as a romantic destination, and it does not disappoint.

ISO 320 • 1/750 sec. • f/4.8 • 50mm lens • Rome, Italy

Humor

I like to laugh, and I really enjoy making other people laugh, so I'm naturally drawn to photographing scenes that make me chuckle. The rule for me is if the scene makes me smile, then I take the shot; if it makes other people smile, then all the better. While there is a fine line between capturing a funny moment and doing so at someone's expense, you'll have to find your moral compass to make that decision. As we discussed in Chapter 5's photographer's code of ethics, taking a sincere interest in someone and the environment around you is different from teasing someone. I never take photos to make fun of people, only to document someone if they are doing something funny (**Figure 6.13**).

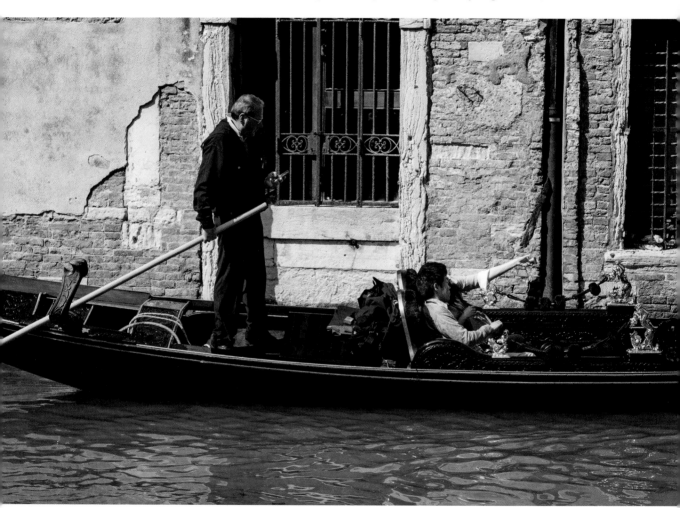

Figure 6.13 **It seems as though even Venice's peaceful gondola rides have not escaped the constant presence of the iPhone.**

ISO 250 · 1/350 sec. · f/9.5 · 50mm lens · Venice, Italy

Advanced Creative Techniques

Once you've gotten your feet wet with some of the locations and techniques I just covered, you'll be ready to move on to more advanced street techniques. It takes practice to get the feel of photographing people in their environment. But once you're comfortable with it, it's time to start creating more unique compositions, such as abstract forms, and implementing more advanced techniques such as learning to stick with a shot.

Abstract Forms

I often look for creative ways to show the human form in the abstract. For example, once I was strolling through Chicago with my camera when I noticed the grungy walls in a tunnel that connects a park to the beach. I planned this particular image by placing myself against the tunnel wall, setting my camera to sligly underexpose the scene, and waiting for someone to enter the frame (**Figure 6.14**). The combination of underexposing the frame and the backlighting at the end of the tunnel created a silhouette of the person, with the grungy tunnel walls in the foreground.

Figure 6.14
I liked the idea of photographing a person walking through this tunnel, so I added an abstract element to the frame by underexposing it and focusing on the foreground.
ISO 250 • 1/400 sec. • f/5.6 • 50mm lens • Chicago, IL

Sticking with the Shot

Not every shot needs to be a full-frontal portrait. Many times I'll do my best to get a photograph from the front, but it doesn't always work out, either because of tight quarters or because it's impossible to get the shot without giving away my intentions. If you find yourself in this situation, consider framing the shot with the subject walking away from you, and remember to take your time focusing on your composition. The biggest mistake many street photographers make is getting busted (**Figure 6.15**), then walking away from the shot. Try sticking with it and working it from a different angle (**Figure 6.16**).

Figure 6.15
I got busted attempting to get a shot of this interesting trio.

ISO 250 • 1/2000 sec. • f/5.6 • 35mm lens • Ghent, Belgium

Figure 6.16
After getting busted, I briefly waited, and then stuck with the shot from another angle.

ISO 250 • 1/2000 sec. • f/5.6 • 35mm lens • Ghent, Belgium

Close-Ups

How often have you seen a person on the street with a really interesting look or face and wished you could take the person's portrait? Growing up, I had a good friend who, unlike me, always had a date for Friday night. I was somewhat shy. I remember asking him what his secret was. He replied, "I ask a lot of girls out and I hear a lot of nos, but eventually I hear a yes!"

The bottom line is, as discussed in Chapter 5, if you want to get good at taking photographs of strangers, you need to develop thick skin and be prepared to hear "no." But if you keep at it and ask enough people, you will eventually hear "yes." Sure, there are plenty of techniques for improving your odds, and being polite and sincerely interested is first and foremost. To illustrate this, I'll share an encounter I had in Italy and then give you a few suggestions for getting good portraits.

Approaching Strangers

It is completely normal to get nervous when you're asking someone to take his or her photo. There is a trick to it though, and that trick is to hide those nerves behind a wall of confidence.

I was wandering the streets of Florence when I spotted two gentlemen, one of whom had a unique look and seemed to contrast the other. I watched them for a while and wanted to get a portrait of them, but not speaking Italian and being a foreigner added to my fear. Finally I worked up the nerve and approached them to ask if I could take their photograph. They looked at me with curiosity and asked, in very good English, where I was from. I answered, and then they asked why I wanted the photo. So, with a genuine smile, I told them the truth: "Because you both look like very interesting guys." The gentleman on the right replied with a big smile and said, "Brilliant!" and gave me the go-ahead to take the photo. I took a quick series of three photos and thanked them for their time. Then the man with the beard gave me his business card and said, "Send me an image." The funny part of this story is he is a famous Italian leather-goods designer, Wanny Di Filippo from Il Bisonte, who is known for his unique style and upbeat personality (**Figure 6.17**).

Keep in mind, any exchange of this nature needs to be swift, and overstaying your welcome is a big no-no. Don't waste time looking at the back of your camera, and be respectful of other people's time—quick and easy is the name of the game. Also remember, I was successful the minute I asked for the portrait. Whether or not he gave me the portrait is irrelevant, because we can't control what people will say or how they'll react, but knowing I tried is what counts. Acting on your creative intuition keeps regrets at bay, and over time, success builds confidence.

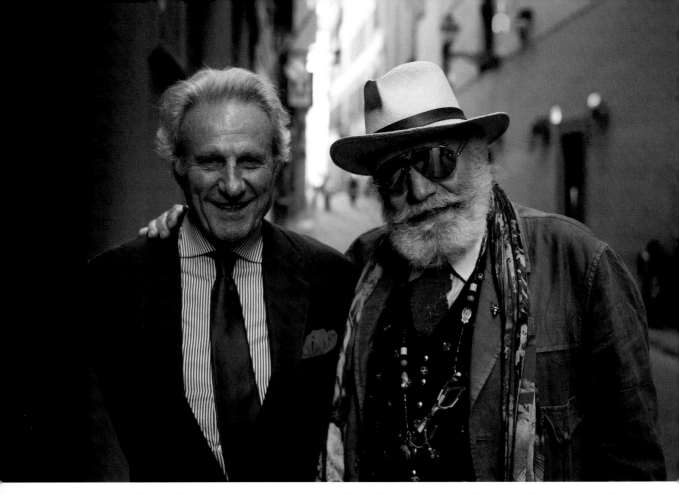

Figure 6.17 I was uneasy, but I went ahead and asked these two gentlemen for a photo. They obliged, and it turns out the man on the right is a well-known Italian leather designer.

ISO 200 · 1/180 sec. · f/2.8 · 35mm lens · Florence, Italy

Homeless people

Most urban environments have a homeless population, and you will need to prepare yourself for how to handle encounters with this vulnerable group. In many cases, the homeless represent easy targets for street photography because they show very little resistance to having their photos taken. The condition of the homeless in most developed countries, and specifically in the United States, is a result of socioeconomic issues, mental illness, drug or alcohol abuse, and misfortune. It's very rare the condition is due to "personal choice."

If you plan on taking photographs of the homeless, the question you need to ask yourself is, "Why do I want this photo?" I take no issue with people wishing to document an urban environment's state of affairs, but I think the interaction and intentions are what count. The standard to which I hold myself is whether I would want this photo regardless of whether the person was homeless or not. Is there something compelling, absurd, or

interesting other than the person being asleep on a bench or not having the wherewithal to say no? Each photographer will develop his or her own approach to photographing the homeless, and while I am not suggesting that we turn a blind eye to their plight, I am suggesting that we don't take advantage of their vulnerable condition. Instead, extend them the same courtesy you would extend to anyone else on the street (**Figure 6.18**).

Figure 6.18
This photo was less about the homeless man and more about his position in the frame, next to the graffiti that was making a social statement.
ISO 400 • 180 sec. • f/4.8 • 50mm lens • Brussels, Belgium

Tipping

If you travel and take enough portraits, eventually you will have to deal with the issue of tipping. This is a very heated debate among travel photographers as they consider the social, cultural, and economic issues of paying for portraits. Many photographers believe that if you pay a tip to your subject, it will set a standard where everyone who poses for a portrait will expect a tip. This is a bigger issue among the less affluent, and especially in third-world countries, where posing for photos has become akin to begging.

My stance on this has changed throughout the years, but generally speaking I don't like being forced to pay for portraits, and often will skip the shot altogether if that's the expectation. However, there are always exceptions; I typically will tip if the person is a street performer and this is his or her livelihood, or if local customs are such that tipping is customary.

When visiting Brussels, I came across a gentleman using his dogs to panhandle (**Figure 6.19**). I didn't pay him initially because it wasn't what I consider an up-close portrait, but he got his due when I returned later that day with my daughter and she made me give him money for his dogs. I'm not the moral police, and there's rarely a distinct right or wrong, but when in doubt, do your research, ask your guide for advice, inquire with photographers in the area, and follow your gut.

Figure 6.19
There are people who pose for photos using all kinds of props, such as dogs or children. It is your decision if you want to pay for a photo or not.

ISO 320 · 1/80 sec. · f/3.5 · 35mm lens · Brussels, Belgium

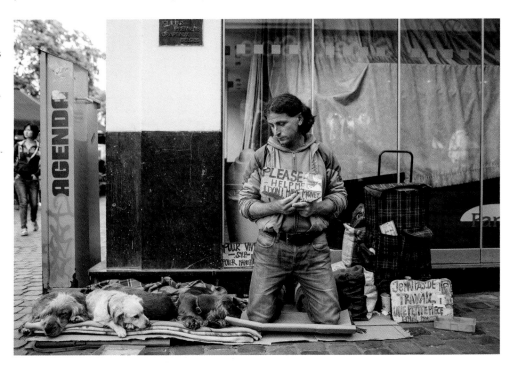

Using a Long Lens

I rarely carry a long lens for street photography, but there are times when you need the extra reach. I did some research ahead of a trip to London and realized I would probably need a long lens to photograph the guards at Buckingham Palace (**Figure 6.20**). As I mentioned in Chapter 5, if you are choosing an observational approach, you'll want to set up with your long lens in a busy area so you can capture portraits from afar without interacting with your subject. There will also be times, such as parades, ceremonies, or concerts, where you may not be physically able to get close enough to your subjects to engage them. If this is the case, you'll definitely want that long lens with you.

Figure 6.20
While I don't normally use a long zoom for portraits, I put my lens through the fence and used a 2x extender to get this portrait of a Buckingham Palace guard.

ISO 640 · 1/250 sec. · f/5.6 · 400mm lens · London, England

Cityscapes

Cityscapes are to an urban environment what landscapes are to the rural setting. A cityscape should convey a sense of place and time in an urban environment. Skylines are the traditional version of a cityscape, but generally speaking, any photograph that encapsulates the look and feel of a city is considered a cityscape (**Figure 6.21**).

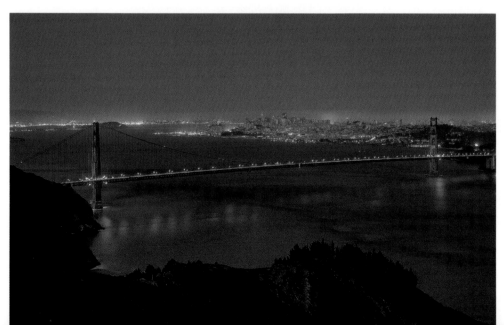

Figure 6.21
To capture this cityscape of San Francisco and the Golden Gate Bridge, I had to head away from the city and to higher ground. I chose a long-exposure night shot to get the beautiful colors of the bridge and the city lights beyond.

ISO 100 · 79 sec. · f/8 · 32mm lens · San Francisco, CA

When you're seeking out skylines, you'll need to travel away from the city center. For example, to get a skyline shot of New York City, you'll need to venture to Brooklyn to get far enough away to capture the entire view. Use a wide-angle lens to help you get the entire skyline into view, and make sure you use a higher f-stop to get a long depth of field.

Finding Different Perspectives

Finding a different perspective always seems to be a challenge. When I was visiting London a few years back, I was quite content with many of my images, but I wanted a better view of Westminster Abbey. I heard the sunset from the London Eye was marvelous, so I bought two tickets for the last ride of the night, which I shared with my daughter. It was a beautiful sunset, and we got a unique perspective (**Figure 6.22**). This image is also a strong reminder that, with a little planning, you can capture beautiful scenes with family in tow! In Chapter 7, "Landscapes, Rural Life, and Road Trips," I'll talk a little more about road tripping with the family and how I go about getting the photos I want while keeping peace in the valley, so to speak.

Other ways to get unique perspectives on cityscapes are long exposures and night scenes. I'll discuss those techniques in the following pages, but in brief, use the time of day to your advantage when shooting a cityscape. Often the golden hour (before and after sunset and sunrise) will create the most contrast in your shot and give a nice glow to buildings. You will also want to look for an active sky. If the city is near a large body of water, such as Chicago or New York, aim for a calm day and try to get a reflection of buildings on the water.

Field Notes

Nearly all of my cityscapes are planned, so I'll often carry a little more gear, including a light tripod and my wide-angle lens. I usually choose a 15mm to 24mm full-frame equivalent lens, but there are times when I make due with my 35mm. While the London sunset photo was planned, I had packed light since I was traveling from Paris for the day. I took the shot freehand and later processed it as a single-toned mapped image in Google's Nik Collection HDR Efex Pro.

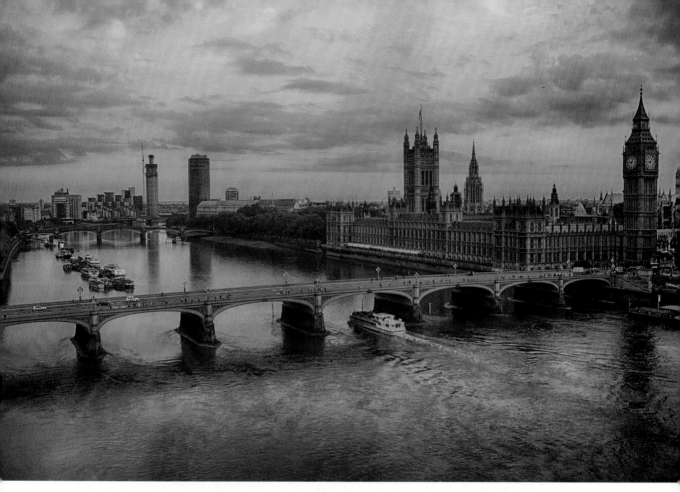

Figure 6.22 The London Eye gave me the unique perspective I was looking for. I went during the golden hour to make sure I'd have nice light.

ISO 500 • 1/125 sec. • f/5.6 • 35mm lens • London, England

Night Photography

Photographing at night allows you to show a different side of a city. The best part about night photography is it really doesn't require a lot of gear other than a tripod and a cable release.

While many of the famous sculptures and monuments are bustling with people throughout the day, at night you will find they are much quieter and have fewer people in the scene. The long exposures required for night photography also eliminate people from the frame. As long as a person is not standing still, if your exposure is long enough, he or she won't show up in your image.

Night photography allows you to be creative in many ways, one of which is capturing traffic trails. When I was visiting Florence, I got up before dawn to do some long-exposure photography. Since there was hardly any traffic at that time of night, I was able to capture a light trail from a single moped whizzing through the streets (**Figure 6.23**). I set up on a tripod, focused about a third of the way into the frame to make sure I had a good depth of field, set my ISO to 100 and my aperture to f/18, and waited until a moped went by.

Suggested Exposures for f/16 at 100 ISO

- **Cityscapes at night:** 20 seconds
- **Neon signs:** 2 seconds
- **Traffic trails:** 30 seconds
- **Brightly lit storefront windows:** 1 second
- **Street scenes:** 20 seconds
- **Brightly lit structures, such as statues:** 8 seconds

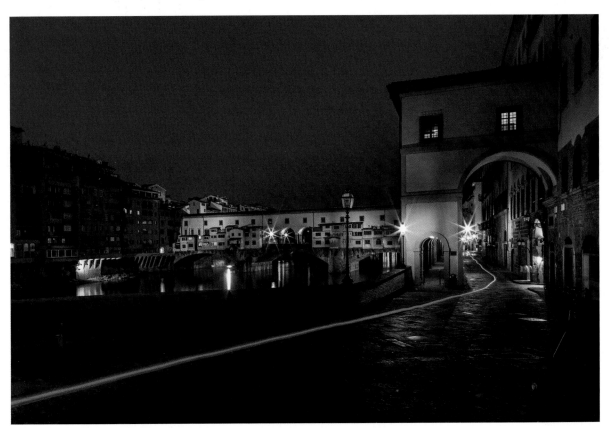

Figure 6.23 I set up my tripod for some predawn shots of the Arno River when I realized I could also get some great shots of traffic. I set up for that instead and waited until a moped went by; you can see the single taillight moving through the frame.

ISO 100 · 30 sec. · f/18 · 24mm lens · Florence, Italy

Night photography takes practice, but once you get out there you'll realize not only is it fun, but it's actually quite easy to get the hang of! Here are a few tips to getting a great night shot:

- Use a tripod.

- Set your ISO to 100.

- Set your camera to Bulb mode.

- Set your aperture to f/16 or higher.

- Focus your lens manually or use autofocus, then switch off autofocus so it doesn't try to refocus on you.

- Turn off vibration reduction. (This is not as big of a concern for long-exposure shots, but it's still good practice.)

- Check your exposure. It should range from 20 to 60 seconds, but you'll want to adjust as necessary.

- Fire your camera remotely using a cable release or self-timer.

Long Exposure

When I visited London's Buckingham Palace, I knew I wanted to capture something a little different than every other photograph I've seen from the fountain, so I decided to change things up and create a long exposure. By definition, this means the shutter will remain open for a prolonged period, but the exact time required is not defined. I think we're safe in assuming anything over 1 second is a long exposure.

As we just discussed, taking a long exposure at night isn't difficult, but during the day it requires the assistance of filters to darken the ambient light. In this case, I used a 10-stop neutral density (ND) filter to reduce the amount of available light. (A 10-stop ND filter is nearly impossible to see through, so you must focus without the filter in place.) The filter allowed me to create a 90-second-long exposure, which in turn blurred the clouds and created a ghosting effect on the people as it captured their movements. People who stayed relatively still for the 90 seconds are clearer but unrecognizable due to motion blur (**Figure 6.24**).

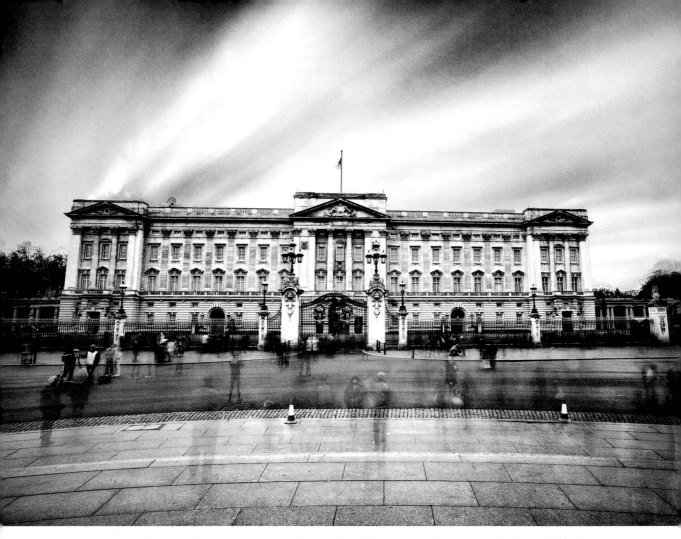

Figure 6.24 To get a creative shot of Buckingham Palace, I set up with a 10-stop ND filter and did a long exposure. The movement in the frame serves as a juxtaposition to the long-standing institution of the British monarchy.

ISO 100 • 90 sec. • f/22 • 18mm lens • London, England

Food and Drink

Whenever I travel with my family to foreign destinations, we love to sample all the different types of food. We always look for places where the locals eat to try and immerse ourselves in the culture, which is also where we often find the best food at the best prices. While I'm not a big food-and-drink photographer, I do like to document special meals and places as reminders of the trip.

Here are some quick tips on food-and-drink photography:

- Try to use natural light. Nothing ruins a photo of beautiful food like artificial or harsh lighting. Just don't be tempted to use your flash. Trust me, flashes and food photography do not mix! Instead, try to locate yourself near a large window and take advantage of the natural light. If the setting is dimly lit or at night, I recommend increasing your ISO and making use of available light. You'll be amazed by how much light a candle will introduce to a scene.

- Use an open aperture—just not too open. You want the majority of the plate or glass to be in focus, so try to keep your f-stop around f/5 or higher. This will ensure a depth of field that is long enough to get everything in focus.

- Take an environmental portrait of the food. Get some background in the image to remind yourself of what was special about the location. For the shot of Italian sparkling wine and hors d'oeuvres in **Figure 6.25**, I framed the plate on an old barrel next to a Venetian canal to add a sense of place.

- Use unique angles and perspectives. Don't just shoot straight down at the plate. Move around a bit for an appetizing angle.

- Make sure your white balance is correct. When it comes to photographing food and flowers, it's very important to have a correct white balance. Check it in post-processing to make sure it looks good.

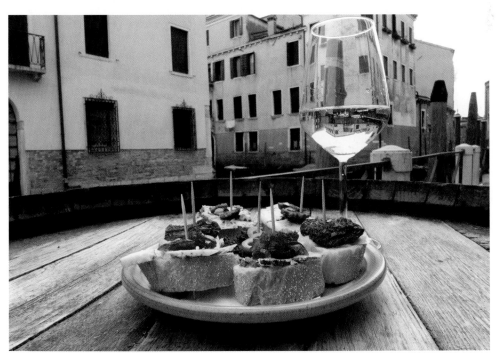

Figure 6.25
I framed this photo with the canals in the background and the reflection of Venetian architecture in the wine. Since I don't like to take my big DSLR to dinner, I shot this with a point-and-shoot camera.

ISO 100 • 1/200 sec. • f/5 • 4.7mm lens • Venice, Italy

No Flash Allowed!

Often when you're visiting a museum or at a performance, you'll be warned that flash photography is not allowed. Don't fret—you can still get the shots you want by making a few adjustments with your camera (**Figure 6.26**).

Figure 6.26
They don't allow flash photography in the Vatican Museum, so I increased my ISO to 500, put my aperture at f/4, and was able to hand-hold the shot at 1/40 sec. While the meta-data isn't perfect, I'm glad I took the shot.

ISO 500 · 1/40 sec. · f/4 · 15mm lens · Vatican City, Italy

The first thing you'll want to do is use a wider aperture to allow more light into the camera while still paying attention to depth of field. Next, you'll want to increase your ISO to make the camera's sensor more sensitive to light, thus allowing you to shoot with less available light. Today's cameras have very high ISO capabilities, but there are always trade-offs in quality. Remember, a lower-quality photo is always better than no photo at all. Typically, when I'm inside buildings with normal lighting conditions, such as a museum, I'll find myself shooting at f/4 and using an ISO of 250 to 2500. In very dark conditions, I'll increase my ISO as far as 6500. If a lot of digital noise is introduced, then I use Lightroom's noise-reduction feature to reduce the effect.

Reflections

I know many travelers aren't happy when it rains, but rain creates new opportunities for us to see a city from a different perspective. My favorite thing to do after an overnight rain is to wake up early in the morning and photograph reflections of buildings in the puddles (**Figure 6.27**). Remember our discussion in Chapter 4 about composition and our need to use a higher f-stop to guarantee a sharp image. You can also find reflections in windows, mirrors, sunglasses, and the sides of buildings. Keep your eyes peeled and you'll find them!

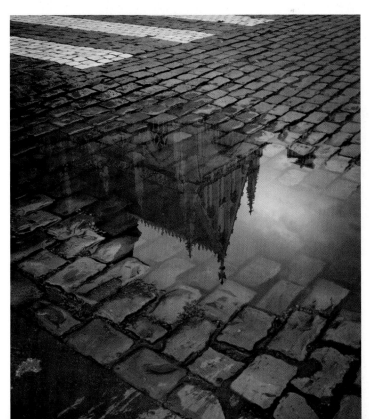

Figure 6.27 While it's never fun when it rains on vacation, you can take advantage of it: Head out shortly after the rain and search for reflections in the puddles.

ISO 400 · 1/60 sec. · f/10 · 50mm lens · Brussels, Belgium

Self-Portraits

Don't be afraid to introduce yourself into images, whether it be a shadow, a reflection, or a creative self-portrait. This is fun to do when you're traveling alone or in groups. I often take group shots of my workshop participants in a reflection to show them how to do it, and because it's fun! Self-portraits are different from selfies in that they require a more creative composition than just smiling into a camera phone (**Figure 6.28**).

Figure 6.28
I used a reflection in the Magritte Museum window to take a self-portrait.
ISO 160 • 1/160 sec. • f/7.1 • 35mm lens • Brussels, Belgium

Public Transportation

What's great about public transportation in most major cities is that, like a magnet, it attracts people who are often busy and distracted. There's a wide range of action as people hurry to catch the next train—or wait patiently for the next one (**Figure 6.29**). Then there are the people on the train or bus who are often lost in their thoughts and disconnected from the world around them.

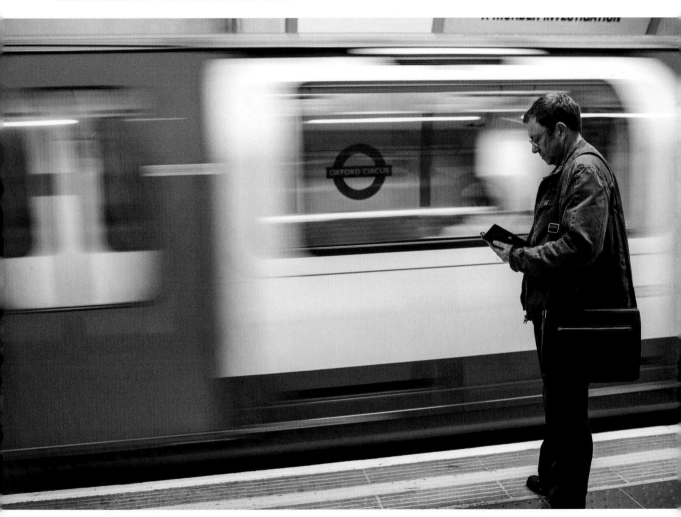

Figure 6.29 I slowed down my shutter speed so that I could capture the movement of the train speeding by this gentleman, who was distracted reading his notebook.

ISO 640 • 1/40 sec. • f/2.8 • 35mm lens • London, England

Shooting Film

Are you ready to take your street photography to the next level? Then consider switching to film. I know it sounds old school, and it seems like there's no point because no one uses film any longer, but the reality is film is still very much alive. In fact, black-and-white film has seen a resurgence in popularity.

Film teaches you to slow down and that every exposure counts. It also helps reinforce the importance of getting it right in the camera, from your exposure to your crop. My recommendation is to dig out your old 35mm, put in a roll of Ilford HP 4Plus, and go shoot 36 exposures. It's a very liberating experience and helps you appreciate what we take for granted on the digital side (**Figure 6.30**).

Many of you are probably wondering where you can get film developed nowadays. There are plenty of locations; check out my street photography page at www.johnbatdorff.com/street-photography for some locations where you can send in your film.

Figure 6.30
I love the process of shooting with film and how it allows me to slow down.

Ilford HP 4Plus film •
80mm lens •
Hasselblad medium-
format body •
Brussels, Belgium

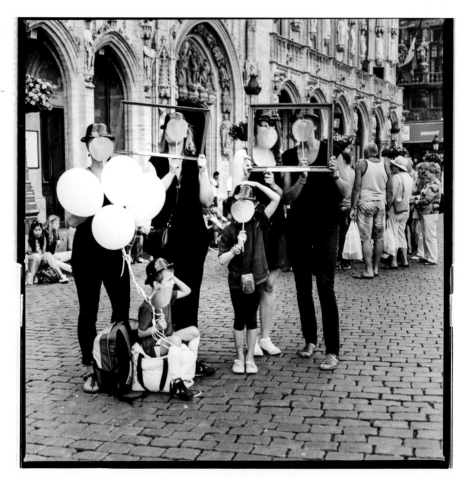

Chapter 6 Assignments

We discussed a lot of techniques for getting the most out of your city adventure, and now it's time for the homework. Here are five exercises that will better prepare you for photographing in an urban environment.

Photograph a festival

One of the best ways to break into street photography is to photograph a festival or parade. You won't be the only person with a camera in tow, and my experience has been people are very amenable to having their photographs taken. Try to capture the spirit of the event and use this opportunity to get that close-up portrait you've been wanting.

Work a location

Find an interesting background, prop, or public park and work the location, maximizing your time by capturing as many images as possible. Don't shoot and run, but stick with it until you have three to five compelling images.

Create a series

Select a theme such as public transportation, parks, street life, or architecture. Create five to ten images that help tell a story about one aspect of a place you've visited, incorporating your chosen theme into each one. Urban environments by nature are large and often hard to comprehend on a macro level, but when you narrow your focus, it makes it easier to create a cohesive story to which people can relate.

Use one lens

Spend a day shooting using only one lens, preferably a compact one such as a 35mm or 50mm. Using one lens trains street photographers to become more proficient in the field.

Shoot with film

Dust off your old film camera or borrow one from a friend. Put a roll of your favorite film in it and spend the afternoon taking pictures. Remember, this isn't digital and every frame counts, so composition matters. Once you're done, make sure you get the roll of film developed and prints made. Don't let it sit in your camera—I want you to have the full film experience.

Share your results with the book's Flickr group!
Join the group here: www.flickr.com/groups/street_fromsnapshotstogreatshots

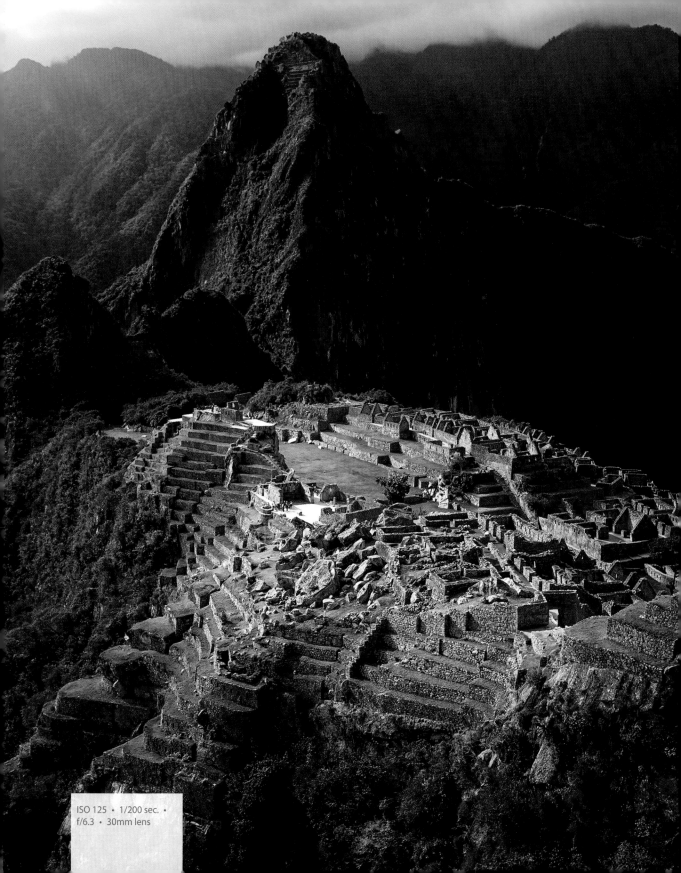
ISO 125 · 1/200 sec. ·
f/6.3 · 30mm lens

7

Landscapes, Rural Life, and Road Trips

Getting the most out of travel to the countryside

In the last chapter, we focused on the hustle and bustle of cities and streets. In this chapter, we'll shift our attention to rural destinations where landscapes and small communities are the focus. We'll cover best practices for photographing landscapes, portraits, and wildlife when traveling the countryside. Then we'll look at specific destinations such as national parks, beaches, and county fairs. Lastly, I'll give you some tips on how to make the most of my absolute favorite type of travel: the family road trip!

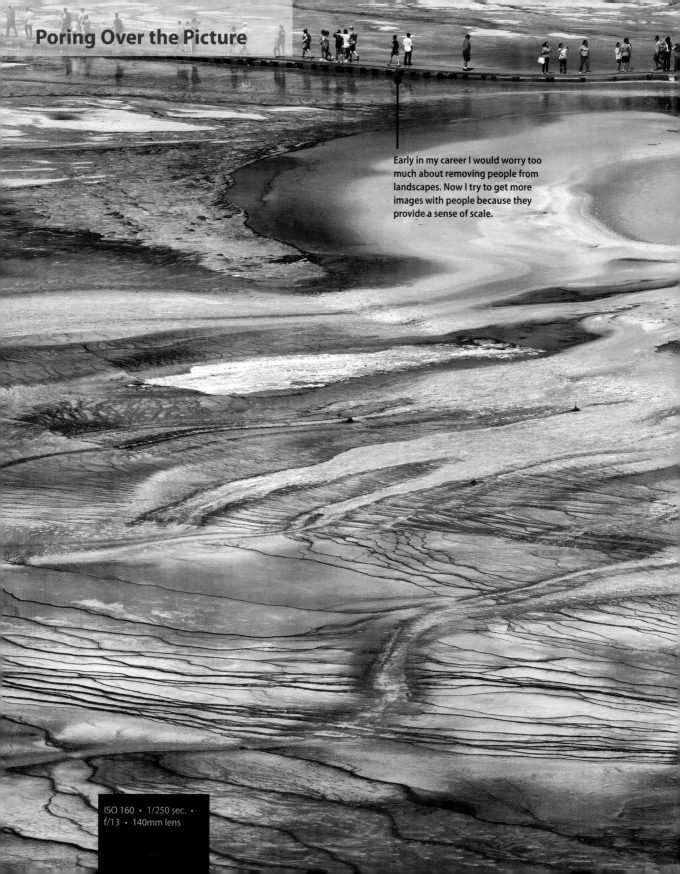

Poring Over the Picture

Early in my career I would worry too much about removing people from landscapes. Now I try to get more images with people because they provide a sense of scale.

ISO 160 · 1/250 sec. · f/13 · 140mm lens

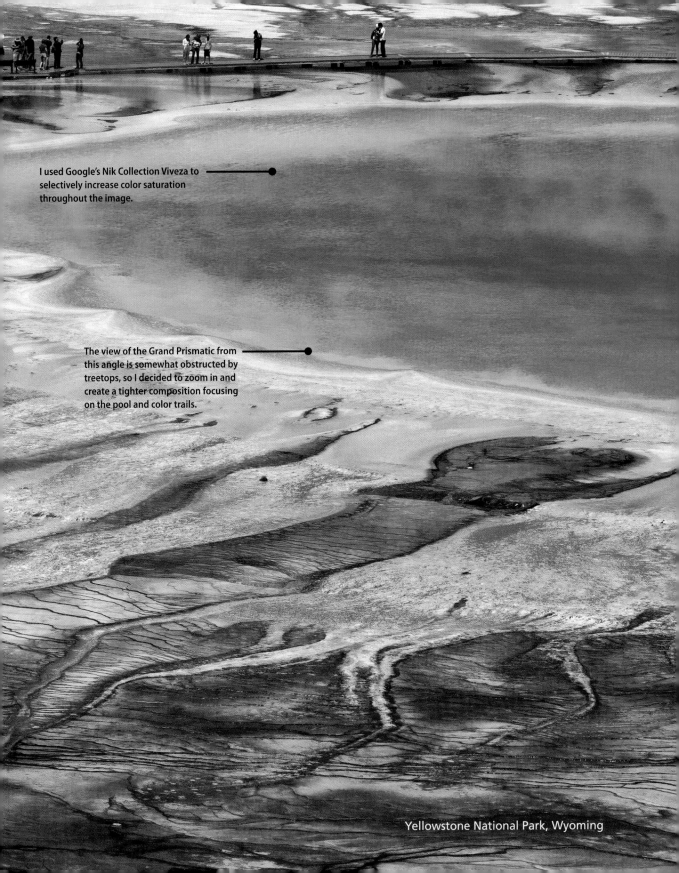

I used Google's Nik Collection Viveza to selectively increase color saturation throughout the image.

The view of the Grand Prismatic from this angle is somewhat obstructed by treetops, so I decided to zoom in and create a tighter composition focusing on the pool and color trails.

Yellowstone National Park, Wyoming

Landscapes

When I think of travel to a rural area, what immediately comes to mind is huge, sweeping vistas of mountains, a lone tree against the backdrop of an endless field, or a rainbow across a giant blue sky. Nothing's more thrilling than capturing these moments with a camera. Landscape photography is something many of us enjoy, so it pays to learn the skills necessary to get great shots while traveling. When planning for and getting great landscape shots, some of the basic things to think about are the best times to photograph, observing the weather, and selecting the proper gear. Once you've considered those factors, it's all about getting to the right place at the right time and nailing the shot!

The Golden Hour

Timing is everything in photography, and while you may not think of landscapes as rapidly changing, the light that shines on them can change very quickly. If you've ever read anything about photography, you've probably heard about the golden hour, around sunrise and sunset. The golden hour is a special time of the day when light is coming from a low angle to the landscape, providing a soft light that creates shadows, produces beautiful colors, and adds depth and character to any image (**Figure 7.1**).

Figure 7.1
I took this image of the sun setting at Badlands National Park at 6:25 p.m., during the evening golden hour.

ISO 100 • 1/10 sec. • f/12 • 16mm lens • Badlands National Park, South Dakota

Professional landscape photographers know that the golden hour typically is the best time to shoot landscapes. In fact, many landscape photographers will plan their entire day around the golden hour, waking up several hours before sunrise, then spending the afternoon scouting locations only to catch a few winks of sleep before heading out to photograph the sunset.

Whenever I'm planning a trip, I try to arrange my overnight locations based on a good sunrise or sunset opportunity. This usually requires research to determine the exact sunrise and sunset times. As I mentioned in Chapter 2, "Planning the Journey," there are a number of planning tools that can help you determine the exact sunrise and sunset times anywhere in the world. Many free smartphone apps are available to help track sunrises and sunsets, but my favorite is a paid-for app called LightTrac, which allows me to save locations for future reference (**Figure 7.2**). Many websites also offer a free sun calculator, such as www.timeanddate.com or suncalc.net.

Figure 7.2 Using a sun calculator simplifies planning for sunrise and sunset.

Active Skies

Blue skies are beautiful and very peaceful, but when it comes to landscape photography they can be the equivalent of boring. When clouds or storms enter the scene, things become very dramatic—and that's when I get really excited about landscape photography (**Figure 7.3**). Don't get me wrong, you need to make the best of the weather conditions you're in, but if you see a storm brewing or clouds forming, take advantage of the moment. This advice is especially true during the golden hour, because clouds can create a very dynamic sunrise or sunset with amazing colors. Pay close attention to the direction of the clouds: Those coming from the east might block a sunrise, and clouds from the west might block a sunset. During this time, look for opportunities where the clouds might break, allowing rays of sun to pierce through the frame.

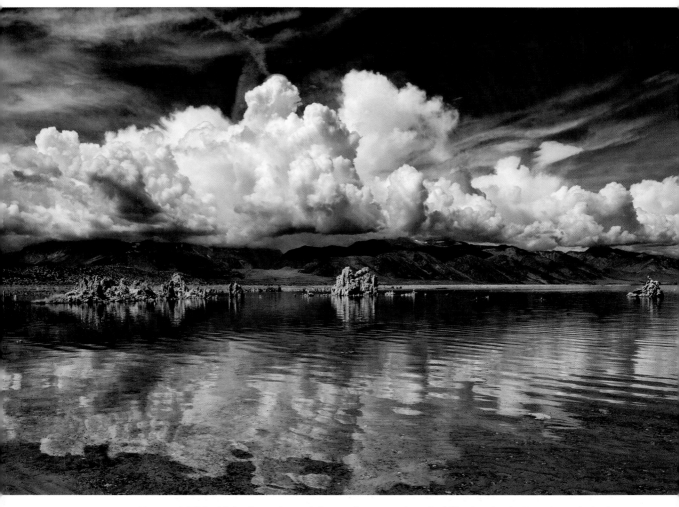

Figure 7.3 While this landscape is certainly stunning at any time, the billowing clouds rising above the horizon and their reflection on the water brought even more drama.

ISO 160 • 1/1000 sec. • f/9 • 24mm lens • Mono Lake, California

Gear Suggestions

While we discussed gear quite a bit in the two previous chapters, here we'll discuss the specific types of gear you'll need for landscape photography. Typically you want a sturdy tripod, a cable release, filters, and a wide-angle lens. But there may be times when you don't have a tripod available, so we'll go over techniques for shooting with and without one. We'll also discuss the pros and cons of using filters for your landscape work.

No-tripod solutions

As discussed in Chapter 1, the best practice for getting tack-sharp images is using a sturdy tripod. Tripods are essential for reducing camera shake and will greatly reduce the movement caused from vibration or wind. However, I realize not everyone will have a tripod on them at all times, in which case I recommend finding a stable surface where you can rest your camera. Horizontal surfaces such as picnic tables, fences, or even your car work great.

If no such surfaces exist, make the best of what's available. Use your body to stabilize your camera by bracing yourself against a building or leaning your camera against a post, adding pressure to keep it stable. If your lens has image stabilization/vibration reduction, make sure it's turned on. Another trick is to place the camera strap around your neck, turn on Live View mode (discussed later), and push the camera outward until there's tension while using Live View to frame the shot. Keep in mind that, depending on the available light, you may need to break the rules and increase your ISO to reduce camera shake as a result of freehand shooting.

Shutter release

There are a number of ways to fire a shutter remotely, including using cable releases and wireless devices. Remote shutter releases reduce camera shake introduced by our hands touching the camera. I use a cable release because it's predictable, inexpensive, and very compact, making it easy to pack and take with me on all my trips. Plus it doesn't need batteries, so I don't have to worry about it going dead when I need it most. In the absence of a cable release, I recommend using your camera's self-timer as an alternative to firing the shutter manually.

Filters

There's a misconception that because we can do everything we need to do in Adobe Photoshop or Lightroom, there's no need to use filters in the field. While digital image manipulation has reduced our dependence on filters, there are still plenty of times when you'll need a filter to create a proper exposure or get a desired effect.

Here are my three essential filters:

- **Graduated ND filter.** A good ND filter is necessary for exposing landscape images correctly when the foreground and background require different exposures. For instance, in **Figure 7.4**, the sky was very bright and the foreground much darker. If I had taken this photograph without my ND filter, the image would have appeared either too dark (as the camera compensated for the bright sky) or too light (as it compensated for the dark foreground). I also could have adjusted the exposure compensation to help split the difference, but getting the effect of a darker sky with a properly exposed foreground was best achieved with an ND filter.

Figure 7.4
I took this image under a very bright African sky. I added an ND filter to help darken the sky and to bridge the gap between the exposures required by the foreground and the sky.

ISO 160 • 1/640 sec. • f/5.6 • 24mm lens • Amboseli National Park, Kenya

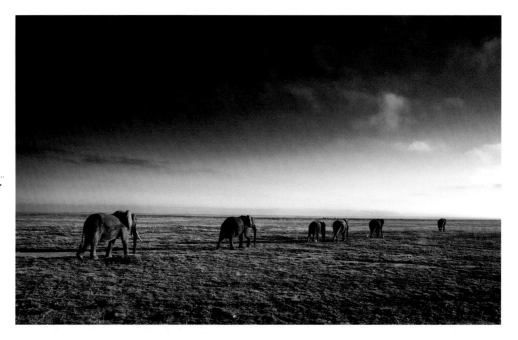

- **Polarizing filters.** A polarizing filter works great when you need to remove reflections from windows or glare off water, reduce a hazy sky, or simply saturate the colors in a scene. The best time to use a polarizer is during midday, when it can be used at 90 degrees from the bright sun. To better understand what areas of the frame will be affected, point your index finger at the sun with your thumb extended, making an L shape, then rotate your wrist while keeping your index finger pointing at the sun. Wherever your thumb points is where the filter will have its maximum effect. Keep in mind, the reason this filter works best in bright light is because you use lose 1.5 to 3 stops of light when it's on your lens. Make sure to remove it when the sun starts going down. You'll also want to keep track of your shutter speed, making sure it hasn't become unacceptably slow if you want to maintain the same ISO and aperture.

- **UV or skylight filters.** Use a UV, haze, or skylight filter to protect your lens against dust, moisture, and scratches while reducing hazy skies. Different filters may have slightly cooler or warmer tones. Do you really need a protective filter? It really depends on the individual. Camera equipment is expensive, but I also understand photographers who don't want anything in front of their expensive glass. I was once leading a workshop in Death Valley and watched a client drop a $1500 lens. I heard what sounded like glass breaking from nearly 30 feet away and thought for sure the lens was a goner. The only thing that shattered was her $10 filter; the lens was unscathed. If you do get a UV filter, I strongly recommend buying one that is multicoated to reduce lens flare and prevent scratching.

Purchasing a Polarizer

Before you buy a polarizer, you should be aware that there are two types of polarizing filters: circular and linear. These designations do not refer to the filter shape but instead to the way light passes through the filter. Most autofocusing cameras, including DSLRs and mirrorless, require a circular polarizer because the linear polarizer could interfere with the camera's metering system. Manual-focusing cameras and older models of cameras can use a linear polarizer. Before purchasing a filter, check with your camera manufacturer to confirm which one is best for your model. When in doubt, buy a circular polarizer because it will work on both systems.

Landscape Techniques

I discussed composition in detail in Chapter 4, "Composition." Here I will explain specific techniques for composing and shooting landscapes.

Rule of thirds

Remember, your goal is always to photograph with intent, and using the rule of thirds (introduced in Chapter 4) helps you construct a thoughtful frame. This is especially important during sunset and sunrise, when photographers struggle with choosing whether the foreground or sky is more important. Instead of intentionally choosing, many photographers often end up splitting the horizon (across the center of the frame) without realizing it and creating a shot that isn't pleasing to the eye. Use the rule of thirds and place the foreground in the bottom third of the frame with interesting elements placed at intersections of the grid.

Manual focus

When you're shooting from a tripod or stable surface, I recommend turning off autofocus and using manual focus. This prevents the camera from refocusing prior to you pressing the shutter. Refocusing can be a problem when light is changing quickly, such as during sunset or sunrise, and your camera's autofocus gets confused trying to refocus as the contrast in the scene changes. By turning off the autofocus, you eliminate this possible error. I know many of my clients don't trust their eyesight and rely heavily on the focus beep from the camera, so turning off the autofocus is scary. My suggestion is to use autofocus to establish your proper focus, then carefully turn off autofocus, avoiding nudging the lens out of focus. Another great solution is to use Live View mode, which I'll discuss soon.

VR lenses and tripods don't mix

Some of you may have lenses with vibration reduction or image stabilization, which are very helpful when freehand shooting or in conditions where it's difficult to hold the camera steady (**Figure 7.5**). However, if your camera is on a tripod or a stable platform, I recommend turning off this feature. Vibration reduction, while trying to minimize camera movement, actually creates movement in the lens when the camera is already stable. Locate the VR or IS feature on your lens and slide the switch to the off position. Remember to turn vibration reduction back on once you remove the camera from the tripod.

Figure 7.5 **If your lens has a vibration reduction or image stabilization feature, make sure it's turned off when using a tripod so you don't introduce movement into your frame.**

Mirror lock-up

You place your camera on a tripod to create a stable environment and to reduce, if not eliminate, camera shake. But, even on a tripod, cameras can create their own movements, either from the lens using vibration reduction or from the camera itself. In DSLRs, the mirror reflects the image from the lens to the viewfinder, but in order to record the image onto the sensor the mirror must first move out of the way. This movement by the mirror can introduce vibration with longer zoom lenses, and the vibration can cause a significant loss in sharpness. Because of this risk of movement, landscape photographers place their DSLRs in "mirror-lock up mode." If you're unfamiliar with this mode, I suggest reviewing your camera's manual to learn how to set it. Once the camera is in mirror lock-up mode, press the shutter release once to move the mirror up and a second time to take the image (this sequence may vary by camera model). Remember, you'll want to turn off this feature once your camera is off the tripod.

Live View

Years ago I remember saying, "What the heck will I be using this Live View mode for?" But now I find myself using it all the time when photographing landscapes. I often turn my camera to manual focus and use Live View to focus, using the zoom feature to check for sharp focus throughout the frame. Live View can be very handy when evaluating exposure, focus, and composition. Most cameras allow you to activate a grid in Live View so that you can compose your image using the rule of thirds. Another advantage to using Live View (for many cameras) is it eliminates the need to place the mirror in lock-up position, as mentioned above, prior to taking a photo. Some cameras may still require mirror lock-up mode even when you're in Live View, so check with your camera manufacturer.

Place your focus

Large landscape scenes are fun to photograph, but they can present a problem: Where exactly do you focus when you want everything to be sharp? You'll need to concentrate on how to create an image that is tack sharp with a depth of field that renders great focus throughout the scene.

A tripod provides the stability needed for handling longer shutter speeds with smaller apertures. To create a greater depth of field, you will need a smaller aperture such as f/16 (see Chapter 3, "Finding the Light"). Most of my landscape work is shot in Aperture Priority mode with ISO 100 for clean, noise-free images. The combination of the low ISO and higher f-stop means the camera's shutter may need to remain open longer for a proper exposure.

However, shooting with the smallest aperture on your lens doesn't necessarily mean you will get the proper sharpness. The key is knowing where to focus to maximize the depth of field for your chosen aperture. To determine this, you need to know your lens's hyper focal distance.

Hyper focal distance (HFD) is the point of focus that will give you the greatest acceptable sharpness, from the minimum focusing distance all the way to infinity. If you combine good HFD practice with a small aperture, you will get images that are sharp from foreground to background.

There are a couple of ways to do this. The easiest way is the one that is most widely used by pros. When you have your shot all set up and composed, focus on an object that is about one-third of the distance into your frame (**Figure 7.6**). It is usually pretty close to the proper distance for HFD and will render favorable results. When you have your focus set, take a photograph and then review the image on the camera's LCD to check for sharpness. If your camera allows, zoom in to make sure you're tack sharp.

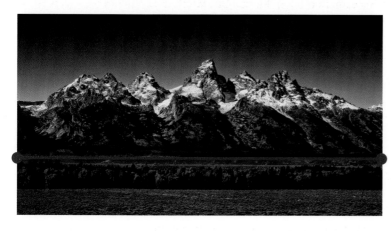

Figure 7.6
In this image of the Tetons, I focused on the fault line that runs approximately one-third of the way into the frame. This gave me sharpness through the entire frame.

ISO 160 • 1/125 sec. • f/19 • 35mm lens • Grand Teton National Park, Wyoming

One thing to remember is that as your lens gets wider in focal length, your HFD will be closer to the camera's position. This is because the wider the lens, the greater the depth of field you can achieve. This is yet another reason why a good wide-angle lens is indispensable to the landscape photographer.

Advanced Landscape Techniques

Let's explore some more-advanced techniques and effects. HDR (or high dynamic range) photography is a technique that many photographers use when they want extreme detail throughout the scene, especially in mixed or difficult lighting. If you don't have your ND filter with you, HDR can help solve the problem of a dark foreground and a bright sky. I'll also give you some tips on getting a silhouette, a technique that's fun to use against the backdrop of a sunrise or sunset. Lastly, I'll tell you how to make a sunburst, another unique effect.

HDR

Human eyes can see roughly 20 stops of light, which means we can see detail in very dark shadows and very bright whites. A typical camera can record only 6 stops of light, so in a single frame the contrast that it's recording is much less than what we can see with the naked eye. High dynamic range photography is the technique of capturing several exposures at varying degrees of brightness and using software to blend them together and reveal more detail in the shadows and highlights (**Figure 7.7**).

I have found people either love or hate HDR, but regardless, it's a wonderful way to understand the effects of exposure on an image. HDR works best when an image lacks vivid colors and when you're not trying to capture motion. Also, many of today's stock landscape photographs are created using HDR or similar techniques, so it's a good process to become familiar with if you plan on selling your work to a stock agency.

A number of software applications allow you to combine images and then merge them into a single HDR. I will not be covering the software in detail but instead exploring the process of shooting a scene. Please note that a tripod is an essential tool for this technique, since you need to have perfect alignment of the images when they are combined.

A side note: Some cameras have true built-in HDR functions where you select the HDR setting and it presets the camera for three exposures (-1, 0, +1). Other cameras have an HDR button, but it creates what I call a faux HDR: The camera creates a tone-mapped effect that mimics an HDR, but it's not truly an HDR. If your camera has an HDR button, check your manual to determine which method your camera uses. You can also try both methods to see which one you prefer before committing to a particular process.

Figure 7.7 To my eyes, this scene had lots of foreground texture and a sapphire-blue sky, but this wasn't coming across in my image. Thus I made an HDR image to capture what I saw. These frames were taken with -2, 0, and +2 exposures. The combined HDR image is last.

ISO 100 • 1/60 sec., 1/15 sec.,1/4 sec. • f/20 • 24mm lens • Madison Valley, Montana

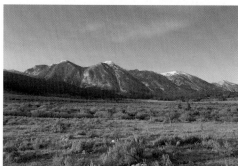

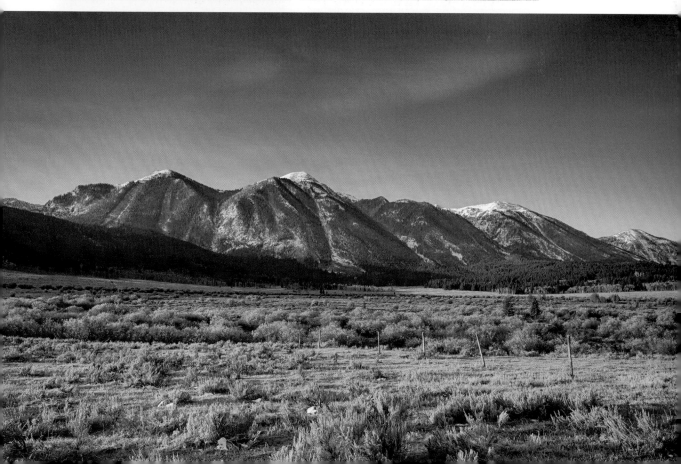

Here's how to set up and capture an HDR image:

1. Set your ISO to 100 to ensure a clean, noise-free image.

2. Set your camera to Aperture Priority.

 You will be taking three photographs in rapid succession, creating an overexposed image, an underexposed image, and a correctly exposed image. The camera will adjust the shutter speed while leaving your aperture alone so you have a consistent depth of field.

3. Set your camera file format to RAW (if it's not already).

 This is extremely important because the RAW format contains a much larger range of exposure values than a JPEG file, and the HDR software needs this information for optimal performance.

4. Change your shooting mode to Continuous Drive.

 This will allow you to capture your exposures quickly. Even though you will be using a tripod, there is always a chance that something within your scene will be moving (like clouds or tree leaves).

5. Adjust the Auto Bracketing (BRK or AEB) mode to shoot three exposures in two-stop increments. Check your camera's manual to determine how to set this feature.

6. Focus the camera, switch off the autofocus, and turn off any vibration reduction/image stabilization.

7. Use a cable release to fire three consecutive images.

8. Remember to turn off your autobracketing when you're done photographing in HDR. Depending upon your camera model, it might continue bracketing all your future exposures if you fail to turn off this feature.

HDR Software

Plenty of programs will create HDR images, such as Adobe Photoshop, Photomatix Pro, or (my favorite) Google's Nik Collection HDR Efex Pro 2. You can learn more about using this software online or in books. To learn about HDR Efex Pro 2, check out my book *Plug In with Nik* (Peachpit Press, 2013).

Silhouettes

Silhouettes are fun, creative, and relatively easy to photograph during the golden hour. To create a silhouette, you need a backlit subject that is clearly separate from the background (**Figure 7.8**). Then follow these steps:

1. Meter the brightest part of the frame by pressing your shutter button halfway while placing your focus point in a bright part of the frame, usually the sky.

2. Recompose your frame while keeping the shutter button pressed halfway or by using your camera's exposure lock.

3. Press the shutter the rest of the way to take the photo.

 Your subject should be nicely silhouetted. If you find that your subject isn't dark enough, I recommend changing your metering mode to spot metering and repeating the process.

See Chapter 3 for more on metering. You can also use exposure compensation to create a darker silhouette by adjusting your exposure down one or two stops.

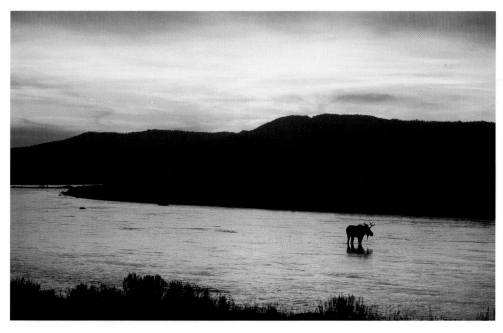

Figure 7.8
I had scouted for moose along the Henrys Fork River several times. On this night, the sunset was really active, so I decided to silhouette the bull moose against the bright orange background.

ISO 100 · 1/200 sec. · f/5 · 100mm lens · Island Park, Idaho

Sunbursts

A sunburst or starburst effect is when you take a photo with a bright light, such as the sun or a bright streetlight, and create the look of rays coming from the light (**Figure 7.9**). Sunbursts can add a dynamic element to a sky or the object off of which it's reflecting. The effect is created as a result of restricting the amount of light coming into the lens. As the aperture blades begin to close down in the lens diaphragm, the light bends or refracts, creating what are known as spikes.

The trick to creating a sunburst is to use a very high aperture such as f/16 (or higher) with a wide-angle lens. The wider the angle of the lens, the larger the sunburst will become. If you're creating a sunburst in the sky and find the sky is slightly washed out, dial your exposure compensation to -1 stop; this should darken the sky and make the sunburst very dramatic.

To get the most out of your sunburst, you'll want to make sure the sky is clear. It's also nice to place the sun in an interesting spot in the frame, usually just peeking over the edge of an object or the elbow of a tree branch.

Lens flare

Lens flare, which occurs when you are shooting toward the sun, is different from a sunburst in that it creates a trail of light artifacts coming through your image (**Figure 7.10**). Intentional lens flare seems to be back in vogue as vintage photography has made a comeback, but for our purposes, I'll discuss how to *avoid* it. If you wish to use it creatively in your composition, just do the opposite of these steps:

1. Try to shoot with the sun coming from over your shoulder, not directly in front of you or behind your subject.

2. Use a lens shade or hood to block unwanted light from striking the lens.

 You don't have to have sun directly in your viewfinder for lens flare to be an issue. The sunlight just has to strike the front glass of the lens at an angle to create flare.

3. Use a multicoated lens or filter to help reduce the flaring.

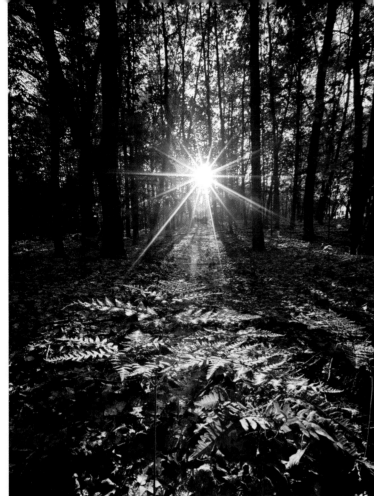

Figure 7.9 I was out walking in the woods in my hometown when I decided to capture the sun beaming through the trees with a sunburst effect.

ISO 200 · 1/50 sec. · f/14 · 16mm lens · Big Rapids, Michigan

Figure 7.10 While attempting to create a sunburst shot, I also got some lens flare in my image. While it doesn't look terrible, it certainly wasn't intentional. I could have reduced the flare by using a hood or not shooting directly at the sun.

ISO 400 · 1/400 sec. · f/14 · 15mm lens · Valley of Fire, Nevada

Local Flavor

The trick to getting any decent photo is truly being interested in the subject, and this is especially true when you're in a rural community. Here are some best practices for photographing strangers, capturing the heart of a community, and creating a cohesive story that resonates with your viewers (**Figure 7.11**).

Figure 7.11 En route to Death Valley, I asked this gentleman if I could take his photo. He agreed, but he was a tough negotiator—I had to purchase a pocketknife from him.

ISO 320 · 1/125 sec. · f/9.5 · 35mm lens · Beatty, Nevada

Understanding Your Environment

The key to connecting with people in any community is understanding a little bit about their heritage and expressing a sincere interest in learning more. Try to do research prior to visiting a place so you know the right questions to ask when chatting with people. It's like attempting to speak a foreign language when you're traveling abroad—the locals appreciate the effort, no matter how poorly the words come out. And I find that the smaller the community, the greater the appreciation.

Portraits

While there are some cultural differences to consider when approaching locals in a rural community, the same techniques apply to photographing people in the city. Since we discussed these techniques at length in Chapter 6, "Cities and Streets," we'll jump right into cultural considerations, and how to look for and find a good portrait to capture the local flavor.

Some of the easiest portraits to take when visiting a small community are of local merchants (**Figure 7.12**). Storekeepers are very accustomed to visitors taking their photograph, especially in locations that are heavily visited by tourists. Of course it's always proper etiquette to ask before taking a close-up portrait, especially if you're in someone's place of business.

Remember, as I noted in Chapter 8, "The Legalities," research the local laws and customs, maybe reaching out to regional photographers or guides to get advice on the best ways and places to take portraits. City folks are not the same as country folks, and what might be socially acceptable behavior in Chicago could very well land you in a bed of hot coals in rural Montana. Knowing your rights keeps you out of jail, but knowing acceptable social limits keeps you out of the hospital!

Figure 7.12 **After chatting with this man about his sugar gliders at a county fair, I asked him for his photo. He was happy to oblige.**

ISO 640 · 1/125 sec. · f/6.7 · 35mm lens ·
Gallatin County Fair, Montana

Environmental Portraits

In a rural setting, an environmental portrait can tell a compelling story, giving insight into the subject's life. An environmental portrait can be difficult because often our time with the subject is very short, but it's critical to make a connection and reciprocate in the interaction versus simply taking photographs and walking away.

The technique I use is to begin a conversation and get to know the person. Once I feel the subject is warmed up enough, I'll ask to take a few photographs, all the while talking to the person while I'm photographing. As long as the conversation is flowing naturally, I find the person will give me more time to capture the images I'm looking for. Of course the key is not overstaying your welcome. My exchanges don't last for longer than five minutes, sometimes a bit longer depending upon the circumstances. In this time I try to get at least one close-up portrait and a wider portrait showing the subject in his natural environment (**Figure 7.13**).

Figure 7.13
I met this cowboy while he was warming up to ride the bulls at a Fourth of July rodeo. After talking a bit, he allowed me to take his photo.

ISO 100 • 1/320 sec. • f/8 • 85mm lens • Ennis, Montana

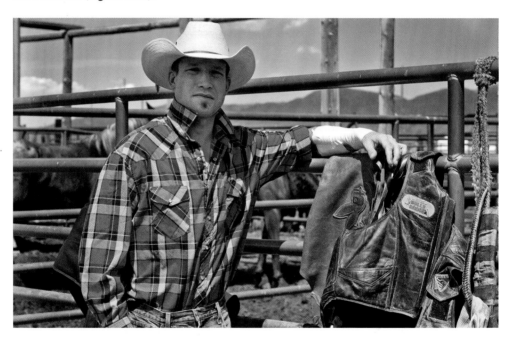

Five tips for great rural portraits

1. **Don't be afraid.** It's hard to take portraits of people if you're afraid of them. The trick is realizing the worst thing you're going to hear is "No." If you don't ask, you'll never know, and the more you practice asking, the more confident you'll become in doing so.

2. **A smile goes a long way.** I know it sounds simple, but smiling breaks through a lot of cultural barriers and disarms people. Often I'll start with a smile, then ask a question or simply motion with my camera if it's okay to take a photograph. Nine out of ten times I get the okay.

3. **Learn to compliment people.** Take note of something that's unique about the person and tell him or her. It can be an outfit, eyes, or simply the person's attitude. Paying someone a sincere compliment can open the doors to a nice portrait opportunity. Most people just want to look good in photos, so knowing that your intention is to show them in a positive light will help people open up.

4. **Work in teams.** If you're not a people person but love taking portraits, you need to partner with someone who's excellent with people.

5. **Use a long lens.** As discussed in Chapter 5, "Observation vs. Engagement," there are benefits to using a long lens—to avoid interaction, to catch people in their natural state, or to capture images you just wouldn't be able to otherwise. Plus a long lens will compress the background behind your subject and create a nice bokeh effect.

Wildlife

Unless you like taking photos of pigeons, you'll probably need to be out in the country to photograph wildlife (**Figure 7.14**). Serious wildlife photography is a subject for its own book. If you're on a trip and you see a lion, tiger, or bear, you're going to want to get a great shot! Much like landscapes, when photographing wildlife, you'll need to consider the time of day, the season, and your gear.

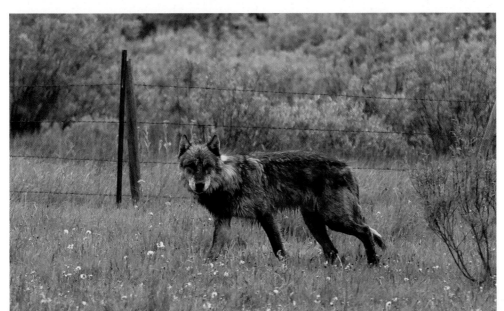

Figure 7.14
I saw this wolf traveling alone just outside of Yellowstone National Park. It's very rare to see wolves, so if you see one, make sure you get a shot!

ISO 500 • 1/320 sec. • f/7.1 • 200mm lens with 2x extender • Yellowstone National Park, Idaho

Time of Day

While the best time for viewing and photographing wildlife very much depends on the species, there are some general rules to follow. Unless you're out trying to photograph a nocturnal species, the best time of day to see and photograph wildlife is morning and evening. Typically animals are most active when it is cool and when bugs are less likely to bother them. The good news is that just as the golden hour is the best time to capture landscapes, it's also the best time to capture wildlife. The warm, directional light that the sun gives off after dawn and before dusk is also great for showing animals in their best light.

Seasons

Some people head to Yellowstone in the dead heat of summer expecting to see a lot of animals, only to complain later that they didn't see anything. For instance, much like this Chicagoan, elk hate the heat and escape to the higher elevations during the summer, coming back down in the fall. This is also the time to capture many animals in the rut, also known as breeding time. The males are typically showing off their full-antlered selves during this time as they're trying to impress the ladies. In the spring, you're likely to see animals coming out of hibernation, many with their young. Knowing the seasonal patterns of the wildlife you want to photograph is critical to meeting your expectations, so do your homework.

Gear Suggestions

The equipment you need for photographing wildlife can be quite different from what you're accustomed to using in your street or landscape work. Often, wildlife photographers use long zoom lenses that allow them to capture great detail without interfering with or distressing the wildlife. As you can imagine, these long lenses require very sturdy tripods to help minimize camera shake, and as a general rule the smaller the animal, the larger the lens. People who photograph birds, often called "birders," know what it means to need a long, fast lens (and a tripod) to capture their feathered subjects' every little detail (**Figure 7.15**).

Figure 7.15
Since I didn't have a zoom longer than 200mm, I used an extender to get close enough to this mountain bluebird. That meant I lost some light, so I had to bump my ISO higher to keep my shutter speed fast enough to prevent blur.

ISO 640 • 1/400 sec. • f/6.3 • 280mm lens • Madison County, Montana

Flowers and Local Plants

When you're traveling to a rural location, don't forget to stop and shoot the roses! Plants vary so much from one ecosystem to another, and it's fun to capture unique flowers and plants that you don't see at home (**Figure 7.16**). Just as with wildlife, you'll need to consider the season in which you're traveling so you know what's in bloom and have the right gear to get the shot.

Seasons

While wildlife movements are relatively predictable, short blooming seasons and changing autumn colors can be very difficult to plan around. I love to shoot Montana's aspen trees in the fall: The blue skies, beautiful golden-yellow leaves, and grey mountains always make a gorgeous landscape shot. Last year I timed my trip out west around peak color time. The problem was an early snowstorm knocked down all the leaves and left a foot of snow on the ground. I was able to find other fall colors in the area, but I was disappointed that I missed out on the aspens (**Figure 7.17**). If you're planning a trip around capturing a certain bloom or fall color change, give yourself plenty of time and follow the local weather closely.

Figure 7.16
I've never seen an ice plant in the Midwest, so I thought it would be beautiful to photograph these flowers blooming along the California coast.

ISO 100 · 41 sec. · f/20 · 16mm lens · Northern California coast

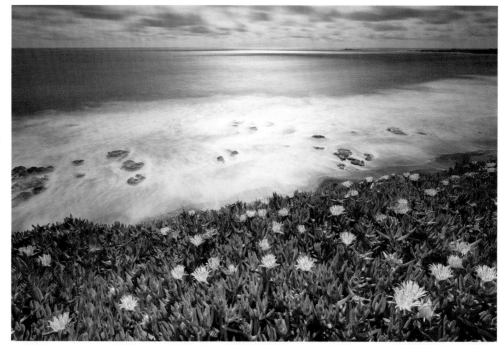

Figure 7.17
When an early snowstorm spoiled my plans to photograph Montana's aspens, I found this beautiful understory that was in its full autumnal glory near Cliff Lake.

ISO 100 · 1/40 sec. · f/16 · 15mm lens · Madison County, Montana

Gear Suggestions

If you plan on taking very tight macro shots, I strongly recommend a tripod, a lens that allows you to photograph 1:1, and a lot of patience. There are many books on macro photography, but you don't have to become a specialist to get great flora photographs. I've seen beautiful images of flowers taken with mobile phones and point-and-shoots. But no matter your devices, the key to getting a great shot is excellent composition.

Five tips for shooting flora

1. **Get up close.** Fill the frame with one object such as the head of a flower, or even one petal or a raindrop.

2. **Isolate.** Separate one flower or plant from the rest, and make good use of negative space. You can isolate your focus on one flower using a shallower depth of field so that it appears to be one of many (**Figure 7.18**).

3. **Change your point of view.** Get low to the ground for a different perspective. Also, wait for a bug or other creature to pass through to add interest to your photo.

4. **Use a shallow depth of field.** Use a wider aperture such as f/2.8 to 3.5 to create a very shallow depth of field. Remember, when using a shallow depth of field, make sure the camera's focus point is on the area where you want your focus. Your depth of field can be millimeters deep in these close-ups, so be careful, move slowly, and take lots of shots.

5. **Avoid harsh sun and windy days.** Flowers and plants usually look their best under the soft glow of the golden hour, and when the wind isn't whipping them around. Keep track of the weather, and go out early morning and late evening for best results.

Figure 7.18
I isolated one tulip out of many and created a bokeh, or blurred, background using an open f-stop with a short depth of field.

ISO 125 • 1/320 sec. • f/4 • 35mm lens • Holland, Michigan

Specific Destinations

Rural travel creates opportunities to visit some very specific areas, such as national parks, monuments, county fairs, and carnivals. Whether it's a famous park like Yellowstone, a small county fair, or the Taj Mahal, there are some specific things to consider when photographing these unique places.

National Parks and Monuments

Chances are, whether you travel internationally or domestically, you'll spend some time visiting a national park or monument. There's a reason these places draw millions of visitors each year: They're rich in history and often very photogenic (**Figure 7.19**).

Figure 7.19
The Grand Prismatic is one of America's most recognizable national park features. To get this shot, you have to hike up high enough to get a different perspective.

ISO 160 · 1/250 sec. · f/13 · 140mm lens · Yellowstone National Park, Wyoming

I admit, I'm not a fan of huge crowds or "bad tourists." But chances are, if you're planning on photographing popular locations, you'll need to learn to deal with the hordes and adapt your shooting style. Here are a few recommendations on how to get the images you want while avoiding crowds:

- **Arrive early.** Generally speaking, tourists are on vacation and enjoy sleeping in. So if you can arrive early, often you'll beat the tour buses and droves of people.

- **Venture off the beaten path.** When possible, take the road less traveled. For instance, in Yellowstone many travelers never get out of their cars—they simply photograph from their windows or wait until they have lunch to venture out on designated paths.

Look for hikes or seasonal features that are off the beaten path. Just make sure to follow any rules and safety guidelines the rangers provide.

- **Get close and work the angles.** Sometimes it's about getting a different perspective than everyone else, so get closer to the subject you're looking to photograph and try to get a different angle (unless it's wildlife—then you'll want to keep your distance). Get down on the ground, move around, look behind you…. There's a lot to see if you're looking for it!

- **Use people to tell a story.** Don't worry about the fact that they're tourists. Think of yourself as a reporter trying to capture tomorrow's feature photo. Wait for the right moment and compose your frame with people in it to help you tell a story and add scale.

County Fairs and Carnivals

Who doesn't love a fair? In my hometown the 4-H fair was the biggest event of the summer, so to this day I still seek out county fairs wherever I travel—and, in some cases, plan my travels around them. Fairs and carnivals are filled with photographic opportunities ranging from rides and games to children tending to their animals and performers walking the strip. Whenever I plan a trip, I check with the local chamber of commerce or visitors' bureau to see if any fairs or carnivals will be taking place. These colorful events provide a different perspective of a community as well as wonderful photographic opportunities (**Figure 7.20**).

Figure 7.20
Last year my family and I explored Montana's Gallatin County Fair, which was a blast to attend—and to photograph.
ISO 400 • 1/500 sec. • f/8 • 35mm lens • Bozeman, Montana

The Family Road Trip

One of my favorite things to do is pack up the car, have the family pile in, and head west to our cabin in Montana. The drive takes nearly three days and covers 1500 miles through five states and some of the most beautiful countryside in the United States. Three people and three dogs tightly packed into a Subaru might not seem that glamorous or conducive to travel photography, but the reality is the family road trip is still how many of us see the world around us.

Over the years I've had the opportunity to capture some beautiful images with my family in tow, but I can't monopolize their time with my photography, or there would be mutiny! Here are five tips to getting the shots you want while keeping friends and family happy:

1. **Plan the trip.** I like to plan road trips so we arrive a few hours early. That way I can explore an area with my family, then set up for a nice sunset or plan a very early morning sunrise shoot while the family is still asleep.

2. **Have your camera ready.** Your camera should be packed in a smaller kit and readily accessible so you're not digging through a packed car when a photo opp arises. Make sure you've packed the lenses that suit the destination. For example, if you're in Yellowstone, make sure you have the zoom. If you're at the Grand Canyon, a wide-angle will serve your creative needs well. Don't forget to take your camera everywhere, even if you're just stretching your legs.

3. **Be location smart.** Select locations that have enough for everyone to do, or destinations that interest the entire family as well as provide photographic opportunities.

4. **Stop shooting.** Remember when to put down the camera and just enjoy the time with your family. I still have to remind myself of this one on occasion. Being present is also sometimes tantamount to getting the shot!

5. **Consider bribes and ice cream.** Most important, when necessary, grovel and bribe. "Ice cream for everyone if you'll just let me stop here for one last photograph!"

Chapter 7 Assignments

Now it's time to get out and put your new skills to work.

Practice learning your lens's hyper focal length

Pick a scene that has objects in the foreground and an object that is clearly defined in the background (for example, rocks in the foreground and a tree in the background). Try using a wide to medium-wide focal length for this exercise, such as 18–35mm. Use a small aperture and focus on the object in the foreground, then recompose and take a shot. Without moving the camera's position, use the object in the background as your point of focus and take a shot. Finally, find a point that is one-third of the way into the frame from near to far and use that as the focus point. Compare all of these images to see which method delivers the greatest depth of field from near to infinity.

Find a local fair

Most counties have a fair every year, so check out a local newspaper or county website to find a fair, and then visit with the intention of finding an interesting portrait. Once you find an intriguing face, chat up the person and ask for his or her portrait. Remember, get the portrait but don't overstay your welcome.

Photograph monuments

Next time you're near a monument such as a sculpture, a famous or interesting building, or the world's largest rubber-band ball, search out a new perspective. Get out of the habit of standing in front of your subject and shooting from eye level. Keep moving until you can create a unique perspective. Try to capture five different perspectives, and don't be afraid to have people in your shot to create scale.

Share your results with the book's Flickr group!
Join the group here: www.flickr.com/groups/street_fromsnapshotstogreatshots

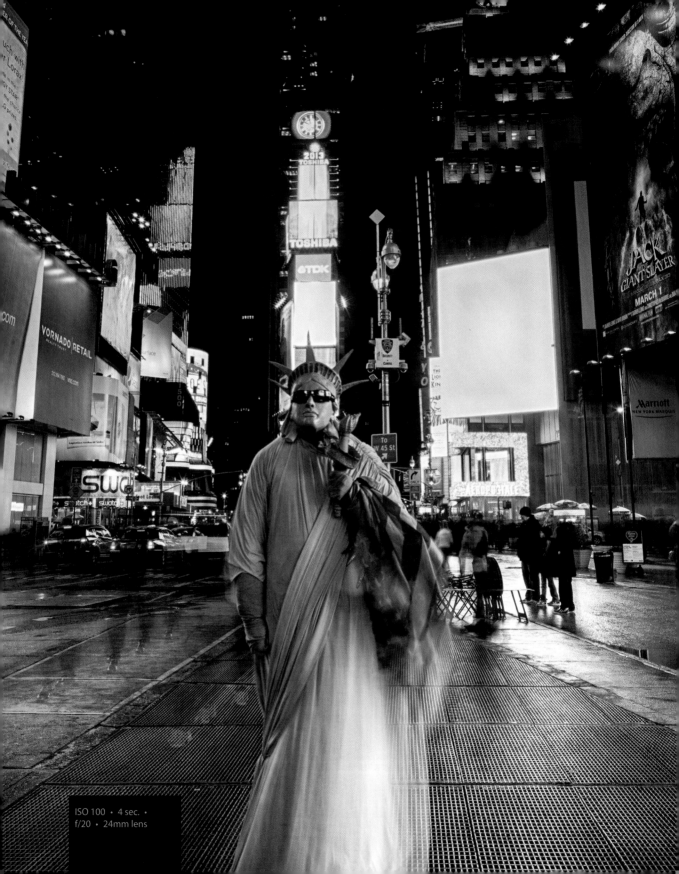

ISO 100 · 4 sec. ·
f/20 · 24mm lens

8

The Legalities

Street and travel photographers' rights

Can you take a photo of a person sleeping on a public park bench without asking permission? Could you sell that image to a news organization for use in a series on homelessness? This is just a sample of the questions plaguing photographers who make images in the public domain.

I'm not a lawyer, and this chapter is intended to offer guidance, not legal advice. If you have specific questions regarding legal issues, seek the advice of professional council. That said, there are generally accepted practices of street photography around the world. Laws and regulations vary, so what might be "fair game" in the United States may be a violation of the law in the UK or elsewhere. Unfortunately (yet understandably), photographers have become a bit more suspect since 9/11 and the Boston Marathon bombings because of our tendency to linger in one location with big heavy backpacks full of gear. Being aware of your rights is key to having a good experience.

Many of the subjects we're about to discuss are based on existing laws that have much legal precedent. My goal is to help you get beyond the legalese to focus on the common-sense applications of the laws that protect photographers and our subjects.

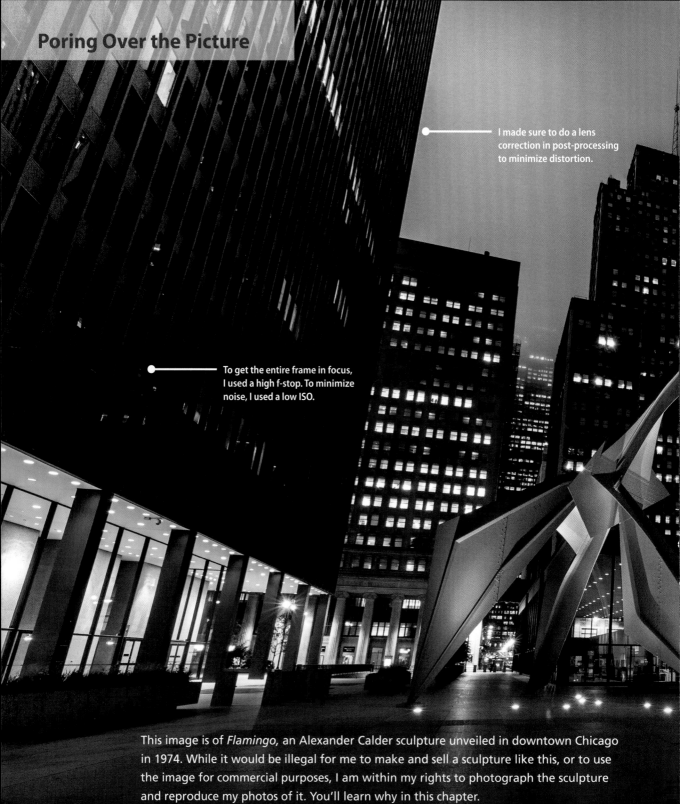

Poring Over the Picture

I made sure to do a lens correction in post-processing to minimize distortion.

To get the entire frame in focus, I used a high f-stop. To minimize noise, I used a low ISO.

This image is of *Flamingo*, an Alexander Calder sculpture unveiled in downtown Chicago in 1974. While it would be illegal for me to make and sell a sculpture like this, or to use the image for commercial purposes, I am within my rights to photograph the sculpture and reproduce my photos of it. You'll learn why in this chapter.

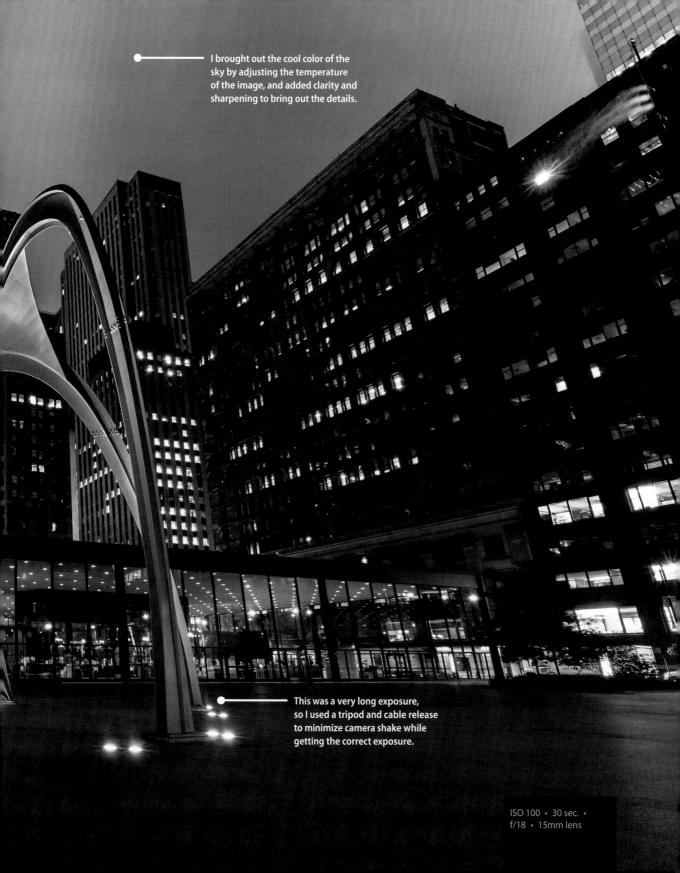

I brought out the cool color of the sky by adjusting the temperature of the image, and added clarity and sharpening to bring out the details.

This was a very long exposure, so I used a tripod and cable release to minimize camera shake while getting the correct exposure.

ISO 100 · 30 sec. · f/18 · 15mm lens

Knowing Your Rights

Most of this chapter is dedicated to photographers' rights in the United States. While many of these rights are similar in other countries, I always advise doing your research before photographing abroad. The laws that govern most photography issues, whether here or overseas, can be broken down into two areas: privacy and ownership. We'll look at how we define these rights in the United States, which should serve as a good baseline for what to expect abroad.

Once again, I am not a lawyer, and nothing in this chapter or book constitutes real legal advice. I have done my best to research these laws, but there is always interpretation. I cannot make any guarantees about my advice; I can only write about how I conduct myself and my business, which I believe is within the law.

You will find that I quote and refer to the American Civil Liberties Union (ACLU) many times. This is because the ACLU's main goal is to protect our civil rights, primarily our First Amendment right of freedom of speech. I do not have any personal or professional affiliation with the ACLU, but I find their website to be an excellent resource for getting to know our civil liberties. They plainly explain our rights as photographers in a helpful way, and often they quote the actual laws or cases that go along with these rights so we can be confident that the information is in fact true.

There are many resources and websites out there that make claims on our rights and laws, though upon further research many turn out to be untrue or misleading. Make sure you always trust your source when you are researching your legal rights, and when in doubt, seek the advice of a licensed attorney.

Public Spaces

Most developed countries have defined the legal rights of photographers. Defining these rights has become a matter of practicality as our world continues to shrink with the growth of social media, plethora of journalistic outlets, and tourism. The camera phone has become so ubiquitous that it's unrealistic to expect or control privacy in public domains, thus the need to define what is a "public space."

The United States defines a public space as an area that is open to the public. Examples of public spaces are parks, streets, beaches, museums, train stations, bus stations, federal buildings, and airports. There are always exceptions, and common sense needs to prevail —for example, photography cannot take place in bathrooms, at ATMs, at some federal buildings and museums, or where a person has a reasonable expectation of privacy. There may be restrictions in malls or stores; look for "No photography" signs. In general, use

common sense and be on the lookout for posted signs. If you have to purchase a ticket to enter, it is less likely that it is a public space, so in those instances you'll want to ask for clarification.

The following are subjects you can photograph in a public space without asking permission. Though as discussed later in the chapter, there are limitations around what you can do with those images without a model release (**Figure 8.1**).

- People of all ages, including children.

- Any building, public or private, that can be seen from a public space, such as a street or sidewalk.

- Most public transportation stations, such as airports (see sidebar), train stations, bus stations, and subways.

- Private property that is visible from a public space. You may not go to lengths like climbing a tree to gain an unusual vantage point to view inside a private space. To make this legal, you must be acting reasonably—standing on the ground, for example—and the space you are photographing must be in plain sight.

- Shopping malls and individual shops unless a "No photography" sign is present.

- Police officers, firefighters, or other public employees while they are in public spaces.

Figure 8.1
These people were demonstrating in a public place (streets of Chicago), so I was fully within my rights to photograph them. As you'll learn later in the chapter, I can use this photo for personal or editorial use but not commercial use.

ISO 200 • 1/100 sec. • f/8 • 50mm lens

According to the ACLU: "The Transportation Security Administration (TSA) acknowledges that photography is permitted in and around airline security checkpoints as long as you're not interfering with the screening process. The TSA does ask that its security monitors not be photographed, though it is not clear whether they have any legal basis for such a restriction when the monitors are plainly viewable by the traveling public.

The TSA also warns that local or airport regulations may impose restrictions that the TSA does not. It is difficult to determine if any localities or airport authorities actually have such rules. If you are told you cannot take photographs in an airport you should ask what the legal authority for that rule is."

Be aware that customs and passport-control areas usually have restricted photography policies, so look for signage or just keep your camera gear stowed away until you've cleared customs.

Special Considerations

Now that you know what you can photograph, let's spend a little time on the practicality of the matter. I field many questions regarding my approach to photographing homeless people and children, and how I deal with law enforcement officers, so let's examine this further.

The Homeless

All the photographers I know have their own set of rules for what they will and will not photograph, and under what conditions. This is because each photographer's moral boundaries and comfort zones are different. Personally, I don't take many photographs of homeless people, since I've seen my fair share in Chicago and am very familiar with this social problem and our need to do something about it. However, I recognize that their presence is a huge part of our society and to completely neglect documenting them would be the equivalent of closing our eyes to the problem.

The most important part of any photograph is the manner in which we take it and our motivation for doing so. Honor and respect follow those who take a photograph with integrity. I do not believe in photographing homeless people because they make an easy target; I photograph them only if there is a greater goal or an interesting feature. Apply the same rules to them that you would to anyone else on the street (**Figure 8.2**).

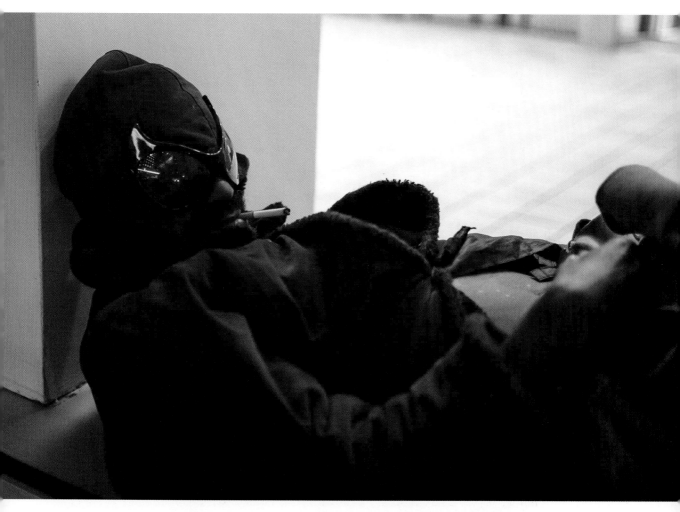

Figure 8.2 I took this photo of a man sleeping in front of an ATM booth not as a commentary on homelessness but because of its interesting nature, as he was wearing Spiderman goggles with a half-smoked cigarette hanging from his mouth.

ISO 1600 · 1/90 sec. · f/1.4 · 35mm lens

Children

I have no issues photographing children playing in a park, school playground, or other public space. But, as a father, I'm not okay with strangers trying to take close-up portraits of my daughter without my permission. While it might be perfectly legal to photograph kids in a public setting, you still might find yourself at odds with a parent, as many parents have good reason to be sensitive to strangers approaching their children. Occasionally I do take street portraits of children by themselves, and I always ask the parent's permission beforehand, even though legally there is no requirement to do so. Of course there are lots of exceptions to this rule, such as at sporting events and parades, where parents realize their kids will be the subjects of many photos (**Figure 8.3**). Keep local customs and laws in mind, as some customs may frown on any photography of minors. Use common sense and, when in doubt, always ask permission.

Figure 8.3
This young boy was at a 4-H fair getting ready to sell his prize cow. I chatted with him a bit about his cow and what it meant to be in 4-H, then asked him if I could take his photo.

ISO 200 • 1/160 sec. • f/5 • 45mm lens

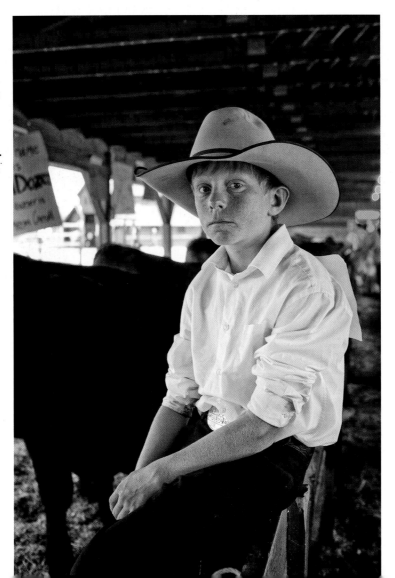

Law Enforcement

Most police officers probably know your rights as a photographer better than you do. Law enforcement agencies are well trained with how to deal with the press and photographers, especially in larger cities and definitely in heavily trafficked tourist locations. As I mentioned earlier, 9/11 changed the world for everyone, and photographers are no exception. On occasion you might find yourself being questioned by law enforcement about your photographic intent. In all the years I've been photographing, I've never had a problem that couldn't be resolved in a professional manner. These hardworking people have our best interest in mind, and they are only human, so kindness and manners go a long way (**Figure 8.4**).

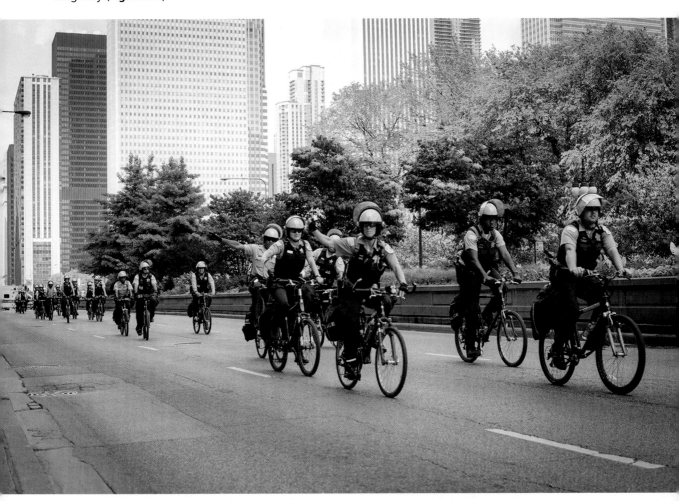

Figure 8.4 Law enforcement officers can be photographed as long as they are in a public space. If you do have an interaction with them, remember to be respectful and courteous.

ISO 200 · 1/320 sec. · f/5 · 50mm lens

You're well within your legal right to photograph law enforcement while in a public space. That said, there are always exceptions, and understanding your rights as a photographer can be a critical part of explaining your presence. The ACLU has done a nice job of educating photographers on how to interact with law enforcement when confronted. Learn more at www.aclu.org.

Here are some key points to remember when you are confronted by police officers about photographing them:

- Police officers are within their right to ask you what you are doing.

- Always be courteous, respectful, and honest, and never be confrontational, no matter the circumstance.

- Be conscious of your body language.

- An officer may ask you to cease what you are doing if it's interfering with law enforcement operations or investigations. If they have barricaded off an area that is restricted from the public, you are not allowed in that area, and it is not a public space. Use common sense—don't think that just because you're a photographer, the rules don't apply to you.

- Police officers cannot confiscate your camera, video camera, film, or memory cards without a warrant, nor can they demand to see your images unless they believe a crime has been committed. However, if you have a photograph of a police officer committing a crime, you're under no obligation to share that image with that police officer.

- Never, under any circumstances, can police officers force you to delete your images or video footage. In other countries where you are unfamiliar with the laws or where civil liberties are not protected and defended, you may find it prudent to delete images if asked, to keep yourself out of trouble. You need to determine how valuable the images are to you.

- If a police officer stops you to ask questions, give a brief explanation of what you're doing; more often than not, he'll be polite and let you carry on. The most I've been told to do is "hurry along." Note that in this instance, you've answered the officer's questions voluntarily. However, there may be an occasion when you feel that the questioning has gone on too long. In this instance, if you ask, "Am I free to go?" you are stating that you are no longer willing to answer questions voluntarily. If the officer says "no," you're being detained. If you're being detained, you should ask politely what crime you are suspected of committing, then remind the officer that taking photographs is your right under the First Amendment and does not "constitute reasonable suspicion of criminal activity" (per the ACLU). If you are still detained, request an attorney and say no more.

Private Property

Private property is defined as land, buildings, pets, or other personal belongings that are not owned by a government or an agency of the government. Examples include homes, malls, restaurants, casinos, and galleries. You can photograph any private property that is in plain sight of a public space. An example: I'm walking down the sidewalk and want to photograph a home along the way. I'm well within my rights to take a photo of that home from the sidewalk. However, using a telephoto lens from the sidewalk to photograph into someone's window would probably be considered an invasion of privacy.

I know common sense should dictate that assumption, but understanding what equipment to use when photographing a subject can eliminate embarrassing questions by local authorities. The use of a zoom lens in the public space to photograph into a public space is fine. Using a zoom lens from a public space to photograph into a private space is not okay. As I stated above, "in plain sight" also refers to how you are viewing into a private space. If you are on a designated sidewalk or walkway, that's fine. You may not climb trees, put up ladders, stand on cars, etc. to get a better view into a private space: Maneuvering to an unusual or higher place to get a better view is not protected under the "in plain sight" rule.

Semiprivate Property

Many people assume that just because the public is allowed into a building such as a mall or casino that it's okay to photograph everything around them. I have made this very mistake. The reality is the property owner has the right to dictate what can and cannot be photographed. If a local store has a "No photography" posting, it's within an owner's rights to ask you to stop shooting.

A few years back, a friend and I were visiting Las Vegas for a photography convention. I made the mistake of taking out my cell phone to take a quick photograph of him playing blackjack. Keep in mind, my gambling experience is limited to euchre in college and Go Fish with my daughter, so I was ignorant of the rules. The dealer immediately told me photographs were strictly prohibited on the casino floor to reduce cheating and protect the privacy of others. The casino acted within its rights to restrict photography.

You may make mistakes when traveling to places where you're unfamiliar with the rules and regulations. However, you will rarely get in trouble for being curious and humble. Just remember, if it's a private or semiprivate space, house rules apply, and you must abide by them.

Harassment

Harassment is behavior that is unwelcomed, threatening, intentional, and often repetitive. Even if you're in a public space, you're not free to harass people while taking their photo. My daughter often jokes that I'm in her "personal bubble" (space). While part of raising a kid is getting in their space from time to time, on the street if you haven't gauged the situation well, then getting into someone's personal bubble might just get yours busted! The best practice to avoiding the perception of harassment is never to linger, and always make sure you have permission to enter someone's personal space.

Defamation of Character

Defamation can occur if you create a false impression that hurts a person's reputation. Defamation of character may occur when inaccuracies are reported in print (libelous) or verbally (slanderous). Images can also be defamatory if used improperly.

Defamation can occur with:

- A false and defamatory statement concerning another.

- A publication not created by the person defamed.

- A publication that is clearly about the subject and harming the subject's reputation.

- A subject who is a public figure and can prove actual malice (see below).

An example of defamation would be if I took a photo of an identifiable man sleeping on a park bench in Central Park and later published an article titled "Homeless in New York City." This could be libelous if in fact the man was *not* homeless and could show that it harmed his reputation.

Public figures

Public figures are held to a higher standard of proof than that of ordinary citizens. To claim defamation, a public figure must prove that the publication intended actual malice or ill will. (Especially if you're a Paul Newman fan, I suggest watching *Absence of Malice,* a movie that covers this very subject.) Public figures include celebrities; government officials; elected officials such as mayors, aldermen, congressmen, and judges; sports figures; and prominent business people such as CEOs of publically held companies. These individuals must show that the person making the statement or publishing the photo had ill will when making the statement or photo, and that it was untrue and harmful to his or her reputation.

Limited-purpose public figures

A limited-purpose public figure is someone who chooses to be at the forefront of a social or public issue but is not an "all-purpose" public figure like those listed above. In order to prove defamation, limited-purpose public figures must prove malice only if the offending statement is in regard to the arena in which they are involved. They are protected under defamation laws as an ordinary citizen in all other arenas (**Figure 8.5**).

For example, if a woman has chosen to be a spokesperson against drunk driving in her community, and the statement in question was that she is an alcoholic, she would have to prove that the photographer or person made that statement maliciously to harm her and that it is untrue. However, if the statement were that she is neglecting her children and it's not true, then she does not have to prove that the statement was made in malice; she must prove only that it was untrue and that it harmed her reputation, because the statement is not related to drunk driving.

Note that truth is often the number one defense to defamation lawsuits. If I photograph a person shoplifting and accuse him of shoplifting, it's difficult for the "accused" to win a defamation of character lawsuit, as indeed the person was shoplifting and there's photographic evidence to prove it.

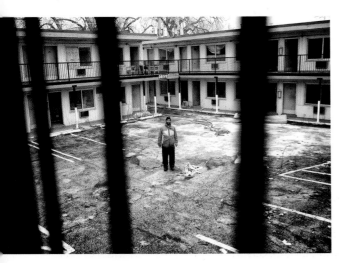

ISO 640 • 1/250 sec. • f/5 • 54mm lens

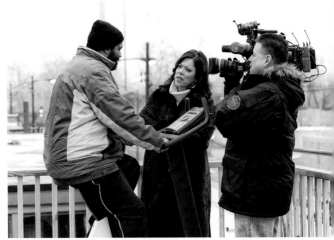

ISO 250 • 1/250 sec. • f/3.5 • 70mm lens

Figure 8.5 Pastor Corey Brooks, from the south side of Chicago, has chosen to take up the cause of ending violence in his neighborhood. Because he has chosen this path, he is a limited-purpose public figure.

Copyright Concerns

Copyright concerns can arise when a trademark or previously copyrighted object is reproduced. You would think copyright laws were being broken with every click of the shutter, but as long as the images are being used for noncommercial purposes, photographers are within their rights to shoot logos and other copyrighted objects. Generally, commercial purposes include advertising and promotions, or if the photo in question is drawing a conclusion that its subject is affiliated with, promoting, or adverting something.

For example, the Starbucks logo is trademarked and covered by copyright law. A lot of street photography takes place outside cafes, and believe me I've known photographers who never leave a Starbucks! So I could not use a Starbucks logo in a photo that I use to advertise my New York City photography workshop, because it might insinuate that Starbucks has endorsed or is affiliated with John Batdorff Photography, which it is not.

The law does allow for photographers to promote themselves and their work, even when a copyrighted or trademarked logo appears in an image. What this means is you may use these images on your blog or website as part of your artistic expression.

Model Releases

The number one question I get from photographers is whether they need a model release while in the field. The answer lies in the intended use of the image. If it weren't for a matter of practicality, one might argue the legally protective measure to take is always obtaining a model release, so that any unintentional or unforeseen use of the image is covered. However, the reality is travel and street photography is very fluid, and obtaining a model release after the fact can be outright impossible. Legal systems in many countries have recognized this issue and developed guidelines that help determine when a model release is needed.

The Simple Facts on Selling an Image

If you intend to sell your photographs, here are some basic facts to keep in mind:

1. A release is required for all images that are to be used for commercial purposes. If you plan on using an image for commercial purposes, ultimately the release is your responsibility.

2. If you've taken an image that you anticipate might sell well on a commercial level, do everything within your means to get a model release so the photo will not be restricted to editorial use only.

3. Property releases (discussed below) or model releases are *not* required to sell a photo online or in your gallery, nor do you need a release in order to publish it in social media, a book, or your blog.

In the United States, a model release is required for any image that is deemed for commercial use. It doesn't matter if the image was acquired in a public space or on private property. The only deciding variable here is how the image will be used. An image that will be used in whole or part for advertising or promotion requires a model or property release. (A model release is needed for human subjects, and a property release is used for everything else, including pets!) However, if an image is used in conjunction with or to illustrate a newspaper, magazine, book, blog, or similar media, then a model release would not be required, providing the image was acquired in a public space.

Keep in mind, photographers do not need releases to take or sell photographs. The distinction is how the photograph can be used later. When uploading to stock photography sites, remember that typically images with a release are more valuable because they can be used for commercial purposes as well as editorial; generally images without releases are restricted to editorial use only.

What Is a Model Release?

A model release is a document that grants a photographer permission to publish a photograph either electronically or in print. Typically, the release is signed by the photograph's subject and releases the photographer of liability as outlined in the document. It may also detail restrictions on how the image may be used, sold, or retouched. Model releases may be granted with or without compensation to the image's subject.

An *adult model release* needs to be signed by anyone over the age of 18.

A *minor model release* needs to be signed by a parent or legal guardian of any model under the age of 18.

When Do You Need a Model Release?

The number one reason you would want a model release is for commercial purposes such as promoting a product, a business, or a person. Most street photographers and travel photographers are not commercial photographers.

What Situations Do Not Require a Model Release?

Generally, model releases are not required for anything outside of commercial use, including newspapers, educational books, online prints, gallery prints, and personal use. Profit does not factor in to when you need a model release. You are allowed to sell photos on your website or in your gallery without a model release (*James Brown v. ACMI Pop Div.*, IL, 2007). You also have the right to put images on social media and photo-sharing sites without a release.

Are There Risks in Forgoing a Release?

Failure to acquire a model release when one is required is ill advised, especially since we live in a somewhat litigious society (particularly in the United States). Most reputable stock photography companies, such as Shutterstock, Getty Images, and Alamy, require releases if the intention is to sell your image for commercial purposes (see the sidebar on commercial versus editorial use).

Note that the company or person publishing the image for commercial purposes is required to have a model release on file. This means that if you're using an image for commercial purposes, you're the one required to have a release. Otherwise, the images will be restricted for editorial purposes only. Thus uploading an accompanying release to stock image companies will greatly increase the size of your potential customer base (**Figure 8.6**).

Figure 8.6 It is legal to use this image for editorial purposes without a model release. However, if a grocery store wanted to use it to promote Dr. Pepper, then the image would require a model release from the subject and a property release from Dr. Pepper.

ISO 320 · 1/320 sec. · f/7.1 · 90mm lens

Property Releases

A property release is required when you take an image of a clearly recognizable place, building, home interior, or even other property such as automobiles, artwork, and pets. Property releases are required for the following items:

- Trademarks and logos (e.g., McDonald's arches).

- Famous locations, landmarks, and monuments unless they are classified as being within the public domain.

- Stadiums, museums, and amusement parks (that require payment for entrance).

- Patented or trademarked products designs (e.g., Nike's swoosh or Apple's apple).

- Artwork (paintings, murals, sculptures, etc.).

The property release serves as a waiver of any potential claims by the owner of the property regarding right to privacy and unauthorized commercial use. As with model releases, a property release is required whenever you plan on using an image or video for commercial use. You may use these images for your personal use, such as your blog, social media, and photo-sharing websites, and you may have them for sale in your gallery or online.

Copyrights Do Expire!

Copyrights don't last forever. For example, the *Mona Lisa* is no longer copyrighted and is part of the public domain in the United States and those countries with a copyright term of life of the author plus 100 years or fewer. However, some corporations may continue to update their copyrights, so it's always wise to do your research.

Cityscapes and Property Releases

Skyline photos that show many buildings versus focusing on one building do not require a property release (**Figure 8.7** on the following page). This is because no one building or trademarked/copyrighted logo is the main subject of the image. For example, New York's Times Square is covered in brightly lit signage and logos. If you photograph it, so long as your image shows the entire area, you are not infringing on copyrights. But if the only thing in your frame is the McDonald's arch, your ability to use the image for commercial purposes would be restricted.

Figure 8.7
This image of the Chicago skyline cannot be copyrighted, so it is open for use or sale, even for commercial purposes.

ISO 100 • 5.0 sec., 1.3 sec., & 0.3 sec. HDR • f/11 • 35mm lens

However, this image of the John Hancock building cannot be sold for commercial use without a property release—though it can be used for personal use and personal promotion.

ISO 400 • 1/125 sec. • f/32 • 50mm lens

Here are some examples of places that require a property release for commercial use:

- Beverly Hills sign, Los Angeles.
- British Royal Residences, United Kingdom.
- Chrysler Building (if it's the main focus of the image), New York City.
- CN Tower, Toronto.
- Disney Studios and theme parks (including the logos, images from theme parks, attractions, products, productions, movies, and characters).
- Eiffel Tower at night, Paris (the lighting design is copyrighted).
- Empire State Building, New York.*
- Flatiron Building, New York.*
- Frank Lloyd Wright buildings.
- The Gherkin, London.
- Graceland, Memphis.
- Grauman's Chinese Theatre, Los Angeles.
- Hearst Castle and San Simeon State Historical Monument, San Simeon, CA.
- Hollywood sign, Los Angeles.
- Hollywood Walk of Fame, Los Angeles.
- London Eye Millennium Wheel.*
- The Lone Cypress tree, Pebble Beach, CA.
- McDonald's arches.
- Pro sports teams and insignias.
- Superdome, New Orleans.
- Rock and Roll Hall of Fame, Cleveland.
- Rockefeller Center (all buildings and sculptures), New York.*
- Rolls-Royce, Maserati, or any images of isolated vehicles.
- The TGV (French high-speed train).
- Space Needle, Seattle.
- Solomon R. Guggenheim Museum, New York.
- Sydney Opera House.*
- Willis Tower, Chicago.*

*Not needed for cityscapes.

Again, if you plan on selling your images to a stock agency, the best policy is to get a model or property release. You can download release forms from my blog, www.johnbatdorff.com/street-photography. Also, Easy Release is a great smartphone app that allows you to use your phone to complete a release form. You can also download releases directly from stock agencies, which would ensure that the images will be accepted and the releases passed on to the company or person purchasing the image.

Top 10 Dos and Don'ts to Stay Legal

1. **Do** know your rights and research your subject matter, especially if you'll be selling an image to a stock photography agency. **Don't** make assumptions about your rights in foreign countries—always research your rights as a photographer while abroad.

2. **Do** keep your photography in the public domain. **Don't** overstep your bounds by photographing into private spaces that are outside of plain view or assume that semi-private spaces are the same as public spaces. Remember, in private and semiprivate spaces, house rules apply!

3. **Do** remain courteous and respectful of law enforcement. If you are being questioned, feel free to ask, "Are we through here? May I go?" **Don't** delete your photos or give your film, memory cards, or equipment to anyone unless you have been subpoenaed.

4. **Do** remain respectful of people's personal space. **Don't** harass people.

5. **Do** be mindful that you are not defaming someone when you are photographing him or her, but keep your moral compass on you at all times. **Don't** intentionally misrepresent someone or publish a photo that is unnecessarily embarrassing or not truthful.

6. **Do** take and sell photos of anyone and any place in the public domain. **Don't** use those photos for commercial use without getting a model or property release first.

7. **Do** get a model or property release any time you want to sell a photo to a stock agency or for commercial purposes. **Don't** limit your potential customer base by not having a release, which will restrict the photo's use to editorial purposes only.

8. **Do** contact a local photographer when traveling to an unknown region if you're unsure of local customs. **Don't** assume customs are the same as they are at home.

9. **Do** always be respectful of your subjects whenever you need a close portrait, and get permission even if you don't need a model release.

10. **Do** your research—**don't** get caught without knowing your rights! Use websites such as www.aclu.org and www.copyright.gov to make sure you're a well-informed photographer.

Remember, I'm not a lawyer. I'm just sharing my understanding of these issues and how I approach shooting on the street. This chapter is meant to start you on your way with this stuff, but it does not constitute actual legal advice.

Chapter 8 Assignments

Now that we've had a crash course in photographers' rights, let's assign a little homework to further your knowledge on the subject.

Knowing your rights

Go to www.aclu.org to see what the ACLU is up to. They offer an abundance of information on freedom of speech. Read a couple of court cases on the First Amendment so you understand the thinking that goes into these decisions. This understanding may help you make decisions on the fly. Finally, do some research on another country's laws and customs—for example, France has very different laws than the United States. Make a list of the differences between several countries.

Finding a release

Create or find a model release that you can carry with you at all times. There are numerous releases available for free online, and many stock agencies post releases that are available for free to their photographers. To learn more and for free general releases, visit my blog at www.johnbatdorff.com/street-photography.

Learning about copyright

Go to www.copyright.gov and search records for known trademarks such as "Coca-Cola." This will give you a better insight into how these trademarks are recorded and their known restrictions. I bet you'll find information that you never knew, or never even knew to ask about.

Share your results with the book's Flickr group!
Join the group here: www.flickr.com/groups/street_fromsnapshotstogreatshots

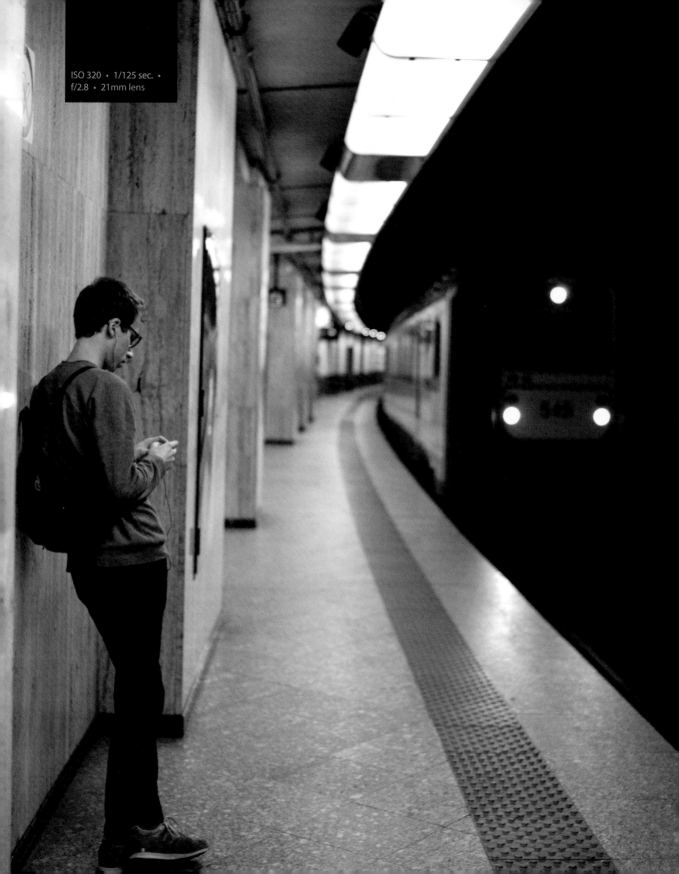

9
Workflow

Creative systems for the visual artist

One of my favorite things to do after a long day of photographing is to sit down at my computer and import all my images into Adobe Lightroom. For me this is a moment of truth and the final step in bringing my creative vision to life. I recognize not all of you are Lightroom users, but over the years I have found it to be the best system for managing and editing my images. If you currently use Lightroom, you already know its benefits, and my recommendations for workflow might be very close to your own. For those of you who aren't familiar with Lightroom, I suggest spending the next few pages getting to know it a little better.

Regardless of which image-editing software you use, this chapter addresses computer setup, post-processing workflow, backup strategies, and a few processing suggestions. Finally, I'll give you my recommendations for creating an efficient and consistent workflow so you can create the best images possible while minimizing the risk of losing files. Exporting and sharing images will be covered in Bonus Chapter 10, "Sharing Your Work" (see Introduction for instructions).

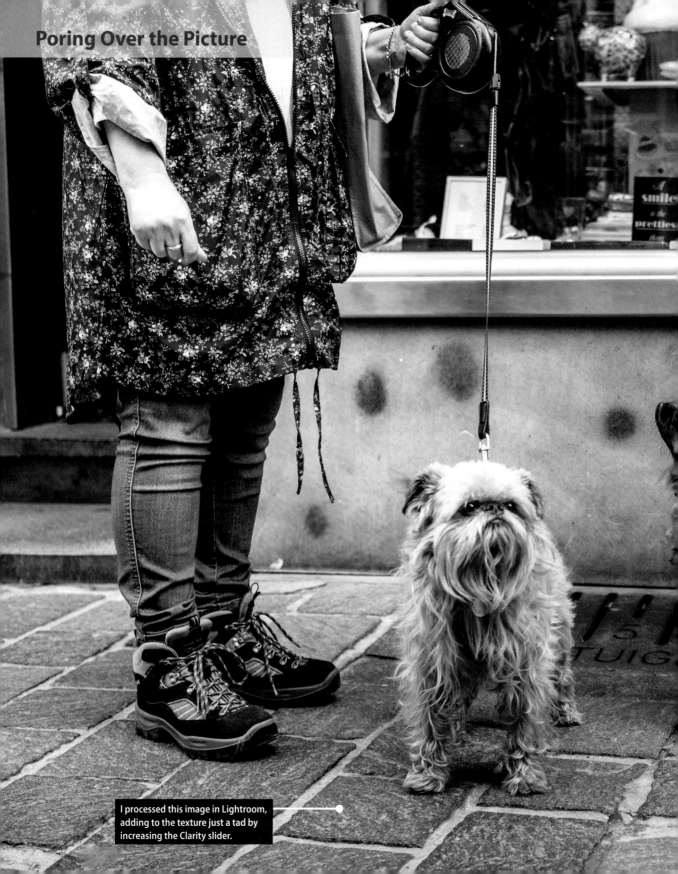

I processed this image in Lightroom, adding to the texture just a tad by increasing the Clarity slider.

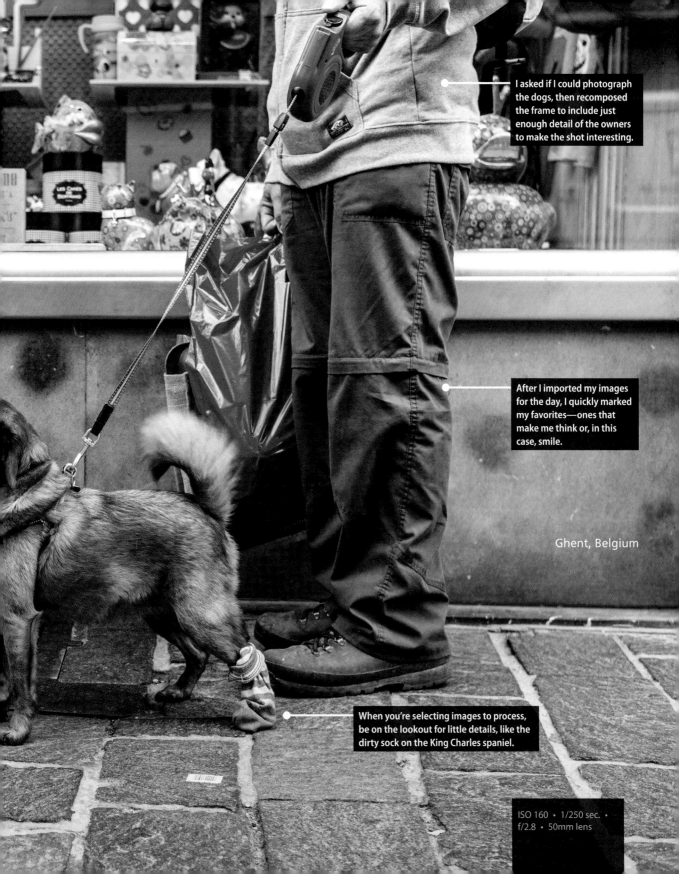

I asked if I could photograph the dogs, then recomposed the frame to include just enough detail of the owners to make the shot interesting.

After I imported my images for the day, I quickly marked my favorites—ones that make me think or, in this case, smile.

Ghent, Belgium

When you're selecting images to process, be on the lookout for little details, like the dirty sock on the King Charles spaniel.

ISO 160 · 1/250 sec. · f/2.8 · 50mm lens

Developing a Workflow

The best way to keep your image-processing workflow organized is to build a system that is simple, consistent, and fail-safe. Your goal is to create a workflow that allows you to catalog, process, and back up your images whether you're on the road or at home.

I'm not the most organized person in the world, but over the years I've adhered to the same processing system, and it has helped me manage a catalog of nearly 130,000 images. I can locate files in a matter of minutes, and the secret to making this all work has been keeping the workflow simple—and always having redundancies.

Most important, my system has been tested by several hard-drive failures and a few corrupt flash cards—and I've never lost a single image. Of course a perfect storm is always possible, but I believe that if you back up with the workflow described in this chapter, the risks are so small they are negligible. Before exploring my system for processing images, let's start by reviewing what sort of computer setup you should consider.

System Considerations

The first thing I tell my students is to try to dedicate one main computer to image storage and editing. I realize this isn't always possible (budget constraints, one computer for the family, etc.), so if you do have to share a computer, try to minimize the amount of unnecessary applications and files. Storing and editing images takes up a *lot* of memory, so having a computer that's set up with photo editing in mind will make the experience much more enjoyable. For example, creating an HDR (high dynamic range) image such as the one in **Figure 9.1** requires a significant amount of processing horsepower, so having a computer that is adequately equipped is essential to preventing unwanted crashes or system slowdowns.

The second thing my students hear me preach about is backing up. With today's technology, losing images to disaster, theft, or hard-drive failure is wholly preventable and unnecessary.

We'll discuss backup solutions later in the chapter, but first let's discuss setting up a machine for image editing. Let's not think of this computer as a workstation (that takes the fun out of it!); instead let's call it a photo station that's dedicated to creating your vision.

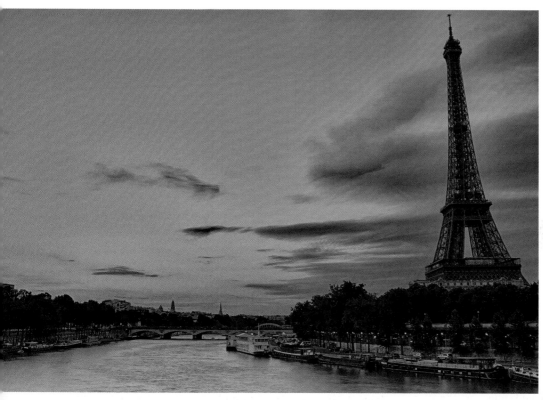

Figure 9.1
If you enjoy creating HDR images, like this one of the Eiffel Tower, you'll want to make sure your system meets your favorite HDR software's minimum requirements.

ISO 100 • 4 sec., 1 sec., and 2.5 sec. (three exposures) • f/90 • 35mm lens

Setting Up a Photo Station

The key to being consistent with your editing and backups is having a workflow ritual that can be performed either from home or on the road. While I'm traveling or in my studio, my workflow is nearly identical, with one exception: I handle my backups differently. I prefer using a laptop for extended trips because it provides the best solution for editing and backing up my images to a portable external hard drive. There are times when I'm traveling for a weekend and will leave the laptop behind, and forgo any major editing until I return home. However, my main goal when traveling is always the same: to create image backups on my laptop, tablet, or portable HyperDrive to keep them safe until I can upload to an offsite drive (**Figure 9.2**). If I can edit a little while I'm away, that's great, but I need to make sure my images make it home to my main photo station.

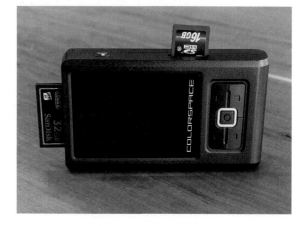

Figure 9.2 A portable drive dedicated to backing up your camera cards can be handy when traveling without a laptop.

There are many technical aspects of a photo station to consider, and I'll get to those, but don't forget to make sure that your space is comfortable, that the lighting is adequate and consistent, and that you are able to focus. I hear people say all the time that they hate being in front of their computers. Why not take a little time to make your space more comfortable so you can enjoy your time there? The technical elements of a photo station make image processing possible, but a comfortable place to work makes processing enjoyable.

Benefits of a Dedicated Photo Station

- Simplified file management
- Streamlined monitor and printing calibration
- Easy-to-deploy backup systems
- Centralized settings for consistent workflow

Let's review some considerations for your ideal photo station.

RAM

Many times when people come to visit me in the studio, they tell me Lightroom is running super slowly on their system. To help troubleshoot, the first thing I ask is how much RAM they have installed. RAM (random access memory) functions as the computer's short-term memory and is responsible for how quickly the computer can process tasks. Adobe states: "Minimum requirements to run Lightroom are just that: the minimum you need for Lightroom to operate. Additional RAM and a faster processor, in particular, can yield significant performance benefits." With this statement in mind, for the best performance I often recommend doubling whatever the software requirements are, and also to leave room for the future needs of the program. As of today, I would say most systems perform very well with 8 to 16 GB of RAM with a recent processor.

Hard-drive space

A hard drive differs from RAM in that it is the computer's long-term memory. Hard drives have dropped in price as of late, so they may be more affordable than you think.

There is one exception: the solid-state drive (SSD). Hard-drive technology has changed a lot in recent years, and now you can install SSDs, also called flash memory, instead of traditional hard-disk drives (HDDs), which use magnetic spinning drives. SSDs are becoming standard on many laptops because they are lighter and faster than traditional hard drives. Solid-state drives use similar technology to camera cards and provide exceptional performance—nearly 30 percent faster than standard drives—so when it comes to editing images and opening applications like Lightroom and Photoshop, you notice a big difference. If you're a speed freak you'll love the performance… but it comes at a cost, as SSDs cost significantly more than comparable-sized HDDs. All that being said, if you're on a budget, I would give up hard-drive space for more RAM.

Portability

If you need one system to work both on the road and at home, you'll want to consider a laptop display size that fits your needs. Thirteen-inch laptops are very portable and easy to stow when traveling, yet some people find them too small to rely solely on them for editing. If you're looking for a desktop replacement system, I would recommend a 15-inch laptop so that you have the most enjoyable experience while editing. If you're going to be doing most of your editing on a desktop computer at home, I suggest getting a smaller 13-inch for your travels and enjoying the benefits of traveling light.

> ### Tablets vs. Desktops
>
> Today many people have switched from post-processing images on desktops to laptops. And as mobile continues to grow, I suspect we'll see even more photographers start to use tablets. The lines of what are considered to be portable solutions and home solutions will continue to blur. However, I still prefer to do most of my work on a desktop machine with a large monitor because it's easier on my eyes and provides more space to view and edit my images. Whatever system you choose should be one that you enjoy using, because nothing takes the joy out of editing images more than using a system you hate.

Calibrating Your Monitor

If you do a lot of printing and want consistent results, you should calibrate your monitors routinely. Monitor calibration takes only a few minutes a month and can help ensure that what you're viewing on your screen will translate to print. Oftentimes, people will increase or dim the brightness of their monitors, and then proceed to edit images. The inherent problem with making these changes is they create an inconsistency in lighting. Keeping your monitor calibrated is even more important when color accuracy is vital (**Figure 9.3**).

I also recommend selecting a workspace to edit your images where direct light doesn't fall on the screen, and where you can control the volume of light in the room via dimmers or blinds. When on the road, the best place to edit is away from bright windows and fluorescent lights.

Figure 9.3 **Monitor calibration is easy, and critical for consistent editing.**

Post-Processing Workflow

Here's my basic workflow after a day of taking photographs:

1. **Import images into Lightroom.** This step isn't glamorous or exciting, but it is incredibly important. Importing your photos correctly is the first step to being organized and laying a solid foundation for creative editing.

2. **Immediately after import is complete, back up images to an external device.** Again, we're not yet to the fun part. But remember, the only thing less fun than diligently backing up your images is losing them!

3. **Select images for further processing.** I use a very simple two-step process, which I'll outline in the next section.

4. **Process selected images.**

5. **Share processed images with friends, social media, blog, stock sales, etc.** This part is fun—so much so that I've dedicated an entire chapter to it (in Bonus Chapter 10). (See Introduction for instructions to download).

6. **Back up Lightroom catalog to external drive as part of a scheduled evening backup.** Even though your images are backed up, if you skip this step, you can lose your catalog of edits, so all the fun you just had editing those images might be lost.

7. **Back up photos to the cloud.** (This requires a high-speed Internet connection and often isn't a realistic option when traveling.)

Now that you have the seven steps, I'll delve into the details of each one. Note that there are entire books dedicated to processing and editing photos. There is a wealth of information out there, beyond the scope of this book. My aim here is to get you started with a proper workflow and give some tips for working with my favorite program, Adobe Lightroom. Once you get the basics down here, you can explore your image-processing program more in depth.

Working with Adobe Lightroom

Let me start by saying I don't work for Adobe, nor do they pay me to promote their products. I recommend Lightroom because it's what I use and it has become an essential part of my workflow for the past seven years. Moreover, when it comes to ease of use, image organization, and nondestructive editing, it's hard to beat the tools that Lightroom provides.

At the end of the day, you need to use a system that works for you, but I strongly recommend investing your time and money in a system that's here to stay. Adobe's the leader in this space, and I suspect they will be for years to come, so learning Lightroom will prove to be a strong investment in your future growth as a photographer.

Importing Images

After a day of shooting, my number-one goal is to get the images off my card and on to my computer so that I have a solid backup. Second, I ensure that my images are indexed properly so I can easily locate them in the future. Lightroom does an excellent job of accomplishing both tasks in a single step: the Import function (**Figure 9.4**).

Importing images is a relatively straightforward process, and it's the easiest time to apply metadata to your files. Often we think of metadata as the information our camera records, such as ISO, shutter speed, aperture, focal length, date, time, etc. This information is added automatically to your images upon import. But metadata can also include descriptive information you choose, such as copyright, photographer contact info, and keywords. Let's review the import process, which looks pretty much like this:

1. Convert RAW images to DNG files.

2. Rename files.

3. Apply keywords and metadata.

4. Organize your image folders.

Figure 9.4
Lightroom's import process streamlines organization and keywording.

Converting RAW to DNG

I convert all my images to DNG (Digital Negative) upon import. While this process might take a little more time, the upside—having a reduced file size and standardized file format—is well worth the extra few minutes (**Figure 9.5**).

Figure 9.5

I convert all my RAW files to DNG upon import. As the images are being imported, Lightroom gives you a conversion status report.

Adobe originally designed DNG to resolve compatibility issues with RAW files. Many camera manufacturers create proprietary file formats, such as Nikon's .nef or Canon's .cr2. While we're currently able to open these files and work with them, it's hard to predict if we will still have that ability in 30 years. That's why Adobe provided DNG, an open-source solution that guarantees files will be able to be read in the future. As a matter of fact, some camera manufacturers such as Leica use .dng as their standard RAW file format. I suspect in the years to come this will be an industry standard, much like what we've seen with the JPEG file format.

Remember, you can convert only RAW files to DNG; JPEGs will not convert.

Reasons to Convert RAW files to DNG

- DNG is the most widely compatible of all RAW file formats.

- Open-source code means it's free for anyone to develop software.

- DNG can detect if a file is corrupt, while problems with proprietary RAW files can go undetected.

- Camera companies are already beginning to use DNG as their standard.

- File size is 15 to 20 percent smaller than traditional RAW files.

- DNG files will store Lightroom's nondestructive edits, such as white balance adjustments, cropping, and exposure. A RAW file that hasn't been converted to DNG requires Lightroom to create an additional file called an .xmp sidecar file. This .xmp file must be stored with the original RAW file or all your Lightroom edits to this file will be lost. The bottom line: Converting to DNG streamlines file management by allowing Lightroom to store all its edits on one file.

Renaming Files

After converting images to DNG, Lightroom offers several options for naming the files. You can leave File Renaming turned off and simply import your files using your camera's default filenames, or you can create custom names upon import. I prefer to use a combination of shoot name and original file number, because it provides a more descriptive title with a unique file number (**Figure 9.6**). If you decide to rename your files, use unique names to avoid any confusion in the future. I've seen cases where people rename their files "image 1," "image 2," and so on, then mistakenly delete files because they think they're duplicates.

Figure 9.6
File renaming can be very useful for keeping track of your images.

Using Keywords and Metadata

Early on in my career I never used keywording because I didn't fully understand the benefits. So now when I have downtime I find myself going back into my archives and updating the keywords (**Figure 9.7**). Keywords are useful in helping locate files as your database of images continues to grow. They're excellent when you need to do broad searches, for instance to locate all images that were taken on a beach or of a particular person. Also, if you ever decide to sell your images online, you'll want to consider exporting your keywords because prospective buyers use them when searching for images.

Figure 9.7
Use keywording upon import when you want to apply keywords to every image being imported.

Actually, if you plan on sharing your images digitally, I strongly recommend creating a metadata preset with your contact and usage requirements so that potential clients know how to contact you and are aware of your image restrictions (**Figure 9.8**).

Figure 9.8
I've had clients see an image online and then contact me after reviewing the metadata.

Organizing Folders

The last step in the import process is to copy your images into the appropriate folder. I prefer to use a system where all my images are located in one Picture folder, then I create subfolders by year. Finally, each year has another subfolder that is labeled by subject (**Figure 9.9**). The most important part of this process is picking an organizational system that will work for you. I remember things by year and subject; other people use a system that's by year and then actual dates, or by subject and then year. Remember, regardless of what system you use, you can use keywords and metadata to locate files as your image library grows.

Now that you've properly imported your images using your predetermined organizational structure, it's time to make another backup. I use this same system whether I'm home or traveling, because you just never know when you could have a system or card failure and lose your images. There are many options for backing up, so next I'll share my process and recommendations.

Figure 9.9 Design a folder management system that makes sense to you and has the ability to grow as you add images.

Backup Solutions

A major mistake many people make in their workflow is not having adequate image-backup systems in place. Some statistics state that as many as 20 percent of all hard drives fail within four years, and surprisingly 5 percent may fail within the first year. To make matters worse, recovering files from a failed hard drive can be a very costly operation, setting you back thousands of dollars—without any guarantees. The cost of hard drives and cloud-based storage systems has plummeted in recent years, so there's no need to put your images at risk.

Here are three things you can do today to greatly minimize the risk of losing photos due to computer failure:

1. **Get an external backup.** This isn't a PC/Mac or even a desktop/laptop discussion. This is about backing up your catalog and Pictures folder to a place other than your local drive. Once you get an external drive, do the backup, and do it regularly. Make a schedule and stick to it.

2. **Create on offsite backup.** Offsite backups help insure you against loss from fire, theft, water damage, natural disasters, and so on. You can perform offsite backups via the Internet to a cloud-based storage or locally to another external drive that you place offsite.

3. **Back up to an array device, or a RAID (redundant array of inexpensive disks).**
A RAID is an external backup device that is built with several independent drives. Your files are distributed over several of the drives in a manner that allows for one or more drives to fail before you lose data. If one drive fails (which they all eventually do), you simply insert a replacement drive without running the risk of losing data. Drobo makes my favorite RAID device, and I have used it flawlessly for the past five years, but there are others on the market (**Figure 9.10**).

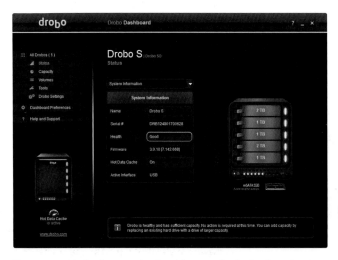

Figure 9.10 **My Drobo contains five drives varying in size from 1 to 2 terabytes. As drives fail, I can replace them inexpensively and without any loss of my images.**

Local vs. Cloud-Based Backups

You may be wondering why you need a local backup if you're already backing up to a cloud. Cloud backup is a cost-effective way to create an offsite backup, but its biggest drawback is speed. Many cloud-based backups are limited to the speed of your Internet connection, and while some services offer you the ability to send them a hard drive to "seed" your initial backup, it's still an extra expense. Moreover, in case of failure, you're limited by the speed of your Internet connection when it comes time to restore files. Once again, many services will send you your backed-up files on hard drive for an extra fee. But your best solution is to use an external drive to back up your files immediately while a cloud backup is taking place in the background.

Backup Rules to Live By

- Never use the camera to delete images off of the card. This should be done only as an absolute last resort if you've run out of card space while in the field and don't have a replacement card.

- Do not reformat your cards until you have imported your images and created at least one backup of your drive. Ideally, wait until you have an additional offsite backup completed.

- Always back up your system to an external device, regardless if you're at home or on the road.

- Create an offsite backup of your images or subscribe to a cloud-based backup system.

There are a number of cloud-based services, several of which I've used. But at the time of writing, I think the market leader is CrashPlan because of its overall flexibility (**Figure 9.11**). CrashPlan works great on Mac and PC, and you can use it for free to back up locally or between two machines. Or, if you choose to, you can subscribe to CrashPlan for around $60 a year and have unlimited cloud-based backups.

Figure 9.11
CrashPlan backs up to my studio RAID device and to the CrashPlan cloud solution.

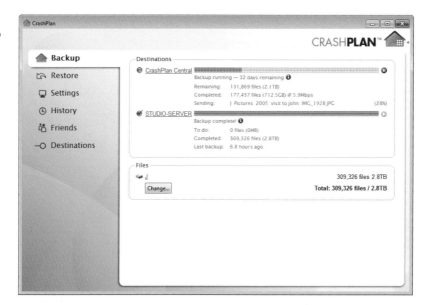

Selecting Images

Once my images have been successfully imported into Lightroom and backed up to an external device, I begin the image-selection process. For me, this process is about quickly identifying images that I want to process further and worrying less about deleting images that don't work. In fact, I rarely delete images out of my workflow until I'm absolutely sure I have no intention of using them in the future. I think photographers need a cooling-off period before they completely delete images from their library. After all, you don't want to throw out an image you don't think will work and later regret it because you hadn't thought about possibly converting it to black and white or being more creative with a crop.

Here's a quick step-by-step of my image-selection process:

1. Using the single-image view in Lightroom's Library mode, I use the arrow keys to begin working my way through the images.

2. When I come across an image I want to work on further, I press the P key to flag it as a "pick" (**Figure 9.12**).

3. Once I've flagged all of my picks, I sort the recently imported images. When I have my picks in front of me, I begin processing them.

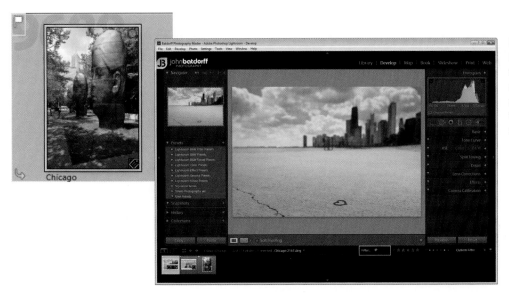

Figure 9.12
I flag images that I want to process as "picks." That way I can filter by this status when it comes time to edit.

Processing Images

Now that you know which images you want to process, it's time to move into Lightroom's Develop module to begin creatively editing your images. I try to spend as little time as possible—any more than five minutes per image is very rare—processing my images in Lightroom. Most of my edits involve very quick, basic adjustments such as straightening, white balance, exposure, color correction, and lens correction. If I find myself spending more than 15 minutes on an image, chances are I'm trying to make it something it's not, and best practice is to move on.

I believe processing is a very intimate process, much like taking a photograph, and it needs to be well aligned with your creative vision. As a RAW shooter you'll find yourself doing more processing than a JPEG shooter, because with JPEGs the camera processes the image. With RAW, *you* have to process it. Each image requires a different approach. One thing I find myself doing repeatedly to images is adding black back in as well as adjusting the tone curve (**Figure 9.13**).

Figure 9.13
The image on the top is an unprocessed RAW file. The image on the bottom has been processed, adding contrast and increasing vibrance.

ISO 320 · 1/500 sec. · f/9.5 · 50mm lens

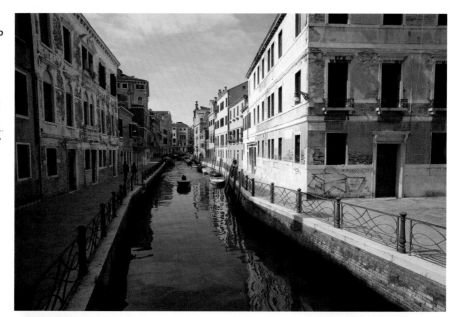

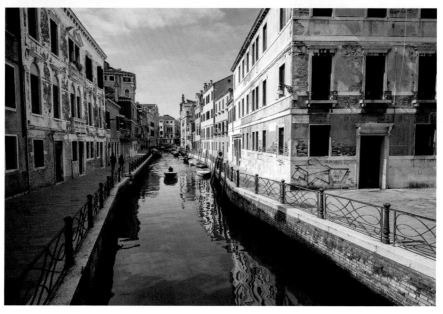

Using Presets

When processing images, if I find myself repeating the same steps on multiple images or I stumble upon a distinctive look that I like, I'll create a preset. For instance, when I'm processing black-and-white images, oftentimes I'll make several adjustments to the color sliders, tone curve, sharpening, etc., and then I'll create a preset that I can use on future images.

Presets are great for speeding up workflow by combining routine adjustments such as autoexposure and lens correction. My favorite use of a preset is to provide a preview in Lightroom's Navigator window of what an image could look like if a preset is used (**Figure 9.14**). This allows me to determine very quickly if I want to convert an image to, say, black and white or use a vintage look. Lightroom comes with built-in presets, and you can also purchase them from pros, so experiment with various presets to help guide your vision.

Figure 9.14 **Using presets and previewing your images in the Navigator can speed up workflow.**

Removing and Adding Objects

One of the major considerations when processing images is what your policy will be in regards to removing distractions. Are you going to clone out power lines in landscape images, people from architectural photographs, or facial blemishes on portraits? Some of these answers depend upon what the image will be used for. Is it for microstock, your personal portfolio, or a client? An editorial photographer might have different standards than a landscape photographer, because removing objects may compromise the accuracy of the scene. My policy has changed over the years, but as a general rule I'll remove only dust spots from my images and avoid adding content. My recommendation as a street photographer is to keep your work as authentic as possible while still expressing your style and vision (discussed later).

My Thoughts on Lightroom Mobile

We've been able to edit images on our smartphones for years, but it's only recently that software companies have started developing ways for us to edit our images remotely using the cloud. At the time of writing, Adobe announced Lightroom Mobile, which allows you to edit your files using an iPad or iPhone. This requires you to upload and sync images between your main Lightroom library and the cloud; these files are then synced

with lower-resolution previews to your tablet device. All edits performed on your tablet device are then synced back to your main catalog library (**Figure 9.15**).

All of this requires an Internet connection, which you may not always have. But this technology is a huge leap forward, especially if you travel and need to be able to edit and share images while on the road. I suspect this technology will improve immensely in the next couple of years and add to the argument for leaving your laptop behind when traveling. However, for my workflow, the technology is not there just yet. (Another benefit to learning Lightroom is being able to take advantage of true professional mobile editing when the time arises.)

Figure 9.15
Mobile editing is here, and though far from perfect now, I'm sure within a couple of years it will be a real option for travel photographers.

Developing a Personal Style

One of the things many photographers struggle with is how to develop a personal style. We often think of style in terms of fashion or an object's design, and many times we mimic these styles as we cultivate our own. The same principle holds true with photography. We can learn from those who have gone before us. I developed my style by studying the masters, reading books about Ansel Adams, Henri Cartier-Bresson, Paul Strand, Irving Penn, and the list goes on. Photography blogs are another great way to gain insight into your own style as you learn techniques that can be applied to your own work. The biggest piece of advice I can give you is to be true to yourself and take risks. It's taken me nearly 20 years to take all this seriously and truly start focusing on developing a personal style, so give yourself room for error and time to grow (**Figure 9.16**).

Figure 9.16
Twenty years ago I went to Zabriskie Point in Death Valley for the first time and snapped this photo with a Kodak disposable camera.

ISO 400 · Kodak film · Disposable camera

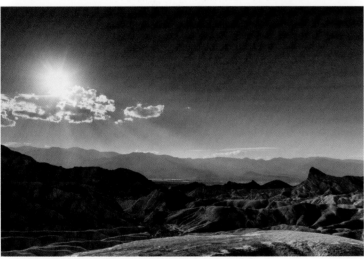

I recently stood at the same place and took the photo again. I have since developed a style (and purchased a slightly nicer camera).

ISO 100 · 1/200 sec. · f/14 · 24mm lens

Here are five tips for developing your own style:

1. **Take note of what you're interested in.** Do you like macro photography, portrait photography, street photography, landscapes, color, or black and white?

2. **Don't fret about being good at everything.** Remember the saying "Jack of all trades, master of none"? Select a type of photography that you really enjoy and immerse yourself in it.

3. **Study the work of photographers whom you respect and try to duplicate their style.** The dirty truth is that all photographers, whether they realize it or not, at some point in time have copied another photographer's style on the path to their own.

4. **Take risks and experiment with techniques such as HDR, black-and-white conversion, shooting with film, and learning Lightroom.** You may not use these techniques every time, but they will give you insights into the elements that you like in photos and give you a basis for branching out.

5. **Create a preset when you edit a photo that really resonates with you.** Then try it on other photos and see where it goes (**Figure 9.17**). You can continue to tweak the preset to see if you can come up with a basic style.

I heard great advice from GoPro creator Nick Woodman. This may sound overly simplified, but when asked why GoPro is so successful, he said it's because initially he had "mono, maniacal focus." I think that same advice can be given to beginning photographers, as I've seen many who have fully immersed themselves in photography develop a style in a relatively short period of time.

Figure 9.17
The color image taken at Café du Monde in New Orleans is the unprocessed DNG file. I converted it to my style of black and white using my Street Portrait preset.

ISO 200 · 1/90 sec. · f/5.7 · 35mm lens

Conclusion

We've covered a lot of ground in this book, and I hope that you've enjoyed our journey. The goal of this book was to give you a solid foundation to help you improve upon what you already know and to take your photography to the next level. I realize many of you don't have intentions on being a "professional" photographer, but are simply looking for ways to get the most out of your travel and street photography. Hopefully this book is one step in your lifelong pursuit of your passion.

If your goal is to become a professional, then let me say this: I hear other professional photographers complain that nowadays "everyone's a photographer." You know what? It's true—and it's okay! Don't feel intimidated by other photographers. Any photographer who makes you feel less than equal isn't secure with his or her own ability. You're no more or less of a photographer than the next person, and we all started exactly where you are: reading books and learning as much as we can about our craft. From one photographer to the next, welcome to the club, and here's to keeping it all in focus!

We covered a lot of ground in this chapter, and now it's time to strengthen your own personal workflow with a few assignments.

Set up your photo station

Whether you plan on editing on a laptop or desktop, it's important to identify one computer where you'll be performing the majority of your image editing and backups. Clear your computer of any unnecessary programs that might slow performance or eat up crucial hard-drive space. Install the latest version(s) of your preferred image-editing software.

Keyword your images

Make searching for images easier by using keywords. Spend some time looking over your archives and keywording. If you ever plan on selling your images to a stock agency or uploading to an online portfolio, keywording can be an essential tool for helping others locate your images.

Back up now

If you haven't already, purchase an external drive and start backing up your images. If your images are already stored on one external drive, then back up that drive. You should always have two backups of any photograph. Take it a step further and subscribe to a cloud-based backup service so you have the protection of offsite backup.

Time to calibrate

Calibrate your monitor so you can achieve consistent results. You should perform color calibration regularly. Most software will prompt you to calibrate daily, weekly, or monthly. I calibrate my system monthly and have had great results.

Learn Lightroom

I never make recommendations that I don't feel strongly about. I have seen firsthand how many people have taken their photography to the next level by learning how to use Lightroom. You can download a free 30-day trial of Lightroom; visit www.adobe.com/lightroom to learn more. As always, if you have questions, feel free to email me. My blog door is always open!

Share your results with the book's Flickr group!
Join the group here: www.flickr.com/groups/street_fromsnapshotstogreatshots

Index

INTRODUCING

Fuel BOOKS

Powerful Ideas. Inspired eBooks.

Need a little boost? Then fill up on Fuel! Packed with practical tools and tips that will help you quickly advance your creative skills, these short eBooks get right to the heart of what you need to learn. Every FuelBook comes in three formats—MOBI, ePUB, and an elegantly laid out PDF—so you can choose the reading experience that works best for you on whatever device you choose. Written by top authors and trainers, FuelBooks offer friendly, straightforward instruction and innovative ideas to power your creativity.

For a free sample and more information, visit: fuelbooks.com